The
PATRIOT PARSON
of LEXINGTON
MASSACHUSETTS

REVEREND JONAS CLARKE
and
THE AMERICAN REVOLUTION

RICHARD P. KOLLEN

THE
History
PRESS

Published by The History Press
Charleston, SC
www.historypress.net

Copyright © 2016 by Richard P. Kollen
All rights reserved

Cover image of Hancock-Clarke House by Paul Doherty.

First published 2016

Manufactured in the United States

ISBN 978.1.46713.538.2

Library of Congress Control Number: 2015955758

CONTENTS

ACKNOWLEDGEMENTS

Several organizations and individuals were critical to this book. I would especially like to thank Susan Bennett and Elaine Doran of the Lexington Historical Society. As society director, Susan supported the book and offered advice from its inception. I always had easy access to manuscript materials and images because of Elaine Doran, society curator. Susan Bennett, Mary Keenan, Mary Fuhrer and Philip McFarland all read the book at various stages and provided feedback that I incorporated in the manuscript. Ben Carp and Richard D. Brown were helpful at the beginning stages. This project also benefited from the manuscript collections of the Massachusetts Historical Society, the American Antiquarian Society and the Arlington Historical Society. Acquisitions editor Stevie Edwards and production editor Ryan Finn at The History Press guided skillfully the project to its completion. Finally, I would like to thank my wife, Yinnie, for always encouraging my work.

This publication was made possible, in part, by the Massachusetts Society of the Cincinnati.

PROLOGUE

The sun had started its descent on April 19, 1775, as Reverend Jonas Clarke returned to the meetinghouse with his wife, Lucy, with a baby in her arms, and their eleven-year-old daughter, Betty. Earlier that day Lucy, baby Sarah and the other Clarke children, nine living at home in all, had desperately scattered into the woods; the youngest were hurried thirty miles away to their grandfather Thomas Clarke's house in Hopkinton, Massachusetts. Jonas Clarke's houseguests at the time, Whig leaders Samuel Adams and John Hancock, along with Hancock's fiancée and aunt (all alerted by couriers Paul Revere and William Dawes), had already fled to neighboring Woburn.[1]

That same dawn, British Regulars, hoping to travel undetected from Boston to Concord to seize rebel arms and stores, had marched as far as Lexington, where they encountered the town militia parading on the Common in a show of force. The British set about to disperse them. A bloody skirmish ensued, and eight men, seven of Lexington's own, perished near Reverend Clarke's meetinghouse. Clarke had observed the action standing outside his parsonage no more than four hundred yards from the Common. When the firing ended, the Regulars marched on toward an already alerted Concord.

By two o'clock that afternoon, thirsty and exhausted British troops were staggering back through Lexington in a desperate flight to the safety of Boston. Fortunately for them, a relief mission led by Colonel Earl Percy had set up a rear-guard action near Munroe Tavern to cover their retreat. But

before the British passed on through Lexington, they inflicted further scars. A cannonball tore through the roof of the meetinghouse, Munroe Tavern was damaged and three private homes were torched.

Some of the militia from surrounding towns who had pursued the Regulars from Concord as far as Lexington now drifted over to Reverend Clarke's parsonage and partook of the provisions he offered them. Around four o'clock in the afternoon, the minister gathered remnants of his family still in town and grimly headed toward the meetinghouse.[2] Clarke had earlier sent his son Jonas to Menotomy (today Arlington) to check with Reverend Samuel Cooke on the death toll there. Now the time had come to reckon the price Lexington had paid.

Reverend Clarke stood in front of eight caskets stacked one on top of the other inside the meetinghouse and prayed. His parish had just endured a gut-wrenching tragedy. Deeply saddened at the loss of life, the minister was furious at the British Regulars, although he fully understood his part in what had happened. Clarke had been a pivotal actor in the events of the fateful day, even if he had not physically stood with his parishioners on the Common while the British Regulars rushed at them, bayonets glinting in the rising sun. Warned of British plans, he had consulted with his houseguests Samuel Adams and John Hancock as to the proper course to follow. Beyond that, he had for years guided his parish toward opposing imperial legislation, thus contributing to the hostile environment that had led the British to send their expedition to Concord. A pastor of decidedly independent sensibilities, Reverend Clarke maintained a Whig parish through the formidable power of his office. Beyond his leadership from the pulpit, through writing town meeting resolutions and instructions to the town General Court representative, the colony's legislative body, he had shaped Lexington's response to the tightening vise of new laws imposed by Parliament. With this history behind him and although pained by the deaths of his parishioners and other Massachusetts colonists later in this fateful day, Clarke remained convinced that the recent struggles served a larger purpose.

Events of April 19, 1775, lit the spark that set in motion a course leading to the independence of the United States. Jonas Clarke, through an accident of geography, through marriage, through his own sense of responsibility and through faith in divine providence, played a major role in what came to pass. Like many "country" ministers of the time, his work has gone largely unnoticed in histories of the Revolution. Even Loyalist Peter Oliver's often quoted pejorative reference to the "black regiment" was directed at Boston ministers whom he knew. Reverend Charles Chauncy, Reverend Jonathan

Mayhew and Reverend Samuel Cooper have enjoyed historical recognition for their leadership in Boston.[3] But Whig country ministers have more often been treated as anonymous abstractions, rarely singled out for their significant contributions.

A simple country minister, Reverend Jonas Clarke certainly rose in prominence once the battle rent his town. But the skirmish on Lexington green would not have occurred without Clarke's critical work in preparing the ground for resistance. An ordinary man in extraordinary times who found himself at a historical crossroad, he chose to follow the path that led to revolution.

BEGINNINGS

Today, a birth to a Christian family on December 25 would deepen, if not overwhelm, its holiday celebrations. But Jonas Clarke's arrival in Newtown (Newton), Massachusetts, on December 25, 1730, competed with no festive observances. Congregational communities still largely condemned Christmas celebrations as pagan rites associated with post-harvest saturnalia. Some rowdy behavior might have occurred on the fringes of Boston social life, but orthodox Calvinists still had little use for English Christmas traditions as practiced then. Instead, residents of Newtown and its environs went about their activities on the day of Jonas Clarke's birth as on any other Friday. For Thomas and Elizabeth Clark, a new son brought profound joy to the household.[1] Even so, they could hardly have imagined their son's significant role in severing ties with a government overseas to which they paid loyal homage.

Formerly part of Cambridge, Massachusetts, the colonial legislature had set off the village of Clarke's birth in 1688 as a separate town with the name New Cambridge. The name was changed to Newtown in 1691, becoming Newton seventy-five years later. The original settlers of Cambridge (itself originally called New Towne) were among the first generation of Puritan immigrants to settle Massachusetts Bay Colony in 1630. Having fled the "corrupt" Church of England and its head, King Charles I, these Puritans pursued God's purpose for them: to create "a City on a Hill," a godly community that could stand as a model to the world. Their migration left them free to practice their Calvinist theology unburdened by interference from the Anglican Church bureaucracy

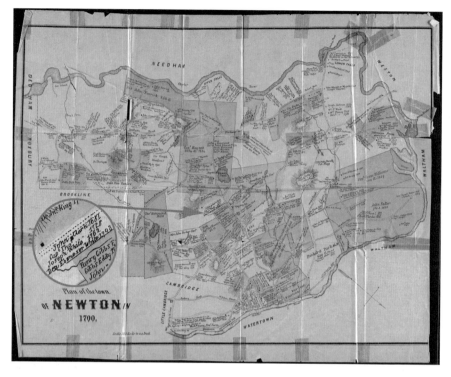

Map of Newton, Massachusetts, 1700. Reverend Clarke's grandfather and father's homestead location is inset. *City of Newton, Massachusetts.*

while remaining British citizens. The jealous regard that the American colonists felt for liberties conferred by their citizenship would later place Jonas Clarke at the center of momentous events.

Thomas Clark's land occupied a space in Newton near today's Lyman Street, stretching across the west side of Institution Hill in the center village.[2] His mansion house stood near the town Common on the east side of Dedham Road, now called Centre Street. Jonas's great-great-grandfather Hugh Clark had conveyed the sixty-seven-acre parcel to his son John Clark in April 1681.[3] Public records refer to Hugh Clark's occupation as a husbandman, one who farms and raises livestock. By his own reckoning, he was born in 1613 and so likely immigrated to New England as a young man during the Puritan exodus of 1630 to 1640 called the Great Migration.

Hugh Clark first appeared in Massachusetts's vital records in 1641 as a resident of Watertown. Hugh and his wife, Elizabeth, raised two other children before they moved to Roxbury in 1660.[4] While in Watertown, he achieved respectability as a freeman, a status requiring church membership,

ownership of land and an acceptable reputation. Freemen enjoyed full political and civil rights and were obligated to pay taxes. Six years later, Hugh Clarke joined Boston's Artillery Company (later the Ancient and Honorable Artillery Company), a militia patterned after the Honourable Artillery Company of London and meant to train citizens in military discipline and tactics. In 1768, Reverend Jonas Clarke would preach the annual election sermon for the same organization. Although never wealthy, Hugh amassed an estate substantial enough to provide a farm for his oldest son, John, in what became Newton. Hugh and Elizabeth remained in Roxbury until their death in 1693.

Hugh conveyed the Newton farm to his son when John married Abigail in 1681. Abigail died a year later, but by 1684, John had taken another wife, Elizabeth Norman. Later, he built a sawmill on the Charles River, the first in Newtown, at what would become Newton Upper Falls. That successful business venture advanced John Clarke's status and likely influenced his election as town selectman.[5] Born in 1680, John's first son, his namesake and Jonas's grandfather, also served as a selectman in 1722. Young John would marry Ann Pierce of Dorchester, who in 1704 bore Jonas Clarke's father, Thomas, their oldest surviving son. John, the grandfather, died several months before Jonas was born, but the grandmother, Ann, lived long enough to see the child enter Harvard at seventeen.[6]

Surviving documents refer to Jonas's father as Captain Thomas Clark. Likely elected a militia captain earlier, his rank indicated that he maintained a favorable standing in the town. It was customary for a high rank to be retained as an honorific long past active militia service. Thomas had joined a family of good standing, his father and grandfather having maintained substantial estates while serving in elective town office. He had married twenty-four-year-old Mary Bowen of Dorchester in 1728. In 1749, Thomas continued family tradition by becoming a Newtown selectman. Later, Thomas and Mary moved to Hopkinton. During the fateful year 1775, they died there within days of each other.

For Thomas and Mary, raising a family proved both a source of pleasure and unimaginable heartache. Peter, their firstborn, in 1729, did not survive his first year. Consequently, Jonas in 1730 became the oldest sibling in the family. Penuel died within two years of his birth, followed by three other siblings: another Penuel, Sara and another Sara, none reaching three years of age. Of eight births, only Jonas, Mary and Thomas survived into adulthood. In 1755, Mary, six years younger than Jonas, married John Cotton, son of the minister of Newton's First Church. John Cotton died young, leaving

Mary a widow for most of her adult life. The third surviving Clark child, Thomas, was considered insane and remained largely dependent on his family his entire life.[7]

Although a high infant mortality rate was a tragic fact of eighteenth-century life, the Clark household clearly suffered more than its share of misfortune. Perhaps his family's tragic encounters with mortality bore on young Jonas Clarke's decision to enter the ministry.

Typical of colonial Massachusetts's meetinghouses, Newton's First Church, constructed in 1698, remained unheated in winter. Its all-day Sabbath services broke at midday for a meal. For those who lived at a distance, the town had constructed nooning houses. Plain one-story structures, they were equipped with fireplaces to warm parishioners on bitterly cold days typical of New England winters. Newton built three or four such structures, one near the Clark homestead in 1730, Jonas's birth year. "The Selectmen staked out land near Clark's fence," town records note, "for the relief of sundry inhabitants on the Sabbath days."[8]

Young Jonas no doubt interacted regularly with Reverend John Cotton. Not only did the boy live near the meetinghouse, but the parsonage also stood within a mile on the west side of Centre Street, at the junction of Cotton Street today.[9] This proximity awakened in Reverend John Cotton's son, John, an appreciation of Jonas's younger sister, Mary. Their courtship surely brought the minister and his family into closer association with the Clarks. Young John Cotton was one year older than Jonas, and as boys and young men, the neighbors likely spent significant time together. John entered Harvard earlier than his neighbor, graduating in 1749 to pursue a medical career.[10] Jonas did not enter the college until 1748.

The town held its parson in high esteem. At age twenty, Reverend Cotton had been ordained as the third minister of Newton's First Church. His name no doubt advanced his clerical aspirations, for he was the great-grandson of the celebrated John Cotton, first minister of Boston's First Church, one of the best-loved and most learned ministers of the Massachusetts Bay Colony in its early years. But name alone did not win the later Cotton his position in Newton in 1717. Congregations selected ministers with great care, knowing that their choice would probably serve for life unless he was removed, a prospect both difficult and disruptive. Consequently, towns typically invited several candidates to "audition" before settling on one. Newton chose Cotton over four unusually qualified candidates, including the future president of Harvard College.[11] Perhaps Cotton's speaking style won over the parish,

as Reverend Cotton was later known as "the Great Gun of the Gospel."[12] Frequent interaction with such a charismatic individual may have favorably inclined impressionable young Jonas toward the ministry.

When Jonas attended meeting on Sundays, he sat in a section of the gallery designated for boys. The prospect of disorderliness necessitated a tithing man be stationed in proximity to preserve decorum. As needed, this official exercised his authority by rapping the heads of recalcitrant lads with a ball attached to a long stick.[13] Meanwhile, the length of Cotton's prayers and sermons varied, but they tended to be lengthy. Deacons placed an hourglass on their tables, and the congregation considered their minister's sermon too brief if the hourglass was not turned at least once.[14] Once a preacher himself, Jonas Clarke's own prayers and sermons were famously longwinded.

Jonas would have been too young to understand the news that emerged from the western Massachusetts town of Northampton in the mid-1730s regarding a remarkable number of spiritual conversions "harvested" by minister Reverend Jonathan Edwards. But when almost ten years old, he probably felt the excitement surrounding George Whitefield's visit to the Boston area in September 1740. Reverend Whitefield was a charismatic twenty-four-year-old British parson whose animated preaching style met with great success in England. As a student, he had joined the Methodists led by John Wesley, a more "pious" sect that had split from the Anglican Church. Their ardor led the young man to have a conversion experience, and after his success in England, Whitefield ventured overseas in 1739 to preach to enormous crowds through the Middle and Southern Colonies of America. In 1740, he headed north.

That November, Jonas Clarke likely attended Whitefield's sermon at Reverend Cotton's First Parish in Newtown. The noted evangelist had a powerful effect.[15] George Whitefield's brief but dramatic ten-day stay in the Boston area attracted huge, ecstatic crowds. He preached to a rapt congregation at Boston's Brattle Street Church, then to an overflow audience on Boston Common and later to seven thousand students in Harvard Yard in Cambridge.[16] His message remained the same. He railed against the cold rationality of European Enlightenment ideas then becoming popular in American intellectual circles and in some colonial meetinghouses. For Whitefield, the heart, not the head, held the center of spirituality. True piety emerged from welcoming God into one's heart, a life-changing event known as a conversion—an experience required of all church members of New England's first generation. Subsequent generations had eased this original

bedrock requirement for church membership in response to declining conversions. This offended Whitefield.

On this first Boston tour, the Englishman met with the approval of Congregational and Harvard authorities, who discounted his dramatic, extemporaneous style, judging his sermons to be beneficial even if a little undignified. They welcomed anyone who might revitalize the people's faith. New England clergy worried about diminishing piety among parishioners. Therefore, local ministers sponsored Whitefield's sermons throughout New England, hoping that his words would enlarge their congregations. At first, these hopes were rewarded. In Newtown, Whitefield and the subsequent Great Awakening tangibly increased spiritual concerns, with 104 new members joining the church in the ten months of late 1741 and early 1742.[17] But it also brought division. Newton historian Francis Jackson wrote that Whitefield's Newton sermon "divided the community, every man was either an ardent supporter or a decided opponent."[18]

Ultimately, Whitefield provoked a more widespread and profound revival than most established clergy desired. Other revivalists visited Boston soon after Whitefield. As the revival gained strength, the Great Awakening began to hold sway in country towns west of Boston, where meetings led to congregants swooning and fainting during conversion experiences. Such theatrics caused established Congregational ministers to retract their support. For those ministers, later called Old Lights, sermons must be firmly rooted in the intellect and worship dignified and restrained. The itinerant, uneducated preachers whom the revival spawned repelled the more traditional clerical establishment.

Furthermore, in 1741 Whitefield himself offended established authorities by publishing a journal of his Boston tour. In it, he called Harvard and Yale "seminaries of paganism" whose "light is darkness."[19] To Whitefield, those colleges dedicated to training Congregational ministers were largely responsible for the rational direction of the New England church. He condemned ministers for abandoning conversion experiences as a requirement for church membership, and he implied that they themselves remained unconverted. In turn, he questioned the legitimacy of unconverted ministers. To New Light ministers, the Old Lights hid their lack of conversion behind the pedantry of a worthless education.

The revival's emphasis on conversion and emotion over rationality threatened conventional authority. To New Lights, conversion, God's great equalizer, had a socially leveling effect, placing all converted on the same level regardless of wealth. If a minister remained unconverted, he

was considered inferior to his converted parishioners. According to many New Lights, college-educated yet unconverted clergy lacked legitimacy and should be denied a pulpit.

While the Great Awakening burned bright, some parishes opposed their minister and, on occasion, removed him. If division arose in the congregation over doctrine, the New Lights often seceded and established a separate church. This happened in neighboring Concord.[20] Such doctrinal divisions in a congregation left residual tensions even after the revival's fire had burned out. For instance, Jonas Clarke's future father-in-law, Reverend Nicholas Bowes, left his Bedford parish in 1753 likely over a doctrinal dispute.[21] Bowes proved to be an Old Light minister in a New Light town.[22] A native of Lexington, Reverend Matthew Bridge faced discord over those same issues upon his settlement in Framingham in 1745.[23] In Newton, a Whitefield convert, Nathan Ward, founded a separate church in a parishioner's home, an antecedent of Newton's First Baptist Church. Ward lacked education, and his ministry met with opposition; the town taxed him, refusing to grant him a clergyman's exemption.[24]

After the Great Awakening exerted its greatest influence in the years 1740–43, it began to wane. By the time Whitefield planned his return visit to Boston in 1744, Congregational authorities had aligned themselves against him. Now the Englishman faced opposition from several prominent Boston ministers.

In 1745, Reverend John Cotton joined nine other parsons in his ministers' association to advise Reverend Nathanial Appleton regarding a request made by members of his Cambridge parish to invite Whitefield to his pulpit. Although most ministers present, including Cotton, had welcomed Whitefield in 1740–41, by 1745 the Englishman's behavior and those of his acolytes had led to firm opposition among most established clergy. Because of Whitefield's "principles, expressions and conduct," Cotton's group unanimously advised against his being allowed to preach in Appleton's church.[25] Reverend John Hancock of Lexington, Jonas Clarke's predecessor, chaired the meeting. Hancock's son-in-law, Bedford's Reverend Nicholas Bowes, returned to Bedford to deny the pulpit to Whitefield, despite interest among his congregation in hearing the visitor.[26]

Several factors may have contributed to the Clark family's decision to send Jonas to Harvard. Surely, the young man showed signs of industry along with intellectual promise. Doubtless his interaction with the Cotton family figured prominently in his college matriculation. A family so important to Massachusetts's religious history reminded the Clarks of the virtues

and rewards associated with the clerical life. Because the Clark family had advanced socially over successive generations, taking a place among Harvard families seemed a natural next step. With a college degree, Jonas could look forward to a professional future in medicine, in law or, perhaps, with a graduate degree, in religion. Although Harvard had been founded primarily to train ministers, by the mid-eighteenth century the number of graduates pursuing ministerial careers had declined to 34 percent.[27] Clarke's matriculation at seventeen, a few years older than average, suggests either ambivalence or a need for time to acquire tuition.

Generations earlier, a clerical life would have been a logical choice for the eldest son of a family of means. Clarke's neighbor, young John Cotton, would likely not have given the medical profession a second thought had he lived in an earlier era. The percentage of first sons becoming ministers declined, however, as the century progressed.[28] This trend coincided with a decline in status that ministers suffered throughout the eighteenth century. Comparatively low salaries and increasing discord between clergy and their parishioners, especially during the Great Awakening and its aftermath, led to the profession's loss of prestige and appeal.[29] At the same time, secular professions such as law and medicine began emerging as more lucrative career opportunities. None of this mattered, of course, to men who felt a calling to pursue the clerical life. Clarke may have harbored a predilection toward a ministerial career from the start.[30] If so, it would have pleased Reverend Cotton, who probably had the same hopes for his own son.

One can only speculate on Jonas Clarke's preparations for Harvard. The college required a candidate to pass an exam demonstrating proficiency in Latin and Greek, including writing a simple theme in Latin.[31] Therefore, a Harvard candidate needed instruction far beyond what the common schools provided children in their towns. Most likely Reverend Cotton helped Jonas prepare, as Reverend Clarke later helped prepare college candidates in Lexington. Local clergy were expected to tutor promising young men for Harvard, since few college-educated men could be found in most towns.

Jonas began his Harvard College years in the middle of August 1748. Harvard's campus comprised four buildings in the Yard for the housing and instructing of about 120 students.[32] That year, his future brother-in-law, John Cotton, was a senior. Among the 34 students in the class of 1752, Jonas ranked 25th. Harvard based this "placing," done in the spring of freshman year, not on academic achievement but rather on the wealth and standing of the student's family. Jonas was not a scholarship student, but his ranking reveals that his family's wealth placed him among the more humble young

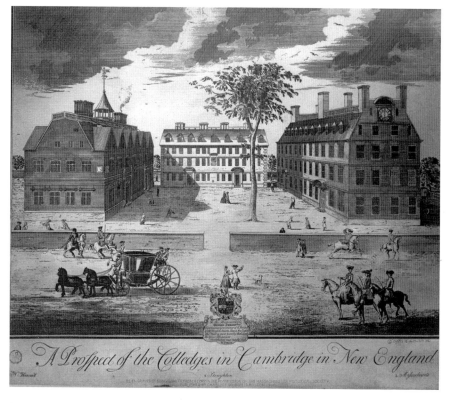

Harvard College in 1726. *Library of Congress.*

men in his class. Seniors voted Jonas Clarke to be their waiter for meals in the Commons, thus enabling him to earn wages.[33] Perhaps John Cotton had lobbied his classmates to vote for Jonas. The freshman's classmates ranged from thirteen years of age to twenty-one, with Jonas falling in the middle at seventeen and a half when the school year began.[34] But most were younger than Jonas.

Harvard required students to eat at the Commons, although the wealthy simply paid the fee and dined elsewhere. On campus, food quality was the subject of ongoing student complaints, even leading to several "disorders."[35] A law responding to those complaints passed by the Harvard Corporation in 1750 required "two sizes of bread in the morning; one pound of meat at dinner with a sufficiency of sauce [vegetables] and a half pint of beer, and at night…a part pie" with more beer.[36] But to the student body, food quality remained erratic, as did the portions, even after the new regulation. As a supplement, the college operated a store called

the Buttery, where students could purchase wines, groceries, stationery and items unavailable in the Commons. Harvard hoped to make the campus self-sufficient through the Commons and the Buttery, removing any need for students to venture into Cambridge proper, where they might cause trouble.[37] Despite Harvard's intentions, students ventured out anyway.

Clarke's roommate for his first three years was Thomas Browne, a minister's son from Haverhill, Massachusetts. The freshmen shared a room at Harvard Hall and then moved to Stoughton Hall for the next two years. The roommates remained friendly after Harvard, both as ministers. While a senior, Jonas shared a room in Massachusetts Hall with David Lane of Bedford, Massachusetts, and a member of the class of 1753. Many eighteenth-century Harvard students and today's college students shared the propensity to mix studies with drinking and carousing. Instances of undergraduates using "wine, beer and distilled liquors" in their rooms and indulging in "habits of frequenting taverns and alehouses" were common by midcentury.[38]

One carousing student was Jonas's future cousin-in-law, John Hancock, who spent his freshman year (1750–51) boarding with Reverend Nathaniel Appleton, Cambridge's minister. At thirteen, Hancock was the youngest in his class.[39] As a sophomore, he moved into Massachusetts Hall, embracing at least the social aspects of college life; with several friends, he soon lost standing in class rank for an episode in which the group induced a black servant (likely a slave) to become dangerously intoxicated.[40] Future minister of Boston's prominent West Congregational Church Jonathan Mayhew was fined seven shillings during his senior year for drinking.[41]

Harvard College never punished Jonas Clarke for drinking, but he did run afoul of the authorities on several occasions. On December 27, 1751, Harvard fined "Brown, Baldwin, Langdon, Clarke and Cullen" five shillings for "making loud and tumultuous noises." Clarke's "card playing" and "cutting class" cost him five shillings on three occasions. But closer inspection reveals that the class cutting involved returning late from winter vacation "beyond ye time allowed."[42] During the winter breaks of 1750 and 1751, Jonas Clarke earned money by teaching school in Needham, a common practice among Harvard students of middling and poor families. The Needham academic schedule may have conflicted with the beginning of Harvard's spring semester. Clarke surely recognized the irony in his correcting student misbehavior as a teacher before resuming his status as student at Harvard, only to be punished for his own transgressions.

Thomas Browne was no older than some of Clarke's Needham students. Perhaps Browne's lack of maturity led him to misbehave more seriously,

since one Sunday he "absented himself" from church attendance to break into a cellar "with a false key." For this, he was degraded seven places in rank. Undaunted, Browne soon after sought access to the same cellar. This time he procured a real key by "by stealing [it] out of the Master's Chamber." Apparently it was a wine cellar, since Browne used the key to steal "sundry times a quantity of Wine of at least twenty bottles." After a vote to expel him failed, the college degraded the boy to the lowest rank in his class.[43] Clarke showed sense and maturity enough to avoid his young roommate's capers while remaining on good terms with him.

The curriculum Jonas Clarke studied in his undergraduate years continued his Latin and Greek and began Hebrew. In addition, he learned logic, metaphysics, ethics, natural philosophy, geography, astronomy and some math. A typical day began at 5:00 a.m. with a prayer and morning meal before an hour of study. Next, the class attended its tutor's lecture. For the class of 1752, the tutor was Joseph Mayhew, cousin of the noted Reverend Jonathan Mayhew of Boston's West Congregational Church. All classes then returned to the Commons for their main midday meal. Waiters like Jonas served dinner while presumably eating between courses. Students spent the remainder of the afternoon reciting and debating the morning lecture with tutor Mayhew. Prayer followed at five o'clock, with the lighter evening meal at 7:30 p.m. Students passed the rest of the evening in study while light permitted.[44]

Jonas Clarke met the academic challenges of his undergraduate years. But as he prepared for his undergraduate graduation in 1752, a smallpox epidemic struck the Boston area. Commencement, an annual Cambridge festivity and an opportunity for alumni from throughout New England to gather, was canceled. No doubt Thomas and Mary felt deprived of publicly celebrating this proud family event, contenting themselves with commemorating their son's accomplishment privately. Jonas was not finished with Harvard, however, for he decided to pursue his master's degree in theology, a prerequisite to becoming a minister. With the financial aid of a Hopkins Fellowship, he remained on campus, boarding at Massachusetts Hall until his graduation in 1755.[45]

Clarke served as schoolmaster in Dedham in 1754, receiving three pounds, six shillings and eight pence in August for six months of work.[46] He returned to the classroom with more confidence. Schoolmasters often faced a non-graded, one-room schoolhouse with large classes of unruly students intent on testing a new teacher's disciplinary mettle. Clarke, now twenty-four years old, with two terms of teaching experience behind him, likely greeted

his students with a greater air of authority. But conditions in Dedham sorely tested him. As he wrote to his brother, Thomas, his class consisted of "about 60 scholars and sometimes more."[47] One can imagine the long day in a crowded one-room schoolhouse trying to accommodate a wide assortment of abilities and ages while maintaining some semblance of order. Later, the inherent authority of his clerical position, as well as the aid of tithing men overseeing the male children's behavior, made the Lexington experience far easier.

In addition to teaching, Clarke earned money in several locations during 1754 and 1755 as a supply minister. Supply ministers either substituted for settled ministers who fell ill or preached when a parish was between settled ministers. The towns Jonas Clarke served in that capacity included Bedford, Lynn's End (Lynnfield), Brookline, Braintree and Woburn. For each Sunday's work, the standard rate was one pound, six shillings and eight pence.[48] His time in Woburn led to young Clarke's being asked in January 1755 to be a candidate for settlement as minister of its First Parish Church.

He competed with two other candidates, Aaron Putnam and Stephen Minot. With the death of Woburn's junior minister the previous September, a series of supply ministers had heretofore served the church. By January 1755, the congregation had decided to offer each soon-to-be Harvard alumnus the pulpit for two Sundays each. But the town remained unsure of its choice after the young pastors' probationary employment ended, so it offered each three additional Sundays. With the second audition completed, the parish promised to choose its settled minister on June 18. But a vote revealed no clear choice among the three. So the parish began the search again—with new candidates.[49] By then, Clarke was competing for the Lexington pulpit.

Jonas Clarke had achieved a higher educational station than anyone in his family, present or past. At twenty-five years of age, he stood on the verge of finding his life's work in a town that became his home for fifty years, in a parish that he would lead through one of the most significant periods in our nation's history. For Clarke, the future held great possibilities, but he never could have imagined the events that would happen virtually on his doorstep.

LEXINGTON

Lexington was a recent town by Massachusetts Bay standards. Not incorporated until 1713, it lay twelve miles northwest of Boston (founded in 1630). Despite its proximity to the provincial capital, Lexington was considered a "country town." Without a bridge over the Charles River to connect Boston with Charlestown, a traveler to the capital from the western villages could only follow one land route: pay the toll and cross the river on the wood-planked Great Bridge at Cambridge (Anderson Memorial Bridge today) and then travel through Brookline and Roxbury to Boston—an indirect route making the town less accessible than actual distance might imply. Even with that obstacle, Reverend Clarke remained closely connected to the provincial center of commerce and government.

Like Newton, Lexington began as a precinct of Cambridge. Cambridge farmers seeking additional land for meadow-, pasture- and woodland found it in the northern terrain. Cambridge's coastal location had spurred rapid population growth, especially during the Great Migration, a period from 1630 to 1640 during which twenty thousand Puritans emigrated from England to the Boston area. For seventeenth-century farmers, this influx led to population density that threatened their livelihood. Livestock required pastureland for grazing distant from the center and meadowland to raise hay. In 1634, responding to inhabitants' complaints that they "were straightened from want of land, especially meadow," the Massachusetts General Court, or legislature, granted an extension of Cambridge's boundary eight miles north of Cambridge Common.[1]

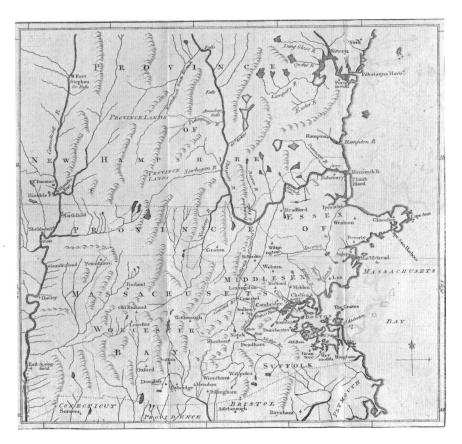

Map of eastern Massachusetts from a 1775 British almanac. *Lexington Historical Society.*

Eventually, this North Cambridge Precinct became the Farms, a backcountry tract of essentially unpopulated pasture-, meadow- and woodland. Later, Cambridge farmers, dividing their holdings to provide for multiple heirs, eventually passed that land to offspring who settled and improved it.[2] Once enough people lived in the precinct, they petitioned for Cambridge Farms' establishment as a separate parish. When their petition was granted in 1691, the parish population stood at about 270 residents.[3]

For several years, the parish lacked funds to settle a minister, so it engaged one on a temporary basis. This was likely Benjamin Estabrook, son of Reverend Joseph Estabrook of Concord. When in 1696 Cambridge Farms acquired the means to hire a minister full time, it formally joined hands as a covenanted community—that is, it entered a formal covenant or agreement on which the church community would be based. At the

outset, Puritan churches existed apart from ecclesiastical authority, with a democratic polity emanating from the church membership. Congregants formally joined together through a written covenant, pledging themselves to one another and to God.[4] The Cambridge Farms congregation's written covenant committed the parish to "combine together to walk as a particular Church of Christ according to the Holy rules of the Gospel." This involved

Sketch of the first meetinghouse. *Lexington Historical Society.*

not only pledging themselves "to the fear and service of the only true God" but to one another as well—"We do likewise give ourselves to each other."[5] As a covenanted community, it decided to call Reverend Benjamin Estabrook to be its settled minister, a familiar and trusted cleric. Unfortunately, he died nine months later.

A growing number of farmers had come to regard the Sunday treks to the Cambridge meetinghouse as an imposition—one that warranted a parish of their own. But even when granted, Cambridge still controlled the farmers' civic lives, such as school funding and road building, and it insisted that Cambridge Farmers participate in town responsibilities distant from their homes. Finally, in 1713, the General Court answered Cambridge Farms' repeated pleas for separate township status.[6] This separate political entity became Lexington.

Until Clarke's arrival, and through Lexington's entire history once incorporated as a town, the impressive Reverend John Hancock, who replaced Estabrook in 1698, shepherded the township through the difficulties that befell many New England villages in the eighteenth century. Over time, the Lexington minister's prominence reached beyond his parish to earn him the honorary title of "Bishop." Although the existence of bishops constituted a grievance that Puritans held against the Church of England, Hancock's colleagues bestowed the title with ironic affection.

For townspeople to replace a public man of such significance, and one who had served them so long, must have been daunting. But their choice, Jonas Clarke, ultimately proved more than equal to the task. Even after his death, Hancock's influence on his successor's life continued. Indeed, Clarke's trajectory as a minister, as a family man and, later, as a political figure owed much to Bishop Hancock.

Before the turbulence of the Great Awakening, Congregational ministers still wielded profound influence on their communities. For rural towns with few, if any, educated residents, ministers stood at the center of spiritual and civic life. The minister, who baptized and buried, held sway over parishioners every Sunday for services and midweek for lectures, the only times that the entire town came together under the same roof. The minister also officiated at public rituals such as fasts and thanksgivings. As an acknowledged, dispassionate authority, he settled disputes, and in his role as "watchman," or moral arbiter, he rebuked antisocial behavior. He also served as informal liaison between his parish and the provincial government, since the governor in Boston distributed colony-wide proclamations by sending them to pastors to read aloud on

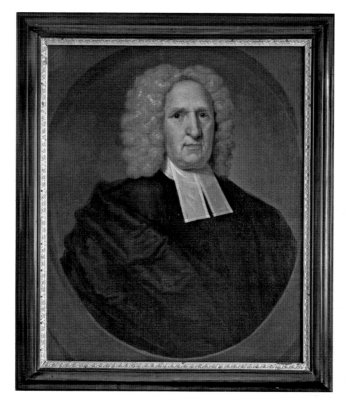

Painting by John Smibert of Reverend John Hancock, "the
Bishop," 1734. *Lexington Historical Society.*

Sunday. As residents, settled clergymen were of the people, especially after
increasingly meager salaries required many to farm to supplement their
incomes. Epidemics and droughts affected a pastor's family as well as those
of his parish. But as the eighteenth century advanced, New England clergy
began to distance themselves professionally from their congregations.

The formation of both county- and colony-wide ministerial associations
furnishes an example of this.[7] These local groups met periodically to discuss
discipline, doctrine and church management. Because most ministers in
Middlesex County had graduated from Harvard College, the meetings
became, as Richard D. Brown has noted, "de facto alumni clubs."[8]

The growing clerical distance contributed during the Great Awakening
to local rebellions against established Old Lights. But after the revival
played itself out, the next generation of Congregational ministers
became more aloof and professional than their predecessors. Bridging

the seventeenth and eighteenth centuries' clerical attitudes, and calming the revival's potential divisions in Lexington, was the comforting presence of Reverend John Hancock.

In large measure, Hancock's fifty-five-year tenure in Lexington prepared the town's smooth transition to the Clarke pastorate. This was no small thing. During the Hancock years, disputes among parishioners over their minister roiled towns throughout Massachusetts, not only due to the Great Awakening but also over other doctrinal and financial disputes. Subsequent tensions could divide a parish long after the minister's departure.[9] Even though most eighteenth-century clergy enjoyed lifetime tenure once settled, Lexington was most fortunate in settling two consecutive ministers who rendered such long and effective leadership. Its pastors each arrived quite young, and both enjoyed long lives, Hancock dying at 81 and Clarke at 74. Together, Hancock and Clarke, aside from an interregnum while the town searched for Hancock's replacement (1752–55), served Lexington for 105 years. The average tenure for a settled minister during the first half of the eighteenth century was 25 years.[10]

A shoemaker's son, Reverend John Hancock grew up in the Cambridge precinct that became Newtown, not far from where Jonas Clarke would be reared. He finished his undergraduate degree at Harvard in 1689, thirteenth in a class of fourteen, a testimony to his modest beginnings.[11] Lexington initially paid Reverend Hancock a yearly salary of forty pounds, the same as his predecessor, Reverend Benjamin Estabrook, along with a settlement payment of eighty pounds. His salary was to be augmented by the proceeds of quarterly collections, although those collections soon ended, and his salary was increased to fifty-six pounds.[12]

For his last thirty years, Hancock served as the senior minister in Middlesex County, chairing ordination councils for twenty-one local ministers.[13] Although his authority remained unquestioned, he exercised a pragmatic rather than autocratic control. Known as a peacemaker, Bishop Hancock possessed no small measure of practical good sense. This stabilized the town concerning matters of church doctrine. But he also lent his common sense to dealing with other town-wide matters, such as settling boundary disputes among residents. In one example, Hancock directed the principals to bring their deeds and plans and accompany him to the area being contested. After listening thoughtfully to both parties, he made his decision and directed each to cut stakes. "Now drive the stakes here and pile some stones around it," he said. "There is your line." With that, the controversy ended, Bishop

Hancock's word being final in Lexington not simply due to his position but also because of his reputation for fairness and good sense.[14]

During the tumults of the Great Awakening, Lexington remained relatively tranquil, largely due to the moderation and political skills of Reverend John Hancock. Hancock considered himself an "Old Calvinist," a clerical group taking a middle road between the excesses of the Great Awakening and the rationality it attacked. He did not dispute New Light theological precepts, even encouraging enthusiastic persons to join his church. He claimed conversion himself, although he could not recount precisely the time and place. "Though I cannot tell the exact time when, or the manner how, or the means and instruments by which the work of grace was wrought in me," he wrote in his commonplace book, "yet I think I may draw the conclusion, that God has made me his."[15] But he opposed the New Light ministers' contempt for education and their embrace of an exuberant preaching style. Earlier, in 1726, in an ordination sermon for his son John, Hancock underscored his personal disdain for an uneducated ministry. He argued that "an ignorant unlearned unskillful and injudicious ministry is the bane of the Church." The objects of his scorn in that sermon were the numerous radical sects that emerged during the English Revolution after 1640.[16]

But Hancock's principal objection to the revival was its divisiveness, setting parishes against themselves. Consequently, he eschewed criticizing the Great Awakening publicly. Instead, he maneuvered behind the scenes, as with his vote to advise the ministers' association in Cambridge, thus calming potential problems before they arose. He remained open-minded, attending outspoken rationalist Jonathan Mayhew's ordination at the West Congregational Church on Cambridge Street in Boston. Hancock's political pragmatism proved effective. The Lexington church stayed together, adding eighty souls to its congregation during the early years of the Awakening. The legend of Bishop Hancock, Lexington's minister for fifty-four years, cast a comforting shadow in which Jonas Clarke would begin his own long tenure.[17]

In 1722, at age fifty-one, Hancock preached the election sermon, which each year opened the General Court session. To be chosen to preach this sermon signaled the apex of professional respect and status, since most clergy passed an entire career without standing in the pulpit for election day. The event traditionally coincided with the annual convention of the Massachusetts clergy in Boston, thus ensuring a learned and attentive audience. Hancock's sermon was entitled "Rulers Should Be Benefactors." In it he observed, "It is the Duty and Excellency of those that are in Authority to be Benefactors."[18] While urging civil authorities to use their power for good, he took a position

that his famous grandson and his pastoral successor would later reject. The earlier Hancock referred to government officials as God's "Lieutenants, his Deputies, his Viceregents" on earth.[19] For rulers to be benefactors would "improve the Power and Authority given them from above."[20] This claim of divine sanction for the king's authority contrasts with social contract theory later embraced by American Whigs wherein the consent of the governed grants power to the government. But Hancock's views in 1722 existed within the tradition of clerical belief at the time. Obedience to rulers was preferable to anarchy, especially while the British government appeared to fulfill its responsibilities as a beneficent father.

Lexington continued to increase Reverend Hancock's salary during his long years of service. Once quarterly collections were abandoned, he received occasional but permanent increases.[21] Nevertheless, Hancock's income failed to keep up with the relentless devaluation of the Massachusetts currency. Thus, he never felt that his compensation kept pace with his standard of living. Lexington purchased a slave, Jack, for him for eighty-five pounds. Town leaders perhaps hoped that with that help Reverend Hancock would make his farm more productive, thus eliminating the need to increase pay further.[22] It was not unusual at the time for a country minister to own a slave.

Although they may never have met, the Bishop's legacy to Jonas Clarke extended far beyond a unified parish. Hancock, his wife and their progeny bestowed on Reverend Clarke familial and political associations that ultimately gave meaning to his personal and clerical life. No doubt, without Hancock, Clarke would never have met his wife or participated so fully in the events involving revolution and independence.

In 1698, upon settling as pastor at Cambridge Farms, Reverend Hancock married Elizabeth Clark, daughter of Reverend Thomas Clark of Chelmsford. The following year, he purchased twenty-five acres north of the meetinghouse on which he built a parsonage.[23] Over time, he and Elizabeth raised five children, three boys and two girls, while expanding their estate to fifty acres. As was common practice with ministers' daughters, Elizabeth and Lucy married pastors. Lucy married Reverend Nicholas Bowes of nearby Bedford and would become Jonas Clarke's mother-in-law. Two of Reverend Hancock's sons, John and Ebenezer, became ministers themselves—John in Braintree in 1726 and Ebenezer as co-pastor with his father beginning in Lexington in 1734.[24] A third son, Thomas, was apprenticed to a bookseller and became a prosperous Boston merchant specializing in manufactured goods imported from Britain while exporting rum, whale oil and fish. Why he did

not attend Harvard and find a pulpit, as did his older and younger brothers, remains unclear. Perhaps lack of interest and/or academic inaptitude figured in Thomas's decision. Likely, too, finances played a role. Because John and Thomas were born no more than a year apart, the Hancocks would have faced economic hardship sending both to college at once. Ebenezer, on the other hand, eight years younger than John, would have been the only family member attending by the time he reached college age.

Braintree's Reverend John Hancock and his wife, Mary, named a son John, the third-generation John Hancock, who would become the most prominent Hancock of all. His birth in the Braintree parsonage in 1737 was followed tragically by his father's death only seven years later. Reverend Hancock, incidentally, as Braintree's parson, had baptized John Adams on October 26, 1734.[25]

The premature death of Braintree's pastor cut short the potential of a third Reverend John Hancock—a hope perhaps harbored by both ordained Hancocks. After John's death, Bishop Hancock and Elizabeth extended an invitation to Mary and her three children to live in Lexington. Thus, the youngest John Hancock, later merchant and Patriot, lived in the Lexington parsonage for several years as a young boy and attended his grandfather's church. As a Lexington resident, the young Hancock walked the short distance from his grandfather's parsonage to the meetinghouse, treading the same path that later, as chairman of the Massachusetts Committee of Safety, he walked on the night of April 18 to meet with the town's militia.

Concerned about young John's future, Reverend Hancock soon sent his grandson to live with his Uncle Thomas in Boston. Childless and without heirs to a growing fortune, Thomas and his wife, Lydia Henchman, welcomed the boy to their new mansion house on Beacon Hill in Boston, built in 1736.[26] It is likely that Thomas also played a part in constructing a larger parsonage for his father soon after, as the present Lexington building dates from about that time. This fact has led architectural historians to surmise that the parsonage might have benefited from the skilled workmanship displayed in the Beacon Hill mansion. The two-and-a-half-story parsonage stood out in a country town as a grand early Georgian structure, the finest in Lexington at the time, and obviously quite an expense for the town's minister to finance on his own. Even so, and although logic presumes the wealthy Thomas's help, evidence of assistance in either designing or funding the parsonage escapes modern eyes.[27]

While living in Boston, young John Hancock made regular trips in the family chaise to visit his grandparents in Lexington. He also took advantage

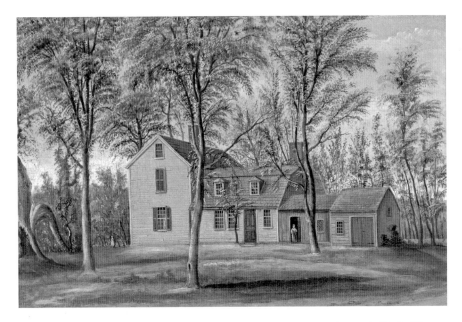

Nineteenth-century oil painting of Lexington parsonage, today the Hancock-Clarke House. *Lexington Historical Society.*

of the village's proximity to his Aunt Lucy and her husband, Reverend Nicholas Bowes, by visiting their Bedford parsonage, Domine Manse, on jaunts into the country. The Bedford visits afforded time with his cousins, who likely marveled at the finery with which Uncle Thomas and Aunt Lydia had outfitted the young man.[28] Likewise, the Bowes family often made the short trip to Bishop Hancock's house over the years.

Jonas Clarke would inhabit John Hancock's grandparents' parsonage, and he and his wife would raise twelve children there. Jonas and young John Hancock surely crossed paths after Clarke married Hancock's cousin Lucy. For the five years that Clarke and the Widow Hancock shared the parsonage, young John likely saw Jonas Clarke a great deal. With Uncle Thomas's support, in 1750 young John entered Harvard, where he surely encountered Jonas Clarke, then in his third year. After John graduated, he began learning the business he stood to inherit. From the moment John Hancock moved into Thomas and Lydia's Boston home, his future was assured. After his uncle's death in 1764, John inherited a great fortune, becoming one of the wealthiest men in Massachusetts at the age of twenty-seven. Naturally, he had no interest in returning to Harvard for the advanced degree required for his becoming the third Reverend John Hancock.

In December 1752, at the age of eighty-two, Bishop Hancock died. Hancock's death, while not a shock, left a great tear in the town's social fabric. Hancock had shepherded its inhabitants for more than half a century, beginning when the parish was still a precinct of Cambridge.

Replacing Hancock required almost three years. The town chose a committee to supply the pulpit until deciding on a settled, or permanent, minister. Eventually, the committee offered the opportunity to three candidates to preach on a probationary basis "a few Sabbaths each." After that tryout, town meeting called a vote on the settlement of either Aaron Putnam, a Mr. Barnes or Josiah Stearns. Before making the decision, Lexington town meeting chose to "keep a day of fasting and prayer on the 25th of the above said April in preparation for said choice." With the decision made, in June Lexington extended an invitation to Aaron Putnam, but he turned it down "for want of unanimity" in the vote. To reject a parish's call on the weakness of the majority vote was not unusual. Putnam feared that a division within the congregation might hamper his ministry from the outset. With discord between parishioners and clergy an unfortunate fact of clerical life, many prospective ministers decided against living among a substantial number of dissenters, even after winning a strong majority in the settlement vote.

Subsequently, Lexington auditioned several more ministers for the position, Jonas Clarke among them. He and his competitors, Stephen Minot and a Mr. Willard, perhaps later president of Harvard College, were offered a few consecutive Sundays to impress the parish with their scholarship and agreeable style of delivery. On May 19, 1755, the town once again put the decision to a vote.[29] Jonas Clarke won, but with a vote that also fell short of consensus, fifty-one to sixteen. If Clarke saw the dissenting votes as an impediment to future success, he kept it to himself. Not surprisingly, his decision rested more on the financial settlement. At issue was his standard of living, which was likely to remain the same throughout his life. As negotiations proceeded, Clarke preached in Lexington as a supply minister, paid at the going daily rate.

The "freeholders and other inhabitants" had voted the settlement. That meant that the town, not just church members, participated in the decision. Almost without exception, town residents attended the same services, but official church membership required standards not everyone achieved. Residents not officially admitted to church communion as members still paid taxes that financed the minister and justifiably participated in how that revenue was allocated. The terms of settlement included 133 pounds, 6 shillings and 8 pence, with one half to be paid six months after the minister

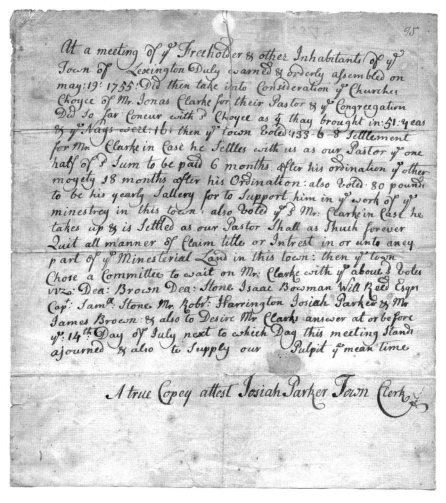

Lexington's settlement offer to Reverend Jonas Clarke. *Lexington Historical Society.*

was ordained and the rest one year later. After that, Clarke would earn a yearly salary of 80 pounds per year. This was exactly the settlement payment and annual salary offered by Woburn to its minister.[30] It appeared to be the customary rate for a town of such size. At the time, about 750 people lived within Lexington's borders.[31]

As part of the settlement, the parish attached a restriction prohibiting the new minister from making any claim to the ministerial lands, a stretch of woodland that Cambridge Farms parishioners had earlier purchased to provide for ministers' salaries.[32] Reverend Clarke's salary derived largely

from town tax revenue, but the new young minister was not yet ready to relinquish claim to the land or the wood harvested from it.

An offer to settle a minister often began contract negotiations. Clarke seemed concerned that the sacrifice of his claim to the ministerial lands would leave him short of wood, a critical commodity in New England. He sent the congregation a gracious letter citing divine direction—"it now appears incumbent upon me to accept your invitation as a call from God." As for the money offered for settlement and salary, he was "perfectly easy." But to deprive him of "all right, title or interest…in the ministerial lands" led the young minister to make a counteroffer in which he "presumed on [the Lexington congregation's] usual goodness and generosity." A yearly supply of wood was actually a common part of a minister's settlement during the colonial era. Clarke proposed that three years after his settlement "you will not refuse to grant me thirty chords [*sic*] of wood for my annual use."[33] The town did refuse, reducing the amount to twenty cords. Accordingly, members present voted once again on the adjusted settlement offer. This time, there were seventy yeas and three nays—a much more unified endorsement. It must have pleased the new minister, who thereupon accepted the pulpit.

Elizabeth Hancock, the Bishop's wife, continued to inhabit the parsonage as a widow. Unlike the living arrangements for ministers in some towns, the Hancocks privately owned the parsonage. During the years immediately after Hancock's death, when Lexington supply ministers filled the pulpit, Mrs. Hancock boarded many of them.[34] In the roughly five months between the town's initial offer and Jonas Clarke's ordination on November 5, Clarke preached every week in Lexington. But his contract did not begin until ordination, so the town paid him on a daily basis. During that time, he boarded with Mrs. Esther Muzzey. Her house was the same distance from the meetinghouse as the parsonage, but in the opposite direction. On November 12, Clarke settled his account with her.[35] Once settled at Lexington, he moved into the parsonage. A young man in the house for company and for manual labor must have been a comfort to Mrs. Hancock. Thus, Jonas Clarke not only started his pastoral life in the shadow of his esteemed predecessor, but he also resided in Hancock's house under the same roof as the Bishop's widow.

At some point, Mrs. Hancock acquired a slave woman, Dinah, who lived with her in the parsonage. Reverend Clarke baptized Dinah at his church on September 9, 1755.[36] The baptism may have taken place soon after the slave's acquisition, occasioned by the widow's failing health, since she died four months later. Clarke took responsibility for Dinah after Mrs.

Hancock's death and made payments for her board in various locations. That he paid for Dinah's board indicates that Mrs. Hancock's will freed her.[37] Upon emancipation, a slave's previous owners often acquired an obligation toward the freed person's support, and Clarke seems to have accepted that responsibility.

Jonas's new living arrangements signaled a critical turning point. He now enjoyed stable employment, presumably for life, and at twenty-five years of age could consider taking a wife and starting a family. Typically, proximity figured in his marriage choice. Boarding at the Hancock parsonage brought him into regular contact with young Lucy Bowes. Lucy, whose mother and sisters resided in neighboring Bedford, had come to live with her grandmother Elizabeth Hancock. Lucy's mother, Reverend John Hancock's daughter (also named Lucy), had married Reverend Nicholas Bowes of Bedford. In August 1754, Nicholas left the Bedford pulpit likely over a doctrinal controversy, remained in town during the winter as a teacher and then enlisted as an army chaplain in the French and Indian War. He died in 1755 during his return from the war to Bedford. Soon after, Lucy came to care for her aging grandmother, joining Clarke's parish in July 1756.[38] The combination of Jonas Clarke's readiness for marriage, the predilections of ministers' daughters for marrying clergy and their living arrangements proved too strong for either to resist.

Jonas, now twenty-six, and Lucy, age nineteen, were married on September 21, 1757, by Reverend Samuel Cooke of Menotomy.[39] The Widow Bowes, Jonas Clarke's mother-in-law, had become Samuel Cooke's third wife. This made Cooke Reverend Clarke's stepfather-in-law. By virtue of that relationship and Menotomy's proximity to Lexington, Cooke would soon become a confidant and mentor to the young minister.

The newlyweds boarded with Widow Hancock until her death early in 1760. The only surviving son, Thomas Hancock, had inherited the mansion house, barn, other outbuildings and the fifty-acre farm. The land extended over both sides of today's Hancock Street and included acreage that fronted the Common. Thomas promptly sold the property to Jonas Clarke for £467, thus ensuring that his niece would be comfortably housed. The farm by necessity supplemented Clarke's modest salary.[40] The Clarkes now owned the Hancock parsonage, today called the Hancock Clarke parsonage. From that house, the anxious family would watch the beginning of the American Revolution.

Jonas Clarke must have felt secure to be settled, personally and professionally. In those first few years, before inflation diminished his income,

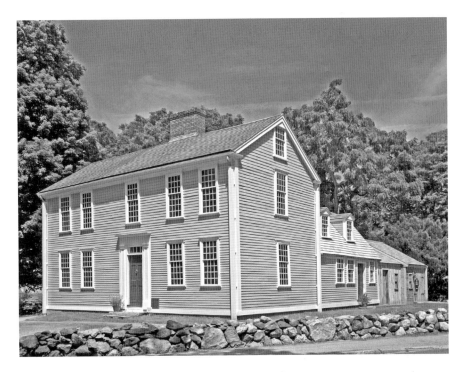

The Hancock Clarke House, 2013. *Paul Doherty photograph.*

his yearly salary of eighty pounds was at its highest purchasing power. Later, raising twelve children grew into an expense that salary increases failed to bridge. Moreover, Lexington's minister was paid in Old Tenor, the most inflated currency, so he found himself losing ground each passing year. But Clarke's frugality and industry led to a modest, fulfilling life.

FARMER AND FAMILY MAN

Tightknit families were critical to colonial New England life. Reverend Clarke's mother, father, brother and sister were never far from his thoughts. By 1758, sister Mary Cotton had become a widow, her husband Dr. John Cotton having died still a young man at twenty-nine.[1] Mary lived with her parents in Hopkinton, Massachusetts, a fate typical of young widows then. Jonas's older brother, Thomas, appears to have lived in Hopkinton with them. The Hugh Clarke family genealogy, compiled by John Clarke in the mid-nineteenth century, indicated that Thomas was insane. Emotional balance may have proved elusive to some in the family, as Jonas Clarke's Uncle Atherton lived under guardianship early in life due to his eccentricities.[2]

Several letters survive from Jonas to his sister, written while he taught school first in Dedham and later in Framingham. They provide rare insight into the young man's playful wit in his early twenties. In one letter, he chastised "your Ladyship" for not writing: "I have not had the Pleasure (as yet) of receiving so much as a line from your own Dear self." He allowed for the possibility "that your epistle is lodged in some careless hands." In closing, he asked Mary to give her best to the family, especially to their brother, who had refused to speak to Jonas during his last visit home.[3]

Perhaps an earlier letter from Jonas that addressed Thomas's agitated state of mind caused the temporary rift between brothers. He opens that earlier letter with assurances to his twenty-one-year-old brother of the writer's "respect and regard" for him and then broaches the nature of Thomas's emotional problems: "A roving mind as it is strange in itself,

so it is as unaccountable in the effects it produces." Clarke's reference to Thomas's lack of focus conformed to contemporaneous thinking. People suffering from mental illness in the late eighteenth century were often referred to as "distracted." One century earlier, the Harvard student might have subscribed to the belief that his brother's affliction had supernatural or spiritual origins.[4] But in this letter, Jonas attempts to lead his brother out of emotional difficulties through rational thought.

When someone is afflicted, "reason is very often deposed," driving the person into innumerable "Absurdities, Weaknesses and Follies" that require him "to wander about, from one thing to another, fickle in everything." Thomas appears to have had a difficult time controlling his emotions, because Jonas wrote that people who cannot control their "passions" become objects of pity. This can isolate a person socially, as the "once agreeable… Companion, is shunn'd and avoided by all." Ultimately, he is regarded as "Fools of the Play."[5]

Twenty-first-century sensibilities understand that depending on the depth of illness, Jonas likely instructed in vain. Although at times emotionally overwrought, Thomas leaves no surviving evidence that he was intellectually challenged. Furthermore, Jonas would not have reasoned in so detailed a discourse if his brother were intellectually challenged. He clearly had some degree of intellectual competency. Charles Hudson's genealogies notate that Thomas was a "soldier in the Revolution."[6] In the 1780s, Jonas made arrangements with a man in Hopkinton for Thomas to do work for him.[7]

Although Thomas's affliction seemed to preclude his leading an independent life, his brother and sister's support kept him from being placed on poor relief, a common fate for the mentally ill during the colonial era. After his parents died, his sister continued to be near at hand in Hopkinton, and Jonas visited regularly. Eventually, Thomas came to live in Lexington, where he died at the parsonage in 1809 while living with his nieces.[8]

"Mrs. Clarke Bro't to bed a daughter[,] Deo Gratia," Jonas Clarke recorded in his diary on March 2, 1767. Clarke's eighth child, and the seventh who survived, was named Lucy after her mother and grandmother.[9] Lucy's birth provides the first available personal record noting the arrival of one of the minister's children. Five more would follow.

The surviving volumes of his diaries, written in his own hand, offer the only extended record of Reverend Clarke's personal life. When Jonas Clarke began as a settled minister, he resolved to keep a diary, presumably to cover his entire pastorate. He served Lexington for fifty years and documented

the half century in five volumes. Unfortunately, the first and third volumes have been lost. This valuable resource begins ten years into his Lexington residence, in 1766, with another gap from 1778 to 1788.[10] Thus, of Clarke's first thirty years in Lexington's pulpit, only ten years are recorded in his diary. These and a handful of letters, in addition to a few recollections by people who knew him, constitute available sources that document Clarke's private life. The original volumes reside in the Lexington Historical Society archives.

For his diary, Reverend Clarke used the first extant volume in a Nathaniel Ames almanac (1766–76), the most popular at the time. A blank page was interleaved opposite a calendar page either by the diarist or by the publisher for an extra fee. For the second surviving volume (1788–98), he used the Nathaniel Low almanac in the same manner. The interleaved approach enjoyed wide popularity among New England diarists since its format and easily referenced almanac had natural advantages for farmers. The tight space for entries in an almanac diary, however, precluded the kind of thoughtful reflection that might offer the twenty-first-century reader access to Jonas Clarke's mind and heart—that is, if he were so inclined. One can

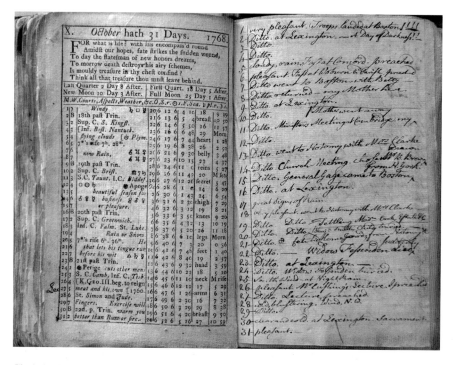

Clarke's almanac diary, October 1768. *Lexington Historical Society.*

discern Reverend Clarke's excitement or despair only by his liberal use of exclamation points.

Since each five- by eight-inch page encompassed an entire month, the entries were necessarily brief, frustratingly so for the modern researcher. Clarke most often recorded daily weather and farm-related tasks he completed each day, typical recordkeeping for eighteenth-century farmers. Fortunately, he also noted his frequent travels and the countless visitors to his home, although discerning whether they boarded overnight or only visited for the day can be a challenge. He often hosted other ministers or relatives or, in several cases, family relations who happened to be ministers. Reverend Clarke noted where he preached each Sabbath sermon and Thursday lecture, as well as the ministers with whom he exchanged pulpits. The pages provide brief reports of town news, most often in the form of births and deaths, as well as barn raisings, smallpox inoculations, household accidents and later Boston events of broader significance. As tensions between Massachusetts Bay and the British imperial government grew, Clarke noted political and military events on a province-wide scale, although without the commentary or analysis that might offer insight into the parson's thinking.

Jonas and Lucy Clarke began a family soon after their marriage in 1757. When Lucy first became pregnant, Jonas could not have avoided an eighteenth-century husband's apprehensions for both his wife and the baby. Many women died in childbirth, and infant mortality had actually increased in Massachusetts due to a higher incidence of disease associated with increasing population density. Childbirth, therefore, brought both joy and fear into a household, since the promised new life existed in tandem with the immediate prospect of death. Lexington, as a travelers' crossroads from Boston to Concord to the west and New Hampshire to the north, suffered more than its share of communicable and deadly diseases. Smallpox epidemics as well as dysentery and measles took lives of all ages. Scarlet fever and diphtheria hit children most grievously.

No one was more aware of life's fragility than the minister. Throughout Clarke's pastorate, he presided over a succession of local fatalities. Of 556 recorded funerals, a stunning 202, or 36 percent, were of infants and children.[11] Each illness brought the minister to the home of the afflicted to offer bedside prayers to the sick and spiritual consolation to the survivors. In addition, on Sunday Reverend Clarke reminded his congregants of the thin thread on which their lives hung, rendering urgent their need to achieve salvation before it was too late. Underscoring death's imminence, the Latin

phrase *Memento mori* ("Remember death") adorned gravestones in the church burial ground not far from the parsonage.

The high mortality rate continued in 1768's first few months, with six adult members of Clarke's parish dying.[12] Believing that the epidemic's severity warranted the most solemn response, Reverend Clarke on April 14 called for a public fast.[13] To Calvinists, only spiritual backsliding could account for the town's uncommonly bad fortune, and Lexington's pastor was ever watchful for the "divine warnings" contained in such town-wide afflictions. To recover his parish's moral rectitude, Clarke announced a special day of humiliation and repentance. Massachusetts held one annual colony-wide fast day on general principles. On Fast Day, parishioners set aside their regular activities to hear their minister lecture them about their dependence on God's mercy in the wake of tragedies. The causes could only be laid at their own sinful feet. In some cases, parishioners forsook their first meal until the second sermon ended in late afternoon.[14] Two days after Lexington's public fast in this present instance, Edward Winship died. On April 26, Jonas Clarke called for a "private fast on account of the sickness" that required homes to abstain from food and to undertake hours of silent prayer. The following day, John Munroe died.[15]

Ministering to a congregation beset with recurring tragedies, especially child mortality, required that Reverend Clarke provide succor while keeping some emotional distance. Parishioners Isaac and Sarah Childs must have tested this professional resolve. In one month's time, in 1778, they lost six children, ages three to thirteen.[16] The relentless frequency of death and an unwavering faith in divine providence may have comforted the parson through such trials. Moreover, his own childhood experiences—when his parents in Newton saw only three of eight children live to adulthood, with one emotionally impaired—might have rendered Jonas Clarke a more effective grief counselor.

Jonas and Lucy Clarke suffered early tragedy themselves when their firstborn died in 1758. Thomas, Jonas's father's namesake, survived only three months. Would the Clarkes be afflicted thus repeatedly? Writing to Captain Thomas and Mary Clarke in Hopkinton during the infant's fatal illness, the anxious father spoke of "our little Son's indisposition." He was "dangerously sick" and "growing worse." Fully aware of the threat to a young and vulnerable newborn, he wrote, "We are not without our Great fears of parting with Him before long." Faith remained a bulwark: "God's power is sufficient; His ways are just." But the father's grief is clear at the letter's close. Usually he ended letters to his parents with "Your dutiful son." This time, however, he closes with "Your dutiful afflicted son."[17]

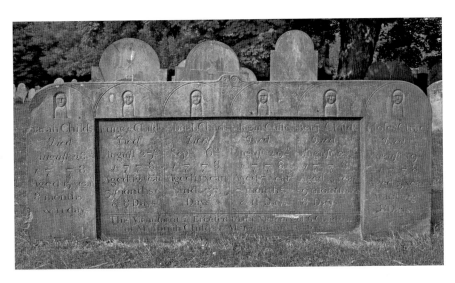

The Childs family grave site (restored). *Paul Doherty photograph.*

As it turned out, fears of future infant mortality in the household were not borne out. Through the years, the sounds of young children filled the Clarke parsonage. Twelve—six boys and six girls—grew to adulthood in that home over the next twenty-two years. The second child, also Thomas, arrived on September 1759. With Mrs. Bowes acting as midwife, Mrs. Hancock likely helped Lucy with the birth of her great-grandchild, since the former parson's wife remained a resident. The following November 1760, Jonas arrived, followed by Mary, Betty, William and Peter. Remarkably, six children ran underfoot by 1765.[18] Henry, the twelfth and last, was born in 1780 when Lucy was forty-four years old.

Even by colonial standards, twelve children constituted a large family. Town tradition has it that Jonas Clarke stood at the foot of the stairs in the morning to wake up the youngsters this way:

> *Polly, Betsy, Lydia,*
> *Lucy, Patty, Sally,*
> *Thomas, Jonas, William,*
> *Peter, Bowen, Harry,*
> *Get Up.*

Considering, however, the twenty-one years between the youngest and the oldest, it seems unlikely that the dozen children slept in the same house together very often, if ever.[19]

The texture of Lucy's domestic life can only be surmised, since no existing documentation details the daily activities of Reverend Jonas Clarke's wife. She receives scant mention in the almanac diaries, except when she travels or suffers an illness. This was not unusual. As historian Laurel Ulrich has written, "Male diarists…are notorious for ignoring their wives."[20] After all, the diary's primary purpose was as a farmer's recordkeeping tool. Some of Clarke's entries, such as "making soap" without naming the soap-maker, conjure images of Mrs. Clarke performing that traditionally female task in a colonial household.[21]

Lucy's daily schedule must have been formidable, especially as she bore her brood of children spaced so closely together. By 1768, Lucy and Lydia had joined six other siblings, with the eldest, Thomas, almost nine years old. No record of servants to help their mother exists. At various times until they married, Lucy's younger sisters, Mary and Lydia Bowes, boarded at the Clarke home, where they assisted with childcare and housework. When not living with the Clarkes, Lucy's younger sisters resided with the Cookes in Menotomy and at the family homestead in Bedford before it was sold in 1767. Lucy's other sisters, Dorcas and Eliza, also passed time at the Lexington parsonage.[22]

To run a household, Lucy Clarke washed, sewed and ironed clothes, for Jonas Clarke's probate inventory lists a flat iron. It also includes two spinning wheels but no loom. The loom's absence fit the normal pattern for towns, as many households spun thread, but few owned looms to weave the thread.[23] Laurel Ulrich noted that spinning, because of its "mechanical nature," was a productive activity for multitasking women simultaneously absorbed in monitoring several small children. Spinning could be interrupted and easily returned to.[24]

A colonial household required women to both prepare and, in some cases, produce food, as in milking the cow. No doubt Lucy performed these daily tasks with the help of her daughters. The girls washed dishes, drew water, fed livestock, sewed and mended as they matured. Although some colonial women slaughtered animals, Reverend Clarke appears to have managed that task, since he uses the active voice describing it in his terse comments—"killed the hog"—over successive Decembers and Januarys.[25] The chore done, husband and wife would have worked together to salt and barrel the pork and beef. But food preparation and cooking fell entirely within the woman's sphere. Lucy Clarke cooked at a huge hearth that required coordinating pots, pans and kettles through a pulley system while tending to several dishes simultaneously, turning a spit for meat and keeping

the fire at the appropriate intensity. In addition, the minister's wife cured ham, made butter and performed numerous other activities about which the record remains silent.

As Laurel Ulrich has written, the "Seventeenth- and Eighteenth-centuries were busy and cluttered places where at any given moment everyone and no one might be watching the children." With the distractions inherent in performing multiple domestic tasks concurrently, accidents in colonial America involving unattended young children occurred with alarming frequency. Large open fireplaces filled with hot coals or flames, as well as open kettles with scalding water boiling over, ranked among the seemingly ever-present hazards that might befall curious toddlers and active young children.[26] For example, between 1790 and 1830 in Henniker, New Hampshire, nine children died in accidents involving the hearth—seven scalded to death and two falling into the fire.[27]

In January 1764, just such a hazard befell the Clarke home, when Elizabeth (Betty) Clarke, then only eight months old, "fell in the fire." In a letter to his parents, Reverend Clarke described the burns to his daughter's face and neck but offered no explanation for the accident's cause, an omission that may suggest how commonplace such occurrences

The Clarke House kitchen. *Paul Doherty photograph.*

were.[28] Betty recovered promptly from her mishap. But the next time she was not so lucky.

Perhaps she was an unusually active child, or perhaps her age rank among her siblings left her unsupervised more often. Regardless, she was burned again three years later. On March 5, 1767, Clarke recorded in his diary, "Betsy burned badly."[29] These burns may have added to her scars, but judging from the aftermath, they proved far more serious. This later accident may have involved scalding water, since pots with boiling water hung over the fire constantly. It should be noted that Mrs. Clarke had just delivered a daughter, Lucy, leaving her bedridden and understandably absent. It may have been the responsibility of the two older children, Thomas and Jonas, to monitor the inquisitive and active four-year-old, although Lucy's mother and sisters likely would have been present.

The day after the accident, the child's condition worsened: "Betsy very bad, had a fit."[30] Over the next month, Jonas Clarke's diary noted several cycles of seeming improvement, regression and improvement. Finally, on the twenty-sixth, he wrote of a small but hopeful measure of progress, as Betty "began to dress [the burns] but once a day."[31] The entry suggests that the burns this second time covered more of the child's body than the earlier accident. Betty remained confined to a room. Eventually, after three months, normal activities appear to have resumed.

Visible reminders remained a topic of interest, if not of daily guilt, as shown in a later letter from Clarke to his parents. In January 1768, he commented on Betty's good health but observed that as she grew, "[h]er scars rather increased than diminish."[32] They never did disappear. Instead, they presented reminders of the childhood accident for the rest of Elizabeth's life. As an unmarried adult, she would observe that the scars were "a mercy sent to her to keep her from being vain about her beauty."[33]

In May 1769, the Clarke family experienced another brush with catastrophe. That month, Clarke wrote in his diary that the curious nine-year-old Thomas ingested a seemingly deadly solution. Five days later, he recorded, "Thomas blind! with poison."[34] How the child came to ingest poison, or the nature of the substance, remains a mystery. But the blindness proved temporary, with Thomas recovering to lead a healthy, productive life. Nevertheless, events such as those bred fear and no doubt private recriminations in colonial homes.

As the Clarke family grew older, the children's maturation decreased the dangers inherent in their domestic life. The record is silent on the children's daily activities when they grew old enough to be useful around the farm.

The boys no doubt helped with daily chores and in the fields, eventually reducing the amount of day labor that Reverend Clarke felt obliged to hire. For recreation, Clarke did take the boys fishing at a pond in the adjacent town of Lincoln.[35] He also taught them to trap pigeons. The girls followed the path of female children in the eighteenth century, learning at their mother's and aunts' knees to perform the multiple daily and seasonal tasks required to run a household.

Farming, especially during planting and harvesting seasons, required a full-time commitment. As with other country ministers, Jonas Clarke combined farming with his pastoral duties, leading to a busy life. Farmers in the area practiced mixed husbandry, which combined raising livestock with growing grains, fruits and vegetables. The paucity of fertile tracts of land in the region, with hilly Lexington no exception, required farmers to fashion a rocky terrain into a productive system. To compensate for unreliable drinking water, apple orchards were relied on to provide cider. Farmers planted apple trees on hills or other places not conducive to effective tillage. They dedicated some land for tillage, some for pasture to graze livestock and some for meadows to produce hay for fodder. Since livestock—especially cows—was critical to the mixed husbandry system, the most important crop was grass.

Historian Mary Fuhrer estimated that the average farm household of six to eight family members required fifty to sixty acres to be sustainable. Based on this estimate, the even more numerous Clarke family's fifty-five acres barely met the minimum requirement. But the minister's yearly salary supplemented his subsistence farming. Typically, wrote Fuhrer, a farmer in Middlesex County devoted five or six acres to growing grains for food. Five or six cows would be needed to produce enough manure to replenish the depleted soil. Eighteen acres of pastureland and twelve of meadowland for hay fed the cows year-round. The average family needed a twenty-acre woodlot to replenish itself while providing fuel for the family hearth.[36] Clarke's yearly twenty-cord wood allotment allowed him to maintain a smaller wood lot, yet he still needed wood from the lot to supplement his contractual allowance. Normally, the family's house and barn sat on a parcel of a few acres.

Clarke paid for day labor during labor-intensive periods, more so when his boys were young and again after they married. His neighbor Amos Tidd was a regular hire through the late 1760s.[37] Professionals such as lawyers, doctors and ministers most often owned slaves, a sign of status in New England society. Both Reverend Hancock and his grandson John owned slaves. Many country ministers with whom Clarke associated, such as William Emerson

of Concord, purchased slaves in order to maintain farms while their owners wrote sermons and made pastoral visits. Why not Clarke? Some ministers, like Clarke's stepfather-in-law, Reverend Cooke of Menotomy, took a principled stand against slavery.[38] It is not unlikely that Clarke felt the same way.

By necessity, Reverend Jonas Clarke took farming seriously. His yearly salary would leave a meager income if unsupplemented. That the last entry in his almanac diary before he died in 1805 reads, "Finished haying!" testifies to his commitment to the farm.[39] But he was fully invested in guiding the spiritual life of his parish. To that end, he devoted countless hours of writing, traveling and meditating.

Chapter 4

MINISTER

When Reverend Jonas Clarke preached from his elevated pulpit in Lexington's meetinghouse, his powerful voice carried beyond the building. Although certainly not evangelical, his preaching style could be very "animated in manner" and "vigorous." To parishioners and other listeners, Clarke presented a dignified bearing and a commanding presence. Fully accoutered in black gown, cassock, bands and a very large "snowy white" wig, Lexington's fastidious pastor took pride in his appearance and encouraged the same attention to detail in others. His family, dressed in their Sunday clothes, sat close by, with the younger Clarkes on their best Sabbath behavior. On those days especially, no person in town stood above Reverend Clarke both literally and figuratively.

The best evidence for these characterizations remains the recollections of Clarke's grandson William Ware, gleaned from family observation and conversations with those who knew Clarke personally.[1] Most subsequent secondary source descriptions of the minister's demeanor have drawn on Ware. Aside from Reverend Clarke's attire and voice, little has been written about his physical appearance. The only surviving representation is a silhouette of his head adorned with a large wig. The wig is made to appear larger because, atypically, the silhouette does not include the subject's shoulders.

One nineteenth-century local historian noted that the reverend's sons were handsome and his daughters considered beautiful. But he didn't say whether their appearances favored their father or mother.[2] A young John

This silhouette is the only likeness of Reverend Jonas Clarke. *Lexington Historical Society.*

Quincy Adams, after meeting the Clarke daughters at a party in 1788, noted their appearance to be "agreeable; and none of them handsome."[3] Beauty being in the eye of the beholder, it should be noted that without benefit of large dowries, four of his six daughters married ministers, considered husbands of choice then.[4]

Jonas Clarke ascended the pulpit in Lexington's second meetinghouse for the first thirty-nine years of his fifty-year pastorate. Built during the town's incorporation year of 1713, the yellow box-shaped two-story building, standing near the head of the town Common, is best portrayed in Amos Doolittle's engraving of the 1775 battle. The church building stood fifty feet long, forty feet wide and twenty-four feet high.[5] Eighteenth-century New England Congregational meetinghouses served multiple purposes—church, town hall and powder house among them. Its doors provided a common space to post notices of interest to residents, such as of domestic animals lost and marriages banns proclaimed.

Inside, town leaders assigned seating for services mostly on a permanent basis. Heads of prominent families purchased the space that lined the walls and built pews for family use. For the benches that filled the middle of the room, a town committee determined the seating according to the age, wealth and status of congregation members. By Reverend Clarke's

tenure, the town selectmen had determined that adult family members should sit together, whereas children, especially boys, would sit where they could be carefully monitored. The upstairs gallery best allowed such supervision. The gallery's second tier, which accommodated slaves and the poor, also provided space to store the town's powder. Invariably, Lexington's pastor preached to a full house.[6]

William Ware noted that in the early years, his grandfather wrote out his sermons completely. Clarke probably composed those in his second-floor study during the quiet of the night, as funerals, pastoral visits and farm chores occupied his days.[7] Later, according to Ware, Reverend Clarke occasionally "extemporized," delivering a sermon now and then from an outline, or "heads."[8] Yet it seems unlikely that he did so very often. Extemporaneous sermons characterized the preaching of evangelical ministers, since "the spirit" carried them through a sort of stream of consciousness. Yale-educated preachers were more likely to speak from notes, whereas Harvard graduates worked from sermons entirely written out. The difference was due to Yale becoming more accommodating to the Great Awakening's New Divinity, whereas Harvard was moving in a more "urbane" and rationalist direction.[9] All Clarke's surviving sermons are fully written out.

Reverend Clarke injected more emotion into his sermons than befitted the dry lecture stereotype ascribed to his colleagues. No Lexington parishioner was surprised when the pastor pounded the cushion for emphasis.[10] Although Betty later considered her father to be an Arminian, a step away from Calvinism, others knew him as a Trinitarian Calvinist. Perhaps he was both at different stages of his life. Reverend Clarke might reasonably have undergone the doctrinal evolution that many other Congregational ministers experienced as the nineteenth century approached. Just fourteen years after his death, his Lexington church changed from Trinitarian Congregational to the more rationalist Unitarian, a not uncommon shift in eastern Massachusetts at the time—a movement inspired by the rationalism of the European Enlightenment. George Washington, Thomas Jefferson and John Adams numbered among the prominent leaders who held beliefs that might be considered Unitarian, although only Adams belonged formally to a Unitarian church.

Even though fewer than thirty of Jonas Clarke's sermons survive, his recordkeeping reveals how many he wrote in all. Like most ministers, he numbered sermons consecutively from first to the very last. Moreover, he

A page of Clarke's sermon log in which he documented biblical texts used. *Lexington Historical Society.*

kept a log—unfortunately not dated—listing the biblical texts on which he based the various sermons. The log covered his entire pastorate through late 1805, with no. 2,238 being the highest numbered sermon.[11] If Reverend Clarke delivered it in his final year, he would have written roughly forty-four sermons on average annually through his fifty-year ministry. Given that a Congregational minister's weekly regimen included two sermons on Sunday and a midweek lecture, the number appears to fall short of a settled minister's customary workload.[12]

Closer inspection explains the anomaly. Only Sabbath sermons enter into Clarke's accounting. He did not count weekday lectures given on Thursdays, which tended to be more doctrinal in nature rather than subjects concerned with personal salvation, the predominant theme of Sabbath sermons. Lecture topics, by contrast, concerned technical questions of theology and special subjects. Different parishes held their lectures on different days of the week so that local ministers could attend.

An April 19, 1761 sermon showing Reverend Clarke's recordkeeping method (at top). *Lexington Historical Society.*

The practice of exchanging pulpits provided one means of lightening the ministerial workload. Quite often Clarke preached in neighboring towns such as Lincoln, Bedford, Waltham, Menotomy (Arlington) and Concord, as well as others more distant, like Reverend Samuel Cooper's Brattle Street Church in Boston.[13] Preaching outside Lexington allowed Clarke to reuse a sermon multiple times. Clarke repeated sermons in Lexington as well, if enough time had elapsed since its initial presentation. He recorded the composition's date on the first page and then added underneath subsequent dates and places where he reused the sermon. Clarke exchanged pulpits in surrounding communities for at least one Sabbath sermon about a quarter of the time.[14] As one might expect, with little backlog of sermons to draw on, Reverend Clarke wrote more new sermons earlier in his career, averaging eighty sermons annually in his first several years.[15]

Along with neighboring clergy, apprentice ministers preached from Clarke's pulpit, further reducing the need for new sermons. To acquire the skills needed to develop their craft, most theology students entered a clerical apprenticeship. Sometimes this involved having the prospective minister, if from out of town, live with his clerical mentor. In at least nine cases, Lexington boys learned at Reverend Clarke's feet while preaching regularly in his meetinghouse.[16] One such apprentice was Joseph Brown, son of Deacon James Brown of Lexington.[17] Brown received his AM from Harvard in 1763 but was ordained as a minister, in Winchendon, not before 1769.[18] In the interim, Reverend Clarke generously offered his pulpit along with sage advice on Brown's sermons. Once ordained, he and Clarke exchanged pulpits, even though Winchendon lay fifty-five miles away.[19]

Clarke delivered the ordination sermons for Josiah Bridge, Joseph Estabrook and William Muzzey, all native Lexington ministers.[20] In his 1761 ordination sermon for Joseph Estabrook at Sudbury, Massachusetts, Clarke advised the new pastor, "A pleasant voice, and easy address, a ready utterance and elegant stile, are very graceful in the minister of the gospel." Clarke probably trained younger aspirants in the Latin and Greek required for admission to Harvard, just as Reverend Cotton had for him. During Clarke's pastorate, eighteen Lexington boys entered Harvard.[21] Whether they intended to pursue a clerical profession or not, most would have learned prerequisite material needed to pass the entrance exams from Reverend Clarke, the only Harvard-educated man in town. In Clarke's obituary, a

colleague claimed that young clerical candidates were "allured by his known disposition to encourage them," and he therefore administered the charge in ordination ceremonies more often than anyone in the province.[22]

When creating sermons, Reverend Jonas Clarke used the conventional "plain style" practiced by several generations of Congregational ministers before him. That is, he spoke in the vernacular, using biblical references but avoiding the Greek and Latin allusions that scholarly men favored. Clarke's predecessor, Reverend John Hancock, wrote in his commonplace book about plain-style speech: "A minister has nothing to say in the pulpit but what concerns all the congregation, and he may if he will express it in words easy to be understood."[23] The "plainest" aspect of the Sabbath sermon was its structure. Divided into three easily discernible parts, it began with a passage from scripture, followed by the minister's explication of the passage within its biblical context. Next, it explored the text's deeper meaning. The most important part ended the sermon: its application to the listeners' daily lives. Thus Reverend Clarke would close by addressing the question, "How can this lesson be used in your spiritual quest for salvation?"[24] The sermons of Lexington's parson were notoriously lengthy, according to his grandson "never less than one hour each" and often longer.[25]

Rarely do any surviving Sunday sermons refer to specific contemporary events, in Lexington or beyond, that might give meaning to the choice of biblical texts on a particular Sunday. This may be because Clarke repeated most of his Sabbath sermons. Or perhaps those that more directly addressed politics have not survived. More likely, he believed it inappropriate to mix politics in his Sabbath sermons. Brattle Street Church's Reverend Samuel Cooper, singled out as one of the "black regiment," also eschewed broaching worldly political matters in his sermons.

One piece of evidence places Reverend Clarke in the same category. In 1889, James Phinney Munroe wrote a fictional letter by Sarah Munroe describing President Washington's visit to the Munroe Tavern one hundred years before. James Phinney Munroe maintained that although fictional, its events were supported by documentary evidence or at least Munroe family tradition.[26] Fictional author Sarah wrote of Reverend Jonas Clarke preparing the town for Washington's visit during Sunday meeting. She cautioned her audience that Clarke's sermons were "Decent, and touching upon Worldly things only so far as might be Seemly."[27] This indicates that Clarke's separating spiritual guidance from worldly matters in sermons constituted a norm.

Reverend Clarke's desk. *Lexington Historical Society.*

While overt references in extant Sunday sermons to political tensions with Britain itself are absent, Clarke's choice of scripture often fit a compelling contemporary event. No doubt a familiarity with the Bible among his parishioners informed their understanding of Clarke's choice of scripture. Thus, his congregation understood the double meaning of his sermons.

What of Clarke's reputation for using the pulpit for political ends? A distinction needs to be drawn between prayers, lectures and sermons. The portion of the church service devoted to prayer could run as long as or

even longer than the sermon. Usually the minister offered two extended prayers averaging a half hour each, before and after the sermon. During these spontaneous "long prayers," the Congregational minister commented on local happenings, such as an epidemic or a family member's death, and divined God's message hidden beneath.[28] One Maine resident recalled that his minister's prayer "served all the purposes of a local newspaper." Through the prayer he learned "who had been married, who were sick, who had died, who had gone on a journey."[29] No doubt Whig ministers exploited this prayer portion increasingly as tensions mounted over imperial colonial policy. But since prayers were extemporaneous, no written record survives. The long-prayer tradition obliged the congregation to stand for its entirety. So lengthy were Clarke's prayers that children were known to disappear, enjoy some recreation and return to the meetinghouse before he finished.[30]

Another occasion when politics might have been discussed was the midweek lectures. Their purposes were less to save the souls than those on Sunday. While doctrinal issues provide the focus for many, increasingly they became politicized. Clarke's oft-quoted and very political 1776 Anniversary Sermon falls into this category since April 19, 1776, did not fall on a Sunday.[31]

Thanksgivings, and especially fasts, were important occurrences in colonial New England life, and they increased in frequency during such difficult times as the sicknesses in Lexington in 1766. Consequently, in addition to a regularly scheduled fast in spring and thanksgiving each autumn, churches also set aside special days, often using the Thursday lecture day. Epidemics, droughts and earthquakes furnished cause to dedicate days to fasting and prayer.

The combination of blessings, prayers, sermons and psalms meant that the entire Sunday service consumed at least three hours. On Sunday, a noon break divided two services. Instead of nooning houses, Lexington congregants who lived a distance from the meetinghouse refreshed themselves, thawed out by the fire and replenished their foot warmers with fresh coals at nearby Buckman Tavern. Reverend Clarke's meetinghouse remained unheated throughout his fifty-year ministry. In winter, Lexington's service must have seemed interminable to devout and less devout alike. Fur-lined gloves slit at the right-hand thumb and forefinger enabled the minister to turn pages during frigid days.[32] Although the length of Clarke's services fell within the normal range of Congregational practice, they pushed at its outer edge.

As a clergyman, Jonas Clarke was exempt from taxes. But in his first two years in Lexington, he returned a portion of his modest salary as a voluntary tax payment because he empathized with his congregation's tax

burden. Along with the contribution, Clarke included a public comment in March 1756 that "public taxes of this province in general and this town in particular are at present extraordinary."[33] It was both a public-spirited and politic gesture by a parson beginning his service in a community. The town thanked him for the "gift." While Clarke contributed money to the public good periodically, the economic demands of his growing family, stagnant wages and an inflating currency hampered his ability to do so.

The colonies' required contribution to the French and Indian War (1754–63), the North American theater of the Seven Years' War, created the "extraordinary" tax burden. The spate of town tax abatements to individuals during the war underscored the financial strain that the conflict imposed on Lexington residents. The last in a series of North American wars between Great Britain and France dating from the seventeenth century exacted from Massachusetts, as from the other American colonies, much blood and treasure. Clarke had been ordained just as the war began. That year, in 1755, Lexington contributed thirty-three enlistments, mostly young men looking to earn a financial stake in their futures.[34] The enlistment bounty and their wages paid at discharge enabled young soldiers to put money away for a start in life, especially those whose fathers were unable to pass on their inherited stake or were slow to do so.[35] Beginning adult life had become difficult for many young New England men, the region's long-standing practice of partible inheritance, or dividing the estate among all sons, having markedly decreased the size of farms.

The war's trigger point in North America lay in the forests of the Ohio River Valley, where American and French colonists vied for the same land. Several Virginians had asserted ownership and created a speculative land company that gambled on American settlers crossing the Appalachian Mountains to purchase land. The French, pursuing the lucrative fur trade, had already established trading posts in the region. Overlapping claims led Virginia's governor, a land company stockholder, to send George Washington, himself a land company stockholder, to establish a presence near today's Pittsburgh, Pennsylvania. Washington led soldiers into the western wilderness despite warnings of French intentions and found a French fort already established there. Fighting ensued, and Washington, outnumbered, was forced to surrender. The French presence in territory west of the Appalachian Mountains arrested American colonial ambitions, especially among the vanguard of land speculators. Great Britain, its sovereignty over what it perceived to be British territory challenged, responded with troops to American complaints.

The New England clergy enthusiastically supported this French and Indian War. For Congregational clergy, the enemy's French Catholicism rendered it a struggle between the papacy and the one true church. A streak of millenarianism led some clerics to portray the conflict as the final battle against the Antichrist.[36] At the war's outset in January 1756, Clarke preached a fast sermon designed to steel the town for the sacrifices ahead. Warning his parishioners of their moral failings and the need for repentance, he chose verse 6 of Psalm 46 to remind his parishioners that in the trying days ahead, they did not stand alone. Several nations had once threatened an earlier group of God's chosen people. But then God "uttered his voice, the earth melted." Thus, with the Lord's help, Israel prevailed—just as this British Israel would also triumph with divine assistance.[37]

From the colony's beginnings, New England Congregationalists had identified themselves with ancient Israel. But the clergy's reading of Israel's history shifted to conform to their congregations' changing needs. Enlightenment thought in the later eighteenth century placed a high value on tolerance and reason, so sermons began to deemphasize Israel's divinely sanctioned intolerance and its miraculous deliverances. Rather than dwelling on Israel's theocracy, in which God spoke through prophets, now David and Moses exhibited political skills that jealously guarded their people's liberties.[38] In this manner, the colonies as the British Israel remained a useful metaphor throughout the American Revolution.

British failures early in the French and Indian War became the occasion for proclaiming several fast days in New England. Often called after military defeats, fasts focused on the colonists' sins, the need for repentance and a new dedication to the pious life.[39] Clergy spoke as one in proclaiming the importance of piety to the war effort. All fervently agreed that defeats in war could be traced to the people's moral failings. All remained confident in the long view that although God's chosen people might suffer short-term reverses, their piety surpassed their papist enemy, and as Israel's history demonstrated, the more pious ultimately emerged victorious.

On July 23, 1763, Clarke's Sunday morning sermon addressed the end of the war by means of James 5:11: "Behold them which endure." In acknowledging the people's perseverance through a long, costly struggle, Reverend Clarke compared their faith to "the patience of Job." He suggested that recent events had led the parish to see "the end of the Lord"—victory.[40] No contemporary event is explicitly mentioned, but scarcely anyone in Clarke's parish could have failed to understand his reference. After nine

years of conflict, the combatants signed a treaty of peace on February 10, 1763. Understandably, the new peace brought with it relief, celebration and hope for a more secure, prosperous future.

Unlike fast days, thanksgiving days, often designated after military victories, provided an opportunity for the people to celebrate themselves and their leaders. Invariably, thanksgiving sermons characterized the victory as providential, citing God as the instrument of the people's deliverance.[41] On July 27, 1763, King George III ordered that a thanksgiving day be observed in the American colonies so that God might be properly thanked for a "happy Conclusion of the Peace." Under the imprimatur of King George's seal, Massachusetts's Governor Francis Bernard responded with a proclamation. Thursday, August 11, was to be the day, a "Day of Public Worship," with no "servile Labor" permitted.[42]

As with all provincial proclamations, the governor sent it directly to Reverend Clarke as the conduit for communications to Lexington residents. The minister's August 11 thanksgiving sermon is not extant, but it would have developed a theme similar to other ministers. Clarke sometimes considered such proclamations to be burdens on his independence, chafing at the obligation of communicating to his Congregational parish royal edicts from an Anglican appointee. On a fast proclamation in 1766, Clarke wrote a note to Reverend Thomas Jones of Woburn, presumably preaching to the Lexington parish that Sunday: "Rev. Sir, as you look upon these Proclamations to be extraordinary and remarkable, I hope you will not take it amiss, that I beg the Favor of you to read this to my People tomorrow, in doing which you will at least free Me from a piece of Disagreeable Servitude."[43]

The war lasted nine years, and the British initially did not fare well. Tactics changed after William Pitt became prime minister in 1757, and his leadership led to victory by 1763. The wartime partnership between the British government and its American colonies would seem to have been a productive one. Yet overall, the experience exercised a negative influence on the relationship. Indeed, war's end marked the beginning of the Revolutionary era, one in which tensions between Great Britain and its American colonies developed to an intolerable breaking point.

Several reasons account for the paradox. While sharing camps with the British Regulars, colonial militia developed a profound disrespect for their character. Although the armies remained under separate commands, provincial soldiers' close association with British troops exposed the cultural divide that separated these British subjects. The British officers' class-based arrogance annoyed the less class-bound New England militia far more than

it did poorer, noncommissioned Regulars. Furthermore, American colonists came to believe the redcoat rank and file to be morally bankrupt. The largely devout provincials grew disgusted with British Regulars' profanation of the Sabbath, with their serial cursing and their indulgence of female camp followers, some of whom performed laundry duties and nursed the sick while others provided the time-honored comforts of prostitutes.

By way of contrast, provincial commanders issued orders that prohibited women from traveling with the troops, forbade taking the Lord's name in vain and required attendance at Sunday service. The Regulars' lewd behavior in the presence of women appalled New Englanders.[44] For Congregationalists, the stakes of the war were more than contested geography. They fought against a Catholic people; its negative outcome conceivably could leave them under the yoke of France and the pope. With God's divine justice, the Regulars' immoral behavior appeared to threaten chances of victory. Congregational chaplains such as Lucy Clarke's father, Reverend Nicholas Bowes, remained vigilant in steadying their flock in the face of daily, flagrant impiety. To devout New Englanders, the immorality of British regulars threatened to doom the war effort.

On the positive side, the imperial relationship provided provincial militia with critical military experience later to be exploited. George Washington, for example, served as a provincial colonel in the war. Several other key American leaders in the Revolution served as junior officers. Provincial soldiers in the rank and file emerged from the conflict battle-tested. Of the Lexington militia who stood on the green on April 19, 1775, the three officers—Captain John Parker, Lieutenant Robert Munroe and Ensign William Tidd—all had served in the French and Indian War.[45] Their presence, in addition to that of other veterans, surely imparted some measure of calm that morning when huzzahing British troops flashing bayonets approached them.

The war's effect on the British economy supplied the most profound impact on the imperial relationship. At the outset of hostilities, the British national debt had stood at £72 million sterling. By 1763, at war's end, it had more than doubled, to £146 million. Parliament believed that citizens in Great Britain had been taxed to the limit, yet taxation had been able to raise only £10 million in yearly revenue, with half of that paid simply to service the debt.[46] Facing such desperate economic prospects, Parliament turned to the American colonies as a logical alternative source of revenue. Had not the war been fought in large part to benefit American landholders and speculators?

George Grenville, First Lord of the Treasury, reasoned that Americans, who lived with a much lighter tax burden imposed by local governments,

could more easily absorb a share of the war's cost. To the British ministry, tightening imperial regulations on trade and navigation seemed long overdue, with legislation already on the books but too long enforced with laxity. In addition, new taxes on American commerce appeared fiscally sound, and the colonies would surely understand the logic of their sharing in a war's cost from which they benefited mightily.

But the Americans promptly characterized such innovations as illegal. Even before imposing new taxes, Parliament's Proclamation of 1763 forbade settlers' migrating beyond the Appalachian Mountains, dashing colonial hopes for advantage from the war. Immediately after the peace treaty had been signed, moreover, the British became enmeshed in Pontiac's War, an Indian conflict that began at Fort Detroit but spread rapidly outward. After defeating the insurrection, Parliament had hoped to preserve calm in the old Northwest by prohibiting settlers from encroaching on Indian land, effectively keeping it as an Indian preserve. The imperial prohibition had far more effect on Virginian speculators than on Massachusetts farmers, inasmuch as sons of villages like Lexington migrated to less developed central Massachusetts towns and to Maine, still a Massachusetts district.[47] Even so, the 1763 legislation indicated that the imperial government, with the French threat out of the way, meant to manage the North American colonies more closely.

The war exerted a further influence. By effectively driving the French from the North American continent, it eliminated the necessity of a primary benefit the colonies enjoyed from the mother country: protection. The French to the west and north no longer threatened American colonists nestled east of the Appalachians. Although never as numerous as the British, the French in Canada and trans-Appalachia had loomed frighteningly close in the colonial mind. Furthermore, fur trapping had brought the French into relations with numerous Indian tribes, one more menacing prospect for English colonists to ponder. Now, with French sovereignty in North America eliminated, the American colonists could breathe free, and that new, free air no doubt emboldened the colonial response to future British legislation.

Once the Catholic French were defeated, imperial policy toward the colonies began shifting toward more closely managing its assets. With those changes as a backdrop, Lexington's young minister Jonas Clarke neared the end of his first decade of his pastorate. By 1763, he was a settled and respected pastor with a productive farm and a rich family life. The trajectory of his days appeared to be settled; a pastoral simplicity seemed to be in the offing. But circumstances soon dictated that he take on another role, that of civic leader.

THE STAMP ACT CRISIS

Congregational ministers served as God's watchmen to guard against their parish's moral backsliding, ever vigilant for "divine warnings" indicating spiritual ill health.[1] By the 1760s, many ministers and social critics had become concerned about a growing threat created by an influx of inexpensive consumer goods imported from the mother country. England's emerging Industrial Revolution made attainable a vast supply of goods previously considered luxury—now they were much less expensive and available in greater variety. Increasingly, the marketplace offered affordable textiles in new textures and colors. Pewter spoons and tea services began to adorn more modest households. In Westborough, Reverend Ebenezer Parkman preached against "the growing extravagance of Velvet and scarlet among people of low rank."[2] A young Reverend Jonas Clarke shared Reverend Parkman's concern.

Ministers had long feared that their parishioners' spiritual piety would succumb to material greed, but when the Great Awakening's influence faded, the trend toward creature comforts increased. Historians consider this consumer revolution in America to also be part of a growing Anglicization, with colonists increasing their reliance on England for their cultural identity.[3] Moreover, observers feared that Americans lived beyond their means, creating a debilitating dependence on British creditors and their goods. But during the 1750s and 1760s, the spiritual dangers preoccupied Congregational ministers more than the political and economic repercussions. They worried that their congregations increasingly favored the counting house over the meetinghouse.

The best Art of Dress : Or, Early Piety
most amiable and ornamental.

A

SERMON,

Preached at Lexington,

TO

A religious Society of young Men,

On LORD's-Day Evening

Sept. 13. 1761.

By JONAS CLARKE, A. M.

Pastor of the Church in Lexington.

"Whom shall he teach knowledge ? And whom shall
he make to understand doctrine ?---Them that are
weaned from the milk, and drawn from the breasts :
For precept must be upon precept, precept upon precept,
line upon line, line upon line, here a little and there
a little." Isai. 28. 9, 10.

BOSTON: Printed by D. and J. KNEELAND, opposite
to the Prison in Queen-Street. M,DCC,LXII.

"The Best Art of Dress: or, Early Piety Most Amiable and Ornamental." *Lexington Historical Society.*

Reverend Jonas Clarke addressed his congregation's growing fixation on fashion and material goods in a lecture dedicated "to the children and youth of my pastoral charge," published in 1761. Entitled "The Best Art of Dress: or, Early Piety Most Amiable and Ornamental," the lecture conceded at the start that people harbor certain predilections "for the fashion and… for the ornaments which they think beautiful." But the parson warned his young auditors to remember that what is most valuable in life "recommends us to God." It is true that "External beauty…may make us admired and revered by a crowd of stupid mortals like us," but God looks to inner beauty. To the impressionable young minds in his charge, Clarke emphasized that God prized piety above all else.[4] He encouraged his listeners to look within for self-improvement. Lexington's pastor intended the lecture as a healthy reminder to the coming generation to stay focused on the ultimate goal of personal salvation.

Ironically, that same commercial onslaught would supply the American colonies with their means of frustrating British efforts to extract tax revenue from them. Although Clarke worried about his parish's dependence on British goods, the dependence proved reciprocal. Americans were a critical British market, significant enough to exert political influence. By the second decade of Reverend Clarke's pastorate, pressing events in Boston would drive him in a radical direction, turning Lexington's pastor into a political leader bent on using commerce as a lever against British imperial overreach.

Although a country town twelve miles from Boston, Lexington was hardly isolated from provincial and world affairs. News reached the town from several sources. Boston newspapers brought information from the broader public square to readers such as John Parker, Joseph Simonds and Reverend Clarke himself. All three, for example, subscribed to the *Boston Gazette*.[5] Published every Monday, the *Gazette* reported regional and world events from a Whig standpoint, increasingly so once political differences widened between the American colonies and the British ministry. The *Boston Gazette* came to Lexington via post riders from Boston. Lexington's Buckman Tavern, sited at the edge of the Common, was the central location for residents to receive communications from the outside, including Boston newspapers.[6] Subscribers often shared their news with others at the tavern, with multiple readers and listeners enjoying a single newspaper.

Reverend Jonas Clarke himself served as a critical conduit for news. Charged with reading proclamations during church services, pastors were intermediaries between the provincial government and the people, inasmuch

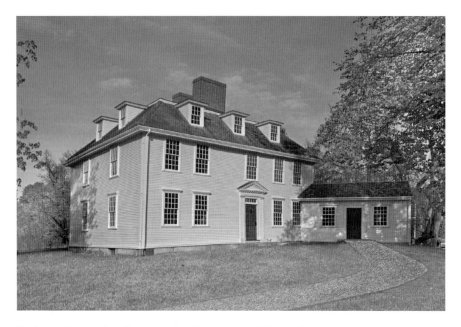

Buckman Tavern sits adjacent to the Common. *Paul Doherty photograph.*

as Sunday meeting provided the single occasion when virtually every town resident sat under the same roof. For information outside government channels, clergy possessed several informal connections. Their network of clerical colleagues presented regular opportunities to exchange information on public affairs. The local clerical associations and their weekday lectures brought ministers into regular contact with one another. Ministers interacted most often in adjacent towns, but the network reached beyond the local area. For example, during the annual clerical meeting in Boston in May, when the General Court convened and a minister preached the election sermon, virtually all Massachusetts clergy gathered together for several days. Harvard commencement supplied yet another instance when alumni mingled, exchanged news and shared perspectives from their region.

The network of friends and colleagues, combined with his clerical duties, led Reverend Clarke and his wife to host a steady stream of visitors at their home. From his diary, it is not always easy to determine whether visitors boarded in the parsonage overnight or met with its parson only during the day. Clarke recorded when someone was "here," and sometimes he noted at a later date that that person "went," leaving the reader to infer whether he or she was a guest during the interval. At other times, a guest's departure is not noted at all. Most guests were relatives or ministers. Reverend Phineas Whitney of Shirley,

Massachusetts, fell into both categories. All out-of-town visitors provided Reverend Clarke with opportunities to learn news of public affairs.

John Hancock, the merchant-Patriot and Lucy's cousin, made two recorded visits during years covered in the earliest surviving volume of Clarke's diary (1765–76). The second was his celebrated extended stay in April 1775. Several local historians have written that Hancock was a "frequent visitor" to the parsonage.[7] He may have visited Lexington more often while his grandmother lived; the first ten years of Clarke's diary (1755–65) are missing, and no extant Hancock source refers to such visits. That does not preclude a close association between Hancock and Clarke in other locations. For example, they met once in 1768 in Menotomy, at Reverend Cook's, and Clarke likely called on Hancock when he traveled to Boston.[8]

Clarke did make regular trips to Boston. In the first surviving volume of his diary, Reverend Clarke averaged more than six trips to Boston a month.[9] For many, he concluded his business and returned home that evening. For example, he traveled to Boston to pick up his new chaise from Adino Paddock, coach maker, and returned to Lexington the same day.[10] But on numerous occasions, he stayed overnight. The annual colony-wide ministers' convention in May required Clarke to board in the capital. Often, his wife, her sisters or his children accompanied him in the family chaise, perhaps to shop or to visit relatives.

We cannot know with whom he stayed on such occasions because Clarke simply wrote, "went to Boston," and then, a day or two later, "came home." He could have stayed at the Hancock Beacon Street mansion. Certainly John Hancock, Uncle Thomas and Aunt Lydia were in a position to easily accommodate guests. After Thomas's death in 1764, Lydia continued as the lady of the house in order to keep a close eye on her twenty-seven-year-old nephew.[11]

Lucy's brothers in Boston, William and Nicholas, would have felt similarly obliged to board their brother-in-law. Uncle Thomas had established the elder, William, in the hardware trade; subsequently, William Bowes became a successful Boston merchant. Later he inherited a large amount of Thomas's property. But he became a Loyalist, fleeing the city with the British army bound for Halifax, Canada, in March 1776. Until that sizable rupture, however, the Clarkes remained on friendly terms with William Bowes and his family.

William's brother, Nicholas, was a printer who published several of Jonas Clarke's sermons. Following his uncle Thomas's early path, he was apprenticed to Daniel Henchman, later inheriting his book and stationery

store across the street from Boston's First ("Old Brick") Church on King Street.[12] Cousin Nicholas held starkly different political sympathies from his brother. He joined Reverend Samuel Cooper, Harvard science professor Dr. John Winthrop and several other notables in becoming a member of Hancock's inner social circle.[13] Clarke's diary makes clear that on several occasions, the parson brought his children to Boston to stay with a relative, traveling to town with one and returning with another. On September 21, 1767, he wrote, "Went to Boston with Polly [Mary] Clarke." A week later, he returned with Thomas and came back with Polly.[14] Any of his three family relations might have welcomed time with the Clarke children.

Reverend Dr. Samuel Cooper furnished still another possibility. The Brattle Street Church's minister seemed the only Boston clergy with whom Clarke shared a pulpit and visited. Cooper stayed at the Clarke home on two occasions, and he would have expected to return the favor.[15] Reverend Clarke likely met Cooper through Hancock, a Brattle Street Church member and close friend. With a parish full of merchants, the Brattle Street Church was Boston's wealthiest. Cooper's close relationships with Hancock, Samuel Adams, James Otis, Dr. Joseph Warren and other Whig leaders placed him among the ministers whom the Loyalist Peter Oliver identified as the "black regiment," singling out Reverend Charles Chauncy, Reverend Jonathan Mayhew and Cooper for special scorn. Cooper corresponded regularly with Benjamin Franklin, then living in England, but sedition never entered his sermons, as Oliver implied. Instead, he engaged in opposition behind the scenes by attending caucus meetings and writing newspaper opinion pieces under a pseudonym.[16] Conversations with Cooper would directly connect Clarke to Boston Whig leaders, as would his visits with Hancock and, to a lesser extent, with Nicholas Bowes. He no doubt interacted with them during his frequent trips to town regardless, and when he did, he returned to Lexington armed with information, as well as confidential intelligence, perhaps, that he kept close for later use.

His years at Harvard would presumably have provided the parson with a basic knowledge of Whig political theory. But the probate list of Clarke's books and pamphlets is likely incomplete and perhaps leaves out such seminal works of Whig ideology as Locke's *Second Treatise on Government* or Thomas Gordon and John Trenchard's *Cato's Letters* or Benjamin Hoadley's *Origin and Institution of Civil Government Discussed*. Instead, the seventy-six volumes listed in Clarke's 1805 probate inventory comprise religious tracts and sermons almost exclusively. The exceptions seem to be Latin and Greek texts.[17]

But Clarke's contributions to Lexington's evolving political position make clear that he was conversant with social contract theory, was suspicious of corruption in the British political system and agreed that passive obedience to that system only led to further oppression. This made him a Whig.

New England Congregational theology of the 1760s complemented and reinforced British Whig political philosophy. Although clerical views on government derived from religious beliefs, those views largely meshed with Locke and Algernon Sidney, as well as other Whig theorists concerning the ends of government. To the clergy, government was founded on a covenant, just as individuals entered into a covenanted relationship when they began their communion with God. According to this covenant, or contract, rulers must promote the citizens' welfare and protect their God-given rights. In return, individuals pledged allegiance to their sovereign. For British citizens, the misrule of the Stuart kings, leading to the English Civil War and the subsequent overthrow of that royal house, best exemplified the consequences of a ruler's violating the covenant. Later, when a restored Stuart king, James II, failed to preserve English liberties, the people rightfully deposed him in 1688. After the Glorious Revolution of 1688 and the Declaration of Rights that followed it, most clergy believed that the British government had largely met the terms of the covenant until recently.[18] That is, until the 1760s.

Eighteenth-century Congregational clergy taught that God entered into covenants with nations. Even as God's grace ensured salvation for elect individuals, he also singled out nations for temporal success. As the French and Indian War illustrates, New Englanders subscribed to this providential view of history. They were convinced that the Congregational colonies functioned as the British Israel, God's special instruments on earth preparing the way for his deliverance. Israel's flight from Egypt to gather strength in the wilderness paralleled the Great Migration from Stuart England into the wilderness across the Atlantic. Especially in times of strife, comparisons with Israel dominated Congregational sermons. Historian Harry S. Stout summarized the analogy's importance when he asserted that it "covered all contingencies."[19]

New England's covenant with God required that its people live in accordance with scripture. Since God ordained a deferential relationship between citizens and their ruler, the people did not take resistance to imperial authority lightly. Reverend John Hancock had referenced this relationship in his 1722 election sermon. Even later British Americans regarded the king as a wise and kind father, distinct from any objectionable policies of his government. Royal lackeys and members of Parliament surely

caused any transgressions from the paternal bond. As Britain's imperial policies increasingly demanded absolute submission, New Englanders experienced dissonance with their own religious beliefs. Ultimately, events drove Congregational clergy to realize the king's complicity with the British ministry to violate the covenant, as the Stuart kings had earlier.

The civil argument for opposing unjust imperial policies complemented the religious one, and records show that Clarke restricted religious explanations for political events to his Sabbath sermons, relying on Whig theory when addressing contemporary controversies in such civic arenas as town meeting.

American Whigs welcomed the clergy's increasing tendency to use the pulpit as a forum for opposing imperial policy. Under the pseudonym Massachusettensis, Taunton Loyalist Daniel Leonard protested, "When clergy engage in political warfare, religion becomes a most powerful engine."[20] Indeed, New England churchgoers attended on average seven thousand services in their lifetimes, roughly fifteen thousand hours of their minister holding sway.[21] Loyalists did not overestimate the power of anti-imperial rhetoric delivered from the pulpit.

Fully aware of that influence, Leonard argued that for a congregation to hear British policy condemned "on Sunday from the sacred desk, with a religious awe," created an advantage beyond any argument. After all, "from their cradles" parishioners had been taught to believe that their minister uttered "nothing but eternal truths," and in country parishes like Lexington, the parson's views commanded even more awe because of his education.[22] But clerical influence was not limited to Sunday meeting. The minister's elevated status in the community created an advantage as well, with individual daily conversations having a powerful effect.

The American Loyalist Peter Oliver, in his *Origin and Progress of the American Rebellion*, made infamous the term "black regiment," an allusion to the power of clergymen's black garments in mounting militant opposition to Parliament in the 1760s and '70s.[23] Oliver, a prominent "friend of government," was the brother of Lieutenant Governor Andrew Oliver (1771–74) and, through marriage, was related to Lieutenant Governor and later Governor Thomas Hutchinson (1758–74). Yet Peter, who served as Massachusetts chief justice of the Supreme Court until 1775, credited political foe James Otis with coining the term "black regiment." Indeed, a pro-Whig fictitious dialogue between a pensioner and a Divine, published in the *Boston Gazette*, has the pensioner paraphrasing Otis's claim that he could not "carry his points without the aid of the black Regiment."[24]

For Oliver, the "regiment's" blackness had as much to do with evil intent as the color of its clerical vestments. He considered Massachusetts clergy to be, "in general, a set of weak men." His experience was with Boston clergy, and Oliver called Boston a "Metropolis of Sedition."[25] Oliver maintained that the two opportunities for Massachusetts clergy to gather—on election day and during the Harvard Commencement—allowed for sedition to be disseminated throughout the countryside. And Lexington's Reverend Jonas Clarke's familial and collegial network placed him closer to this Metropolis of Sedition than most country ministers.

The Stamp Act constituted a profound shift of British imperial policy toward its American colonies. Approved in March 1765, Parliament scheduled the act to become law on November 1. Upon reaching American shores, news of the Stamp Act produced an angry reaction the British ministry had not anticipated. The home population was taxed to the limit, so the American colonies, which had benefited most from the recent war, were expected help pay for the debts accumulated that the French and Indian War had accrued. Earlier, Parliament had levied a stamp tax to raise revenue in England without much objection. What the American colonies viewed as outrageous, the British ministry believed to be a sensible course required by a lack of reasonable alternatives.

Besides, it was not the first direct tax that England had imposed on the colonies. Minister of the Exchequer George Grenville had begun his program with the Sugar Act in 1764, a component of the American Revenue Act. Although that legislation reduced the duty on foreign molasses by half, it added foreign sugar, indigo, coffee and certain wines to the duty list. The new taxes threatened further harm to an already distressed Boston economy struggling to recover from an economic downturn. The French and Indian War had exacerbated an economic decline begun earlier as competition from other seaports had drained wealth and population. A great fire in 1760 and a smallpox epidemic in late 1763 and 1764 had intensified economic distress.[26]

Merchants were no strangers to British mercantile regulations. The economic philosophy known as mercantilism subordinated colonies to the "mother country" as a ready source of raw materials and a market for finished goods. To exploit this relationship, the British regulated their colonies' commerce. Earlier commercial laws, such as the series of Navigation Acts that began in 1651, were casually enforced, rendering them bearable.

But the Boston opposition, led by Samuel Adams and James Otis, observed that the Sugar Act included direct taxes for revenue. Many Boston merchants

opposed the legislation, organizing boycotts of English luxury goods in Boston and New York. American Loyalists argued that the Sugar Act's most important part, reduction of the foreign molasses duty, functioned merely as a trade regulation payable at the port of entry. Merchants could avoid the tax altogether by simply purchasing British molasses. The reduction of the duty on foreign sugar led the ministry to hope that Americans would comply.

Over time, Boston merchants continuing to market foreign molasses found customs officials susceptible to bribes. But the act further damaged a depressed economy in New England ports. In 1766, Parliament repealed the Sugar Act, replacing it with a milder Revenue Act that placed a one-penny duty on French or British imported sugar.

Grenville intended the Stamp Act to fund the British army remaining in the North American colonies after the war. The act required that stamps be affixed to all public and legal documents, newspapers, licenses, playing cards and almanacs. Henceforth, commercial and legal business simply could not be conducted without paying the tax. The American public regarded this as an indisputable direct, internal tax without even a faint resemblance to a trade regulation. Further, it affected both country and port towns. American Whig leaders believed that the Stamp Act posed an ominous threat to fundamental English rights. For the first time, public meetings resounded with cries of "no taxation without representation." So pernicious appeared Parliament's latest legislative innovation that furious Boston leaders urged other Massachusetts towns to join in resisting it.

When a significant issue required a town's formal response, town meeting customarily furnished its elected delegate to the General Court with written instructions. In this way, residents spoke literally through their representative. Such thoughtful expositions enable later generations to access a town's collective mind on public issues. Lexington's town meeting formally instructed Representative Benjamin Reed regarding the town's position on the Stamp Act crisis. Clearly, the most qualified man to craft such a document was Reverend Jonas Clarke. But his clerical position seemed to preclude his participating directly in government. Even so—according to Charles Hudson in 1868, the chronicler of Lexington's early history— the Stamp Act instructions and later town positions "flowed from his pen." Hudson claimed to have in his possession one such document in Clarke's handwriting. It is no longer extant.

Assuming that Hudson was correct, did Clarke act alone? Throughout the Revolutionary era, whenever Lexington town meeting required an

instruction or a set of political resolutions, it appointed a committee of up to seven members. Clarke's name never appeared among Lexington's committee slate, as clergy generally refrained from overt participation in civil government. But Charles Hudson and others believed that Clarke penned the instructions for committee members to simply sign. In addition to Clarke's handwriting, Hudson offers evidence that no one on the committee laid "claim to that finished scholarship."[27]

Subsequent articles and books ascribe sole authorship to Reverend Clarke, although most cite only Hudson for their source. Two sources predate Hudson's work, however. Edward Everett, in his 1835 speech at the reinterment of the Lexington dead to a tomb on Lexington Common, credited Clarke with authorship. If the statement was false, Revolution-era residents still living could have refuted it, and none did. Clarke contemporaries likely furnished Everett with the information for his speech, since he would not have been familiar with the details. Praising the town's instructions and resolutions, Everett noted that "they are well known to have proceeded from the pen of the former venerable pastor of the church."[28] Also, William Ware, writing of his grandfather in 1850, asserted that "these papers in each instance were drawn up by him."[29] But the testimony of Everett and Ware may have oversimplified a process of composition, much as was true for the writing of the Declaration of Independence—for years Thomas Jefferson was believed to have been the sole author of the Declaration rather than its first drafter.

A story exists, surely apocryphal, that the appointed town committee in Lexington would enter a room to deliberate and return immediately with a lengthy resolution, presumably written by Clarke.[30] But it is difficult to believe that those committees of proud citizens simply signed their names to the minister's finished work. Although membership varied, all stood among the town's most substantial figures—militia captains, church deacons and gentry. The political positions they were charged with composing could directly affect lives and property. Clarke and the committee surely collaborated to some degree, but the anecdote, along with Everett's and Ware's comments, placed Lexington's parson in the leading role. The thirty-five-year-old Reverend Jonas Clarke's background, position and connections entitled him to a great deal of influence, if not deference. He could easily have chaired the committee, solicited its viewpoints and then written the paper. Alternatively, Clarke may have written a draft that the committee responded to and revised.

His later overt participation in town politics indicates that Reverend Clarke exerted a controlling influence in crafting political arguments.

In 1779, for instance, after attitudes against the clergy's direct participation in civil government eased, Lexington elected him as its representative to the Massachusetts Constitutional Convention. In 1795, the town chose him to chair a committee to respond via resolution to Jay's Treaty with England. In 1799, when Lexington erected a monument to the fallen Lexington militia, it chose Clarke to write the inscription. Clearly, their minister's name came first to mind when residents required someone to compose their political views.

Even before the war, it was not unusual for country clergy to provide a covert guiding hand when a town government made important political decisions. Historian Alice Baldwin noted that the "black regiment" in Massachusetts included, along with Clarke, Reverend Thomas Allen of Pittsfield, Reverend Henry Cumings of Billerica, Reverend Philip Payson of Chelsea, Reverend Peter Thacher of Malden and Reverend John Treadwell of Lynn. After war began, more clergy became officially involved—as Clarke did—in town government. Baldwin credited more than sixty New England ministers with serving in a civil capacity during the Revolutionary era.[31] In some towns, the parson became the de facto political leader.

Approving Lexington's representative's instructions to the General Court's lower house constituted town meeting's principal business on October 21, 1765. The instructions begin by invoking the principle of natural rights, maintaining that people are a "set of Beings naturally free" who can never be divested of "Those valuable Rights and Liberties…but by their own Negligence, Imprudence, Timidity or Rashness."[32] Appealing to the British sense of fairness, Clarke's instructions reason that as an internal tax imposed by a body outside the province's own representative assembly, the Stamp Act violated basic protections granted by the 1691 Massachusetts Charter. This agreement had been designed expressly to guarantee colonists certain ancient British rights.

When the instructions turn to the Stamp Act's deleterious economic effects, they regret the cost to people on society's margins, especially the poor, "the widow, the Fatherless and the orphan." This regressive tax fell hardest on the growing lower strata of society. As in surrounding towns, many Lexington farmers had experienced reduced income as increasing population density reduced the soil's fertility. In addition, partible inheritance—dividing farms among all male children—reduced acreage, rendering some farms barely solvent.[33] The postwar recession had taken hold by the middle of 1765. Lexington's responsibility for the poor jumped from a few in the early 1760s to twelve that year. By the end of the

decade, it would more than double.[34] Clarke exaggerates, however, when he warns that the "numerous" and "Heavy tax" will "Strip Multitudes of their Property and reduce them to Poverty."[35]

The stamp tax would affect Reverend Jonas Clarke directly. As a subscriber to the *Boston Gazette*, his newspaper cost would increase, since publishers would pass the required stamp duty on to its readers. Since Parliament levied the one-penny-per-issue newspaper stamp during difficult economic times, it may have reduced subscriptions in number. Not surprisingly, the publishers of the *Boston Gazette*, along with the *Boston Evening Post*, fanned flames of opposition. The *Post* published an announcement warning subscribers to "settle" accounts with newspapers before November 1, when the price would rise.[36]

No doubt Jonas Clarke read in the *Gazette* that Nathaniel Ames, son of Dr. Nathanial Ames, planned to publish an almanac, as his father had for years. The son's almanac, to begin in 1766, would be sold before November 1, 1765, so as to avoid "a stamp duty of Four Pence Sterling." Reverend Clarke interleaved his earliest extant diary in this very almanac. The frugal parson surely made the purchase before the Stamp Act took effect. According to the law, publishers of not only newspapers and almanacs but also any printed materials (books, pamphlets, papers, calendars) sold unstamped after November 1 would be fined forty shillings.[37] Thus the legislation promised to inflame literate members of colonial society, along with lawyers—those most able to organize opposition with their pens.

At this early stage, Clarke fashioned instructions that remained conciliatory, conceding that there existed "no debate as to Parliament's right to impose such an Act upon us," even as the instructions argued that the legislation violated Massachusetts's charter. The British ministry had endorsed that charter in 1691, Clarke observed, "by the royal Word and Seal." Further, the charter guaranteed citizens of Massachusetts Bay the "Liberties and Immunities" of British citizens, including exemption from taxes levied by a body to which they did not send a representative.[38] According to Clarke and other Whigs, the charter clearly established American colonists as British citizens, despite their residence outside England proper.

Responding to similar arguments from many quarters throughout the colonies, Stamp Act supporters in Parliament and Loyalists in the colonies contended that Americans were "virtually represented" in the British House of Commons because sympathetic members spoke on their behalf. Americans stood no less represented than the propertyless British nonvoter or resident of a rotten borough with no assigned representative. These British citizens

submitted to Parliamentary taxation willingly because members from other parts of England represented their interests in towns like theirs, even though not formally elected to do so. The same held true for the American colonies. Reverend Clarke disagreed, writing that it was "vain to pretend" that we are "virtually or in any Just sense represented."[39] He noted that Massachusetts's citizens had sent petitions to Parliament, for example, without their receiving even so much as the courtesy of a committee hearing.[40]

Or consider the vice admiralty courts, which received expanded jurisdiction as part of the Stamp Act. Those juryless naval courts were originally designed to settle maritime disputes between merchants and seamen. But in 1764, the British ministry established an admiralty court in Nova Scotia to try smugglers, presuming that trial courts in Boston could not impanel impartial juries. This new arrangement required defendants to travel to Nova Scotia for trial. Worse, it empowered judges to both preside and serve as jury for the trials. In laying a foundation for objecting to the admiralty courts, Clarke reached beyond Massachusetts citizens' charter rights to the source of all British rights: the Magna Carta. Thus, Clarke submitted that the right of the British citizen to the "Lawful judgment of his Peers" has its roots in "the Great Charter of England."[41] In summary, Reverend Clarke furnished his town's representative with arguments based on three sources of rights: natural rights, charter rights and the rights of Englishmen that extended as far back as the great charter of 1215.

Reverend Clarke closed his instructions respectfully but firmly. He expressed Lexington townspeople's "filial Duty and Loyalty to our Sovereign," as well as their sincere "Veneration for both Houses of Parliament." But he requested the legislature to "carefully avoid all unaccustomed and unconstitutional Grants," which only compound the residual economic hardships brought by the French and Indian War and other hindrances on the financial health of the colony.[42] It was a patient but wary response.

No stamps were ever sold. Political agitation directed at designated stamp distributors in Boston, Newport, New York City and other commercial centers turned violent at times, coercing appointees into resigning their posts. On August 15, 1765, Andrew Oliver in Boston resigned after a mob burned him in effigy on a large elm tree (later named the Liberty Tree) on the corner of today's Washington and Essex Streets. From there, the mob turned on Oliver's home nearby, breaking windows and even "entering the lower part of the house."[43] Agitation turned to further violence on Sunday, August 26, when a mob damaged Lieutenant Governor Thomas Hutchinson's Boston

mansion near Hanover Street by entering it to rip the wainscoting off the wall and drink his wine. The mob did not realize that Hutchinson personally opposed the Stamp Act.

A few days later, a rumor circulated that an incendiary afternoon sermon by Reverend Jonathan Mayhew of Boston's West Church had incited the violence that destroyed Hutchinson's home. Mayhew's text had been Galatians 5:12–13; his sermon considered what the apostle Paul had meant by saying, "Ye have been called onto Liberty." Of the different forms of liberty, Mayhew dwelt on civil liberty, and somewhere in the sermon, according to unnamed sources, he mentioned the Stamp Act. Reverend Mayhew denied the charges. But no printed version of the sermon supported his denial, as the minister claimed to have spoken without notes. He subsequently defended himself by reconstructing his words for newspaper readers, but without spoken inflections and emphasis, the sermon's effect remains difficult to assess.[44] Regardless, Andrew Oliver's brother, Peter, who familiarized the black regiment moniker, was not likely to have believed Reverend Mayhew's claims of innocence.

The Stamp Act's true legacy became the inter-colonial communication network and cooperation that it provoked. A clandestine Boston organization called the Loyal Nine later grew into a radical blanket organization among the several provinces under the name the "Sons of Liberty." To communicate with one another, members of the Sons of Liberty began transmitting circular letters by horseback couriers between cities. A Stamp Act Congress called in protest also created temporary cooperation by assembling in New York political leaders from nine colonies to fashion a response to Parliament's action. The Declaration of Rights and Grievances that emerged proved tepid enough for the British ministry to simply ignore it. But economic cooperation proved far more effective.

Whig leaders in Boston felt a natural aversion to mob action. No doubt the intimidation of stamp distributors on August 14 served a useful purpose, but the seemingly gratuitous destruction of property two weeks later offended many Whig sympathizers.[45] Consequently, leaders limited street rampages, and economic coercion became the favored tactic. The Stamp Act generated new energy for non-importation agreements to be extended to other American ports. This proved critical. Without large-scale cooperation, especially from nearby ports like Newport and Salem, Boston merchants standing alone could be made to suffer for their participation. But by September 1765, a boycott of British goods had taken effect in ports all along the Atlantic seaboard. Ultimately, British manufacturers, crippled

Governor's Proclamation of Thanksgiving after the Stamp Act's repeal, 1766. *Lexington Historical Society.*

by the loss of their largest overseas market, anxiously petitioned Parliament for redress. Their appeals, combined with Grenville's replacement by Lord Rockingham, a prime minister far more accommodating to the American colonies, led to the Stamp Act's repeal on March 17, 1766.

In mid-May, Jonas Clarke's diary records that "news of Stamp Act repeal arrived."[46] Unnoticed by most, but unsettling to Whig leaders,

was Parliament's simultaneous enactment of the Declaratory Act. The Declaratory Act made clear that Parliament had by no means ceded its right to tax or legislate the colonies. "Parliament assembled, had," it stated, "full power and authority to make laws and statutes of sufficient force and validity to bind the colonies and people of America, subjects of the crown of Great Britain, in all cases whatsoever."[47]

Two months later, local ministers set aside a lecture day to give thanks for the repeal of the Stamp Act.[48] Reverend Charles Chauncy of Boston's First Congregational Church, an outspoken Stamp Act critic, exulted in his thanksgiving lecture that "[i]nstead of being slaves...we are indulged in the full exercise of those liberties which have been transmitted to us, the richest inheritance from our forefathers."[49] For God once again smiled on the British Israel.

Affairs between the colonies and the mother country did not return to normal for many Whig leaders. A Rubicon had been passed. Any sense of common cause between the Whigs and Massachusetts governor Francis Bernard and his allies had disappeared. Also, Whig leaders began to suspect the British ministry of conspiring to slowly subjugate them. So they remained ever vigilant.

THE TOWNSHEND ACTS CRISIS AND COMMITTEES OF CORRESPONDENCE

The Stamp Act left Lexington residents questioning imperial policy and with a heightened awareness of their stake in its direction. Reverend Jonas Clarke resolved to nourish that interest into productive political efforts, as needed. In August 1769, the *Boston Gazette* reported that forty-five Lexington women had "assembled at the house of Daniel Harrington, with their spinning wheels."[1] The house abutted the town Common, an ideal location for a conspicuous demonstration to support the boycott of British manufactured goods. Rather than purchase English cloth, the women gathered together to make their own. What a sight the forty-five women spinning on Harrington's lawn must have made. Three years after the Stamp Act's repeal, American colonists were still capable of publicly defying their home government against legislative threats.

Although the Stamp Act's repeal appeased its opponents momentarily, the British ministry remained determined to use the North American colonies as a revenue source. When the Rockingham administration collapsed, William Pitt, another friend of the American colonies, became prime minister. But Pitt's chronic gout gave his chancellor of the exchequer, Charles Townshend—a man decidedly unsympathetic to American discourse about liberty—an independent hand in crafting economic policy. The Townshend Revenue Act of 1767 sought to levy a tax and target the revenue to pay royal governors' and judges' salaries. Heretofore,

provincial assemblies had legislated judicial pay. Not only did the new tax propose to extract revenue from Americans, but Whigs also suspected that it targeted the funds to erode their liberties by removing an institutional check on the executive and judiciary.

Parliament enacted Chancellor Townshend's taxes on British glass, tea, lead, paper and paint, confident that such duties could never be considered internal taxes because England collected the duties externally, at the American ports of entry. But for the Whig opposition, where the British customs service collected the duty mattered little. Unlike the earlier import duty on foreign molasses aimed at redirecting American trade from the French to the British product, these Townshend items had no alternative source. Thus, they were expressly designed to raise revenue pure and simple. Although not levied internally, they remained a tax. John Dickinson of Pennsylvania made just this argument in his four-part "Letters from a Farmer," published in newspapers throughout the colonies from December 1767 through February 1768. Dickinson also reminded Americans of non-importation's effectiveness during the Stamp Act crisis.[2]

Boston responded to the new duties by extending the embargo of British goods, this time beyond merchants. Town meeting adopted a citywide non-consumption plan in an effort to diminish demand for British goods. The plan encouraged country towns to join the boycott. Boston's town meeting in October furnished a list of items, luxury goods in particular, to boycott after December 31, 1767, among them loaf sugar, coaches, chaises and carriages, gloves, shoes, gold and silver buttons, snuff, malt liquors and glue. Various textiles and fabrics such as silk, cotton, velvets and any broadcloth worth more than ten shillings were included.[3] Some criticized the list for omitting the Townshend commodities and urged people to dispense with the items. Taking the lead, a group of Boston ladies swore off "foreign" tea for a year.[4]

Lexington was among the first of several towns to join Boston.[5] In December, its town meeting unanimously voted to "concur with ye Town of Boston, respecting importing and using foreign commodities…as mentioned in their vote."[6] By early 1768, newspapers were reporting that twenty-four towns had joined Boston's boycott.[7] The action required that townspeople make real sacrifices—that is, either choose inferior substitutes for boycotted items or do without entirely. For many, their sacrifice constituted their first political act in resisting imperial policy.

Merchants in ports north and south along the eastern seaboard organized to enforce non-importation, and from the start, Southern Colonies acted to include in their boycott the larger population.[8] Of course, such efforts

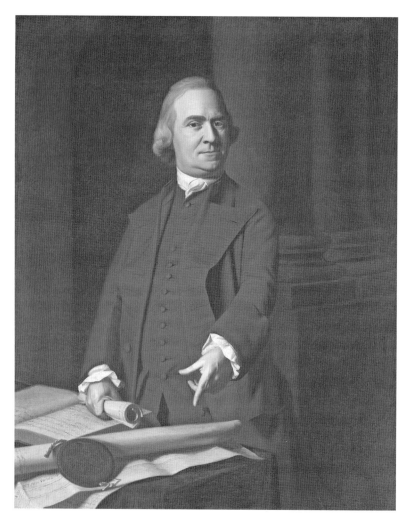

Samuel Adams, 1772, by John Singleton Copley. *Museum of Fine Arts, Boston.*

fell short of unanimity, but in February, the Massachusetts House sent a circular letter penned by clerk Samuel Adams to speakers of the legislative assemblies in other colonies, requesting they unite against the Townshend Acts. Initially defeated as too radical, the measure passed after Adams maneuvered another vote once several conservative representatives from distant towns in Worcester, Berkshire and Hampshire Counties had begun their journey home near the session's end.[9] When news of Adams's circular letter reached England, it infuriated the secretary of state for American affairs, Lord Hillsborough.

On June 10, 1768, royal customs commissioners impounded John Hancock's sloop the *Liberty* and charged its owner with smuggling wine. Hancock had joined the Stamp Act opposition and even served in the Stamp Act Congress that met in New York City. Due to his prominence as a wealthy merchant and selectman, he quickly became a leading figure and financial supporter of Boston's Whig politics. The impoundment appeared to target him, perhaps to make him an example. But the incident only served to elevate his status among the opposition, setting off an explosive chain of events.

An angry mob of several hundred dockworkers gathered at the waterfront to resist the impoundment. As the British naval ship the *Romney* began towing Hancock's ship from the dock, the furious crowd pelted it with rocks. Tensions already ran dangerously high, since violence had previously erupted in April against the *Romney* crew's attempt to press men along the waterfront into naval service. Strong reactions to the hated British press gangs were common, and now another group of angry men reacted en masse to the *Liberty*'s seizure. So enraged were the dockworkers that they pulled customs official Joseph Harrison's pleasure boat from the water to Boston Common, where they burned it within sight of John Hancock's mansion and several hundred cheering onlookers. These threatening and brazen actions understandably terrified Boston's customs commissioners, leading several to board the *Romney* as it retreated to Castle Island nearby.

For months, the commissioners had pleaded with Governor Francis Bernard to request troops from England be garrisoned in Boston. When the governor refused, they appealed directly to the secretary of state for the colonies. After the riot occurred, Lord Hillsborough ordered two regiments from Halifax, Nova Scotia, to garrison in Boston.[10] They would arrive in October.

Soon after the *Liberty* affair, a furious Lord Hillsborough ordered Governor Bernard to require the Massachusetts House of Representatives to rescind its circular letter or face dissolution. In a test of wills, 92 of 107 delegates (later celebrated as "the Ninety-Two") formally refused the governor's demand. To commemorate their service to the cause of liberty, silversmith Paul Revere fashioned a silver Liberty Bowl inscribed with all 92 names. Also listed were the names of the 17 "miscreants" who had voted to rescind. Lexington's representative, Benjamin Reed, understanding his town's temper, stood firmly among "the Ninety-Two." On June 30, Governor Bernard prorogued the General Court until August, but the following day, he simply dissolved it, an act that would require new elections in the fall. On July 4, Boston newspapers ran Hillsborough's letter to Governor Bernard, who by then had

been recalled to England. Lieutenant Governor Thomas Hutchinson took his seat as Massachusetts's acting chief executive.[11]

Reverend Jonas Clarke met with John Hancock and his friend Thaddeus Burr of Fairfield, Connecticut, at Reverend Samuel Cooke's parsonage in Menotomy on June 24. The meeting's purpose was unclear, but surely Hancock, recently charged with smuggling, had much to report. Despite his popular reputation today as a leading colonial smuggler, Hancock seldom broke the law in that way, less out of respect for imperial regulations than because of his trade preferences. He imported a variety of English and India goods and carried to England potash, whale oil and timber.[12] None required illegal commercial maneuvers. Although Hancock had indeed smuggled

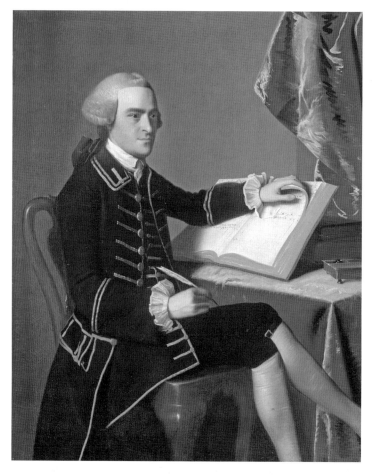

John Hancock, 1765, by John Singleton Copley. *Museum of Fine Arts, Boston.*

wine for personal use on this occasion, he felt certain that the charges brought against him were efforts to harass him for his political activities.

With the imminent dissolution of the Massachusetts House of Representatives, Clarke wrote in parentheses in his diary, "The General Court Prorogued," a week before Governor Bernard actually suspended the session.[13] The preemptive notation may have been based on information Hancock brought of the action's certainty. On July 4, the Lexington minister wrote in apparent alarm, "The Court dissolved!!!!!!!"[14] Clarke seems to have been taken by surprise when Governor Hutchinson went beyond proroguing to dissolution. The General Court did not meet again until May 1769 after elections, ten months later, and soon rumors circulated of the British Regulars' pending arrival. With its colonial legislature shut down, Boston requested that all Massachusetts towns address the crisis together in a September convention.

Four days before the meeting at Reverend Cooke's, Jonas Clarke had the honor of delivering the election sermon before the Ancient and Honorable Artillery Company in Boston. Typically for such a sermon, the subject concerned martial matters, in Clarke's case a justification for the colony's peacetime volunteer military corps. With Chronicles 17:16 as his text, Reverend Clarke took the pulpit of Boston's "Old Brick" meetinghouse on present-day Washington Street to describe the kingdom of Judah as a nation that, even during peacetime, had maintained military preparedness, conducting "martial exercises" and promoting "the cultivation of the use of weapons of defense."[15] The biblical example was apt. Other kingdoms had disarmed when peace came, but "once the martial spirit sinks," a nation grows vulnerable.

One Bostonian in the audience, prominent merchant John Rowe, thought that the visiting minister's remarks made for "a sensible discourse."[16] Reverend Clarke had no way of knowing that in seven years, and virtually at his doorstep, events would press Lexington's local volunteer military corps into historic conflict, one that later made Clarke's words sound distinctly prophetic.

More than one hundred towns and districts sent delegates to the convention, held at a packed Faneuil Hall on September 22, 1768.[17] Like Lexington, about half the towns sent their representatives to the recently dissolved General Court.[18] At a special town meeting called to take into "consideration the distressed state of the province," Lexington appointed an ad hoc committee, silently headed by Reverend Jonas Clarke, to supply Lexington delegate Benjamin Reed with a resolution. It passed unanimously.[19]

Lexington's public position reveals a keen sense of political grievance. Like its Stamp Act response, the instructions begin with the Massachusetts Charter's origin and its guarantee of English rights. It presents three infringements as violations of those basic rights. First, the right to levy taxes "is Specially Granted to ye Great and General Court or Assembly" by the colony's charter. Next, the troops rumored to arrive soon from Halifax constitute "keeping a standing army in time of peace" without the General Court's consent. Finally, regarding the General Court's dissolution, the resolutions submit that the English Bill of Rights requires that legislatures meet "frequently."[20] In the strongest language to date, Clarke's statement insists that Lexington's citizens will, at the "utmost peril of their lives," take all "Legal and Constitutional measures" to defend their charter rights along with those "belonging to us as British Subjects by Birthright." That said, the pledge makes clear that they remain loyal subjects who want nothing more than the resumption of their previous relations with the mother country. The resolution closes on a conciliatory note, that these British subjects will defend the king with their lives.[21]

Lexington understood the magnitude of the stakes. American Whigs had begun to openly accuse the British ministry of intending to "enslave" them. Although this claim may seem overwrought, it arose logically. If the British could impose taxes on American colonists without their consent, therefore confiscating the fruit of their labor, they could easily be reduced to slavery, or at least servitude. As always, Americans embraced their British heritage, admired its political system and cherished their rights under it. No better system existed on earth—for full-fledged citizens. But Whigs began to suspect a sinister plan afoot to reduce their provinces to the status of Ireland. At that time, English landlords owned two-thirds of Ireland's land, real estate that absentee landlords had acquired through political patronage. Now, in Massachusetts, did the increasing number of political appointees arriving on these shores—pejoratively called "placemen"—not signal a similar plan to confiscate American farms?

Even in England, freehold farmers had been diminishing rapidly, with only 15 to 20 percent of the land left in their hands (the rest consolidated into large parcels).[22] The norm for most farmers in the empire was tenantry under lords of the manor, along with stark wealth disparities. Could the same system be imposed on the American colonies? New Englanders took pride in the predominance of freehold farms. Through those farms, most town residents met the property requirement for voting; consequently, they participated in a more representative system with a broader voter base

than Great Britain's. In the eighteenth century, freeholder status signified cherished independence, as the name signifies. Protecting this independent position offered a cause worth fighting, even dying, for.

Mary Fuhrer's analysis of the Lexington militia enlistees' landholding in the fall of 1774 proves telling. Enlistees possessed significantly more land than the non-enlistees. Almost one-half of those Lexington residents who chose not to enlist owned no land.[23] One can only speculate as to the relationship between the two, but it seems reasonable that a landholder owned a greater stake in his future independent status.

The Lexington meeting closed by voting to "keep a day of prayer," with Reverend Clarke left to determine the date. Repeal of the Stamp Act in 1766 furnished an occasion for thanksgiving. Now the politically trying summer and early fall of 1768 required that a fast day be observed. One week later, the minister set aside such a day, and "Mr. Cushing [Waltham] and Mr. Jones [Woburn] preached on account of the times and Fears on every Side!"[24] No doubt Reverend Clarke called on the audience to examine its moral failings, to reflect on why it must endure these current struggles. But the British government would have been roundly condemned as the Whig clergy sought to bolster support for colonial opposition.

The Boston convention produced resolutions, and letters were sent to the governor. Overall, the responses appeared mild in tone, perhaps moderated by so many towns participating. Deliberations ended abruptly, however, when ominous news arrived that transports carrying soldiers approached the harbor. Boston would soon be garrisoning British Regulars. On October 1, two regiments landed, the Fourteenth and Twenty-ninth under Lieutenant Colonel William Dalrymple, with part of the Fifty-ninth joining them, a turn of events warranting five exclamation points in Jonas Clarke's diary. The following day he noted as "[a] day of Darkness!!"[25]

The Regulars received a frosty reception. The soldiers' ethnicity did nothing to soothe tempers. Based on a 1773 report on the Twenty-ninth Regiment, likely applicable to 1768, its regulars and noncommissioned officers were more than 50 percent Irish. About 5 percent were Scots, while barely one-third could claim English citizenship. The regiment featured seventeen boys from the Caribbean island of Guadalupe who served as drummers; their yellow coats and dark skin made the regiment appear exotic. The initial parade of these British troops through the streets of Boston provided a shock to the town's system. Not only was it occupied by a standing army, but it also seemed that the army was largely foreign.[26]

Boston authorities refused to supply the troops with provisions or offer them quarters except at Faneuil Hall. Instead, they suggested the Regulars quarter at Castle Island. British command refused this option, so most Regulars slept in tents on Boston Common. Eventually, under pressure to comply with the Quartering Act of 1767, Boston did make available the vacant Manufactory-House next to the Common, along with various empty warehouses.[27] When, several months later, the Sixty-fourth and part of the Sixty-fifth Regiments arrived, those troops camped at Fort William on Castle Island before returning to Halifax in July 1769.[28]

Meanwhile, Boston merchants continued their pressure on Parliament by means of a new non-importation agreement in January 1769 that targeted the five Townshend commodities.[29] It directed Massachusetts Bay colonists henceforth to avoid purchasing lead, paint, tea, paper and glass. Moreover, by spring, efforts to unite with merchants at other American ports had met with such success that even Philadelphia reluctantly joined. The three largest ports—Boston, New York and Philadelphia—now stood together, and the resulting boycott of British goods meant that the nascent domestic manufacture took on a new importance and energy.

Of necessity, responsibility for sustaining the consumption boycott fell largely on women, who patched clothes, created substitutes for imported tea and produced in their homes other alternatives to boycotted manufactured goods. Even in country towns, British manufactured cloth had become commonplace by the mid-eighteenth century. But to stay faithful to their non-consumption pledge, Lexington's "daughters of liberty" dusted off their idle spinning wheels to start spinning thread and yarn once again. The success of homespun as a political statement is reflected in the account book of wheelwright John Parker, whose spinning wheel sales in 1767 and 1768 spiked steeply.[30] In 1775, the town militia elected Parker captain, with his men proudly dressed in homespun cloth.

As noted earlier, wheels of the politically discontented spun both privately and on public display. In the *Boston Gazette*'s coverage of Lexington's spinning bee on Daniel Harrington's estate, the author chided whoever might scoff at the ladies' contribution, for "what would become of our (so much boasted) Manufactures, on which we pretend the Welfare of our Country is so much depending, if those of the fair Sex should refuse to lay their 'Hands to the Spindle.'"[31] In the first nine months of 1769, the *Boston Evening Post* reported twenty-eight such public spinning bees.[32] Those public occasions, more political than practical, drew crowds

> *Lexington, Aug. 31, 1769.*
> Very Early in the Morning, the young Ladies of this Town, to the Number of 45, affembled at the Houfe of Mr. Daniel Harrington, with their Spinning-Wheels, where they fpent the Day in the moft pleafing Satisfaction : And at Night prefented Mrs. Harrington, with the Spinning of 602 Knots of Linnen, and 546 Knots of Cotton.
>
> If any fhould be inclin'd to treat fuch Affemblies or the Publication of them, with a Contemptuous Sneer, as thinking them quite Ludicrous : Such Perfons would do well firft to confider what would become of one of our (fo much boafted) Manufactures, on which we pretend the Welfare our Country is fo much depending, if thofe of the fair Sex fhould refufe to lay their " Hands to the Spindle," or be unwilling to " hold the Diftaff."†
> † Prov. 31. 19.

A *Boston Gazette* article on the Lexington spinning bee. *American Antiquarian Society.*

of interested observers. At Lexington's bee, the grateful women presented Mrs. Harrington with their day's work.[33]

Jonas Clarke's earlier lecture in 1761, "The Best Art of Dress: Early Piety Most Amiable and Ornamental"—preached before the boycott—revealed his apprehension that parishioners could lose their way pursuing the material rewards of British fashion. But the commercial dependence proved double-edged, and now British manufacturers stood to lose a critical market. With frugality the order of the day, patched clothing became a patriotic sign of boycott compliance, as was avoiding other British items heretofore considered necessities. Lexington town meeting supported the new non-importation agreement. It went further. At its March 1769 meeting, Lexington passed a resolution "not to use or keep any tea or keep snuff nor suffer it to be used in our families till ye duties are taken care of."[34] The *Boston Gazette* opined that Lexington's was "an example worthy of imitation."[35]

What role did Jonas Clarke play in this example of the town's emerging radicalism? No doubt he was the engine that powered it. If one looks only at Lexington's actions regarding manufactures in the home, Clarke's hand

is clearly visible. Traditionally, bees, or "matches," grew out of church sewing circles, with the minister encouraging women to manufacture and display their handiwork publicly. Virtually all bees reported in 1769 Boston newspapers occurred at the minister's house accompanied by an appropriate sermon.[36] Lexington's bee probably occurred at the Harrington home because it stood adjacent to the Common; unlike parsonages in many towns, Reverend Clarke's home was a short distance from the village center. A bee there would have been less visible. Peter Oliver's polemic against dissenting clergy included accusations of directing their sermons toward "Manufacture instead of Gospel." According to Oliver, the "black regiment" kept at it until "Women set their Spinning Wheels a whirling in Defiance of Great Britain."[37]

Clarke likely wrote several articles concerning Lexington that appeared in the *Boston Gazette*, including when his house was burgled. The *Gazette* did not send staff to cover local news events but instead relied on contributions from local subscribers. The article warning against belittling the political work of Lexington women sounds like Clarke's prose. No extant record can connect his hand unequivocally to such political utterances, but their appearance in the press seems all but inconceivable without his active support.

The British garrison created tensions in Boston. Colonists hostile to imperial policies deeply resented the sight of British soldiers moving conspicuously about town. Sentries posted at the guardhouse on Boston Neck stopped travelers entering and departing the town, creating resentment during these often-testy interactions. Indeed, their presence served as an inescapable reminder to Boston residents that their town amounted to occupied territory.[38] For their part, British soldiers suffered from poor provisions, low pay, strict discipline, boredom and verbal abuse. Over time, Boston residents plied soldiers with cheap alcohol and encouraged them to desert, even providing maps with escape routes.[39] To supplement their meager wages, Regulars often tried to find part-time work, therefore competing with jobless town residents.[40] As relations between the two groups went from bad to worse, conflict became inevitable. Skirmishes broke out, climaxing in the notorious Boston Massacre on March 5, 1770. But an earlier violent death occurred before the much-publicized "massacre," setting the stage for the more notorious event.

On the morning of February 22, Theophilus Lillie discovered that Boston Whigs had tarred and feathered his shop. By way of explanation, the perpetrators placed a sign in front charging him with being an importer of British goods. Noticing the vandalism, Loyalist Ebenezer Richardson tried

to remove the sign from his neighbor's establishment. Schoolboys, who had been hurling mud and sticks at Lillie's shop, now turned on Richardson as he walked home. When he reached his house, the boys redirected the pelting toward it. Soon an angry crowd began to gather. A rock crashed through a window, and the crowd began forcing its way into Richardson's dwelling with his wife and three daughters inside. In desperation, the Loyalist fired his musket into the crowd, wounding one boy and killing another, eleven-year-old Christopher Seider. Reverend Clarke noted in his diary, "Boy murdered by one Ebenezer Richardson a famous Informer." The Woburn-born Richardson did indeed inform for the customs service, a fact widely known. He was charged with Seider's murder.[41]

The Boston Whig leadership manipulated the tragedy for maximum propaganda effect, staging a massive show funeral for the young martyr. The *Boston Evening Post* announced that the funeral, which began at the Liberty Tree, would be "attended by a train as numerous as was ever known here" but composed only of "Friends of Liberty."[42] The procession included six boys bearing the coffin, with four or five hundred schoolboys close behind. Thirty chariots and chaises followed those in a line five-eighths of a mile long.[43] A Boston jury later found Richardson guilty of murder, but the king pardoned him. Richardson promptly headed for Philadelphia.

On March 5, eleven days after the Seider funeral, several Regulars fired into a menacing mob in front of the custom house, killing five. The crowd had gathered around an altercation between a Regular and townspeople over an alleged unpaid debt a British officer owed a local tradesman. Lingering tensions over the Richardson affair likely subverted efforts at peaceful resolution, quickly accelerating the mistrust. The frantic ringing of fire bells further escalated the dispute into a mob action as the handful of soldiers dodged insults, ice chunks and oyster shells. Acting without orders from their commander, Captain Thomas Preston, the eight edgy Regulars fired into the crowd, killing five. Whig leaders promptly labeled the event the "Boston Massacre," and before long, propelled by silversmith Paul Revere's engraving, "Massacre on King Street," word of the mêlée had spread throughout the colonies.

Boston authorities arrested the implicated British Regulars, charged them with murder and held them to await trial. Several months later, John Adams defended them in court. Two were convicted of manslaughter and branded with *M*s on their fingers. Fearing more violence, town authorities urged that the British troops be garrisoned on Castle Island, and Colonel Dalrymple reluctantly acceded to their request.[44] The funeral procession for the five Boston Massacre victims began, as Seider's had, at the Liberty Tree, but

An engraving by Paul Revere of the Boston Massacre, 1770. *Lexington Historical Society.*

the size of the procession dwarfed the boy's earlier funeral, with estimates as high as ten to twelve thousand trailing the coffins—Boston's population stood only at about sixteen thousand.[45]

Tensions over imperial policy ebbed in the Massacre trials' aftermath that fall. The Regulars' removal to Castle Island had eliminated one grievance, but soon another disappeared. On the day of the Massacre,

Townshend's successor, Lord North, requested that Parliament repeal the Townshend Acts. North believed that taxes on British manufactured goods disadvantaged home industries. He did retain the tax on tea, however, to avoid any appearance of weakness. Ultimately, the tax's retention proved more combustible than the prime minister could have imagined in 1770.

In the short term, the repeal weakened the non-importation agreements in colonial ports along the East Coast. The near-complete repeal of the Townshend duties led most consumers to resume buying coveted British luxury goods. During the non-consumption boycott, merchants who had complied with the non-importation agreements had lost ground to competitors who had not. Despite Boston's Whig leaders' efforts to maintain economic pressure on Parliament to remove the tea tax, the boycott on English cutlery, linens and fine wines waned.[46] Soon it was all but dead.

With the Townshend Act crisis passed, Lexington town meeting returned to its normal business of "mending" highways, relieving the poor, deciding whether swine should be fenced, hiring teachers and delivering Reverend Clarke his annual wood allotment. The town minister returned to focusing entirely on his parishioners' personal salvation. With the birth in 1770 of Martha, or "Patty," the parsonage now housed nine children, the oldest, Thomas and Jonas, still only eleven and ten years old. The Clarkes would produce three more in the coming years.[47] Meanwhile, Jonas Clarke's Boston connections kept him apprised of the Whig leadership's efforts to keep the people's rebellious spirit from languishing in the absence of a crisis to rouse them.

Relative tranquility continued in Boston for two years after the repeal of the Townshend duties. The calm unsettled Whig leaders, who remained fearful that imperial policy threatened the colony's independence. A Massachusetts public eager for British luxury goods alarmed Samuel Adams, by this time Boston's acknowledged opposition leader in the House. While he presumed the people would quickly mobilize against a visible threat, especially one affecting their purses, they appeared insensitive to more subtle dangers emerging from the British ministry.

Thomas Hutchinson, serving as acting governor since 1769, officially replaced Francis Bernard in the spring of 1771. Although a Crown appointee, Hutchinson was a Massachusetts native whose lineage reached back to the Great Migration. But earlier he had endured Whig criticism for holding two offices simultaneously: lieutenant governor and chief justice of the Massachusetts Superior Court. A mob had trashed his Boston

residence during the Stamp Act riots. Later, in June 1773, Whig adversaries intercepted and published several of Hutchinson's personal letters. These appeared to call into question his commitment to upholding Massachusetts's rights. Already, during Hutchinson's brief time as governor, several of his decisions had generated further criticism.

Most obnoxious to the opposition, he had appointed "placemen and pensioners" to government offices in increasing numbers. By 1771, Hutchinson understood that a party friendly to his administration would never predominate in the House with the Whigs ascendant. So he began appointing his supporters, qualified or not, to such patronage positions as the customs service in order to create an unelected administration party. Many perceived Hutchinson's "placemen" rightly as more likely to act in his interest, and these appointees came from an elite social class with values that threatened civic virtue. It seemed antithetical to Whig leaders' notions of representative government.[48]

Samuel Adams and fellow Bostonian Dr. Thomas Young, an ardent Patriot and Adams protégé, assumed that informed citizens would respond. Although newspaper articles and speeches had edifying value, Adams and Young sought a method to systematically reach the entire province, knitting Massachusetts towns together as a single polity. Toward that end, they hit on the idea of forming corresponding societies that, through town meetings, would span the colony and cultivate far-reaching information networks. Each Committee of Correspondence would compose the collective thinking of its town meeting on a subject and then disseminate that position to other towns through letters. In this manner, not only could each town's residents become aware of their rights, but they would also understand their common interests as well.[49] Previously, opposition to imperial policy had emanated from Boston, with limited rural participation. Now Boston leaders planned to use the Committees of Correspondence to unify the country towns in common cause.

As it happened, events themselves transpired to help establish the committees and elevate their significance. In September 1772, word reached Massachusetts that Superior Court of Judicature judges would henceforth be paid by the Crown through customs revenue. This idea hatched in the Townshend Acts had become a reality. Months earlier, the General Court had learned that the Crown would pay the governor's salary. From the 1691 charter's inception, the House had funded judges' and governors' salaries through provincial tax revenues. To Whig sensibilities, this produced a healthy dependence on the House of Representatives, obliging officials to consider

the taxpayer interest in discharging their duties. The king could remove judges and governors, but the General Court maintained influence over provincial officials' actions through paying their salaries. This latest imperial decision left those officials—the judges and the governor—entirely predisposed to solely serve Crown interests.[50] Understandably, Whigs considered the British ministry's initiative as piercing the heart of Massachusetts's representative institutions, requiring the kind of colony-wide education for which the Committees of Correspondence were created.

Accordingly, in December 1772, the Boston Committee wrote and distributed a pamphlet to selectmen in the 260 towns in Massachusetts (which at the time included Maine).[51] *Votes and Proceedings of the Town of Boston*, also known as *The Boston Pamphlet*, included among its contributors Samuel Adams, Dr. Joseph Warren, Benjamin Church and Dr. Thomas Young. John Hancock served as moderator of Boston town meeting. Predictably, social contract theory provided the basis of the pamphlet's argument, which maintained that citizens enter a society and accept governmental authority as part of a voluntary compact, relinquishing certain privileges for the good of the whole. This obliged the government to protect its citizens' lives, liberty and property.[52] Government existed only by consent of citizens who willingly entered the compact. *Votes and Proceedings* included among its grievances the Declaratory Act, the tax on tea, the political appointments of customs officers and the governor's garrisoning of Castle William with British troops. The final indignity, the royal payment of the salaries of the governor and Superior Court justices, "compleats our slavery."[53]

On January 6, 1773, Governor Thomas Hutchinson crafted a rebuttal, delivered before a House session called for that purpose. For the governor, Parliament's supremacy remained the essential question. Americans claimed the same rights and immunities as British citizens. But to American-born Governor Hutchinson, it seemed obvious that if citizens left Britain to settle in a distant colony, those citizens voluntarily surrendered the right of direct representation in Parliament. The charter made clear that colonists retained their citizenship in the realm, but their rights, once transferred across the ocean, must by necessity be modified.[54] Moreover, Governor Hutchinson argued that while their residence outside England modified colonists' rights and immunities, Parliament supremacy over them remained the same. The governor ordered the speech printed and circulated to counter *The Boston Pamphlet*.

On January 5, the day before that House session, the Lexington committee returned a draft that began by clarifying its instructions to Jonas Stone. As

with Reverend Jonas Clarke's previous town expositions, these established the source of the natural, constitutional and charter rights the Crown violated. They addressed several grievances heretofore unaddressed. The 1766 Declaratory Act, which claimed that Parliament could make laws for the colonies "in all cases whatsoever," had previously passed unremarked. Now, it met belated but forceful condemnation because "by one powerful Stroke" it "vacates all our Charter, and in a Moment dash[es] all our Laws out of existence." The instructions go on to indict the governor for bowing to the king's order to surrender custody of Castle William to the British army. Colonial taxes had paid for the fort's construction and supplied it with munitions. According to the charter, the governor served as the province's "Captain General" and, in that capacity, made the final decision on provincial property. He could not hide behind the excuse that he simply executed the king's orders.

But the paper devoted the longest space to the Crown's payment of Superior Court judges' salaries. Clarke's instructions began by noting that not only does the charter vest the General Court with the exclusive right to tax, but it also grants it the right to decide where that revenue is disbursed. Heretofore, the revenue paid judges' salaries. Such a change "removes that mutual Dependence which preserves a due Balance between [the people and the government]."[55] The instructions assert the consequence directly: "Interest will have its influence to blind the Eyes and pervert the Judgment of the Wisest." Significantly, this change could affect every Lexington property owner because on this highest court in the province "all our interests Respecting Property, Liberty and Life do Chiefly, if not Ultimately depend." Farmers could be dispossessed. Jonas Clarke's instructions ended with an admonition. "Thus the plan of oppression is begun," and (borrowing from Boston's statement) "the System of Slavery will soon be Compleat."[56]

By April, of the 260 Massachusetts towns or districts, 119 had written formal responses to *The Boston Pamphlet*. Towns most likely to respond had actively opposed previous Crown measures such as the Stamp Act and the Townshend Acts.[57] Proximity to Boston played its part, but politics also determined who answered and who did not. In several towns, such as Springfield and Middleborough, local leaders stood with Hutchinson, however mixed might have been the population's sentiments overall.[58] Along with Lexington, almost 90 percent of the towns in Middlesex County, in the eastern part of the province, supported the Boston Committee of Correspondence.[59]

At a January meeting, Lexington concurred with the Boston Committee "in their Sentiments as to the Nature of our Rights, and the high Infraction of

them." It also decided that the town had the right to "Correspond with other Towns, Upon Matters of Common concern," thus establishing a Lexington Committee of Correspondence. As with most towns, it was composed of men of stature, as suggested by their titles: Captain Thaddeus Bowman, Deacon Jonas Stone, Ensign Robert Harrington, Deacon Benjamin Brown and Deacon Joseph Loring.[60] Although unlisted, Reverend Jonas Clarke surely was a covert member.

Thus, Lexington took one more step, and a major one, in its opposition to the Crown. Having resolved against acceding to Parliamentary legislation, and having participated vigorously in boycotts of English goods, it now became a partner to the most radical of the Boston leadership, some with close relations to Reverend Jonas Clarke. It was a portentous way to begin 1773. The year would also end ominously.

THE TEA ACT CRISIS

In May 1773, the Lexington parsonage suffered a burglary. At the time, several family members, including Mrs. Clarke, were recovering from measles, potentially a fatal disease in the eighteenth century.[1] Reverend Jonas Clarke recorded the intrusion in his diary: "House broke open. Tankard pepper box &c stole!" Soon after, the *Boston Gazette* published an article by the parson detailing the items stolen and offering an eight-dollar reward for their recovery. The thief had filched parts of a silver tea service, likely the most valuable item in the house; silver tankard and pepperbox; spoons; and tea tongs. Those bore the initials L.B. (for Lucy Bowes), since it was customary for the woman to inscribe her maiden name initials on her wedding silver.[2]

This thief was not finished with Lexington. He struck again on Saturday, August 28, at Joseph Simond's house. "Heard of our plate that was stole!!" Clarke wrote, his first mention of stolen plate. "Mr. Joseph Simond's House broke open his watch stolen &c."[3] As customary, Simonds published a notice in the *Boston Gazette* identifying the watch and its number so as to circumvent fencing, while offering a three-dollar reward for the watch's return.[4]

Boston authorities soon apprehended the thief, twenty-one-year-old Levi Ames of Groton, along with an accomplice, Joseph Atwood, as they were stealing from Martin Bicker's home in Boston's Dock Square.[5] Authorities induced Atwood to testify against Ames, sealing his fate.[6] Burglary remained a capital crime in Massachusetts in 1773, considered worse than highway robbery because entering a home invaded privacy and exposed occupants to

A broadside issued in 1773 after the execution of Levi Ames. *Library of Congress.*

possible assault. Even when involving items of little value, the crime called for the death penalty.

Levi Ames's execution was set for October 14. Reverend Clarke's diary first mentioned Ames in early September, when he learned of the sentence. The Lexington minister visited the condemned soon after. Perhaps because of his involvement, Clarke felt a pastoral responsibility to persuade Ames to repent and convert before he died. In general, New England courts intended for the interval between sentencing and execution to enable a thoughtful repentance.[7] Ames seems to have responded to the minister's entreaties. "Levi Ames confessed to stealing my plate! Bro't my Plate home," Clarke wrote.[8] Not only did he confess, but Ames also informed Clarke of the remaining stolen items' location. To offer further comfort, or because Levi Ames's repentance seemed incomplete, Reverend Clarke traveled to Boston on October 7 to meet once more with the doomed twenty-one-year-old. Although Jonas Clarke was not the only minister to visit the condemned man, he surely contributed to the young thief's contrition.

The court postponed Ames's execution one week. On October 20, Reverend Clarke noted, "Levi Ames executed!"[9] The next day, the actual execution day, thousands heard a sermon and then witnessed his hanging on Boston Neck. Mid-eighteenth-century New England executions were ritualized morality plays. After being hauled in chains through the streets in a cart, once on the scaffold, the condemned often cautioned young onlookers against his tragic path. Sometimes these words were transcribed and published. More published material followed Ames's execution than any other colonial criminal in the century, partly because the execution of burglars had become controversial.[10] In the end, the Ames execution provided fodder for a movement to abolish capital punishment for crimes against property. In 1805, Massachusetts abolished the death penalty for burglary and arson.[11]

But Jonas Clarke's concerns about his property rights reached far beyond items taken from the Lexington parsonage. Events loomed to cast doubt on the ability of Americans of all sorts to retain their property. A month after the burglary unsettled the Clarke household, Parliament enacted the Tea Act. Another crisis was in the offing.

Periods of relative calm had followed the Stamp Act and the Townshend Acts crises, as the British ministry had wisely let a reasonable interval elapse before enacting further colonial regulations. More important, in both cases the ministry had repealed all or most of the offensive legislation, even while

asserting Parliament's power to legislate the colonies. But no concessions arrived from Great Britain concerning payment of judges and governors' salaries. Worse, another unpopular law followed quickly. In April 1773, Parliament passed the Tea Act, legislation that, at first glance, might hardly have been expected to set American commercial centers aflame with dissent. After all, the new act proposed changes that promised to lower the price of the colonists' favorite beverage. Yet the law became bitterly resented, most famously and dramatically at Boston Harbor in December. It was, however, in Lexington that the first politically motivated destruction of tea in Massachusetts occurred, three days before the Boston Tea Party. Jonas Clarke not only guided the town toward its fiery response, but his stirring words also lit the match.

Parliament intended the Tea Act to rescue the failing British East India Company, Britain's second-largest business enterprise. Corruption within its management, along with drought and famine in the Bengal region of India, had sent company stock plummeting. The company had enjoyed a government-sponsored monopoly in the lucrative Chinese tea trade, but smugglers both in Britain and in America had undermined that trade, leaving large quantities of unsold tea rotting in company warehouses.[12] With the European market already oversold, Parliament turned to American tea consumers to rescue a foundering enterprise.

Colonial non-importation efforts had begun to slacken by 1770 because only tea remained taxed from Townshend's list. By 1773, the market for British tea in America had diminished, many tea drinkers having transitioned to the cheaper smuggled Dutch variety. Willing buyers proliferated, especially in ports south of Boston—those with the best smuggling contacts.[13] Now, through the Tea Act, Prime Minister Lord North and the company directors hoped to recapture the American market and bail out the East India Company in the process. Previously, the East India Tea Company paid import duties in Britain when it sold to merchants there. The British merchants, in turn, shipped the tea to American retailers after adding the Townshend duty to the cost. The Tea Act permitted the company to ship tea directly to American consignees, who could retail it in colonial ports. By avoiding middlemen, the new distribution channel eliminated the British import tax, reducing the price below that charged even for illegal Dutch tea.

American opposition leaders opposed the Tea Act for several reasons. First, the new arrangement buttressed fears of government-sponsored monopoly, sanctioned by the consignee system. In Boston, the five designated consignees all supported Governor Thomas Hutchinson, and three were

members of his family: his sons, Thomas and Elisha, and Richard Clarke, related to the governor by marriage. If the system proved profitable, might consignees friendly to the government profit from the exclusive right to sell other commodities? This would turn merchants friendly to Governor Hutchinson effectively into de facto political appointees, or placemen, and thus would move political patronage into the marketplace. At the same time, merchants out of favor with the governor likely would be bankrupted.[14] Second, Whig leaders feared that the discounted price of London's tea might seduce the public into paying the remaining duty, thus establishing the precedent of Americans abandoning their charter rights to accept taxation from Parliament when the price was right.

As with the stamp distributors earlier, Boston's Sons of Liberty approached the tea consignees, demanding that all five publicly resign their posts at the Liberty Tree. When the consignees failed to appear, the Sons attempted to persuade them over several days in "a genteel manner" to resign, but the tea merchants refused.[15] While some physical intimidation did occur, Whig leaders generally prevented the type of violent action that had occurred during the Stamp Act crisis.[16] Boston's failure to persuade the consignees to resign proved an embarrassment within the inter-colonial opposition, however, inasmuch as radicals in Philadelphia and New York had convinced their consignees to surrender their lucrative posts by December 2. With the arrival of the *Dartmouth* in Boston Harbor laden with tea for sale from England four days earlier, the crisis had intensified.

The day after the ship dropped anchor, Bostonians met and resolved to prevent the unloading of its cargo as long as a tea tax remained.[17] (Boston was the largest American importer of British Bohea tea, with New York and Philadelphia tea drinkers relying almost entirely on smuggled tea.) Within a few days, two more tea-laden ships joined the *Dartmouth* in the harbor. For Boston's leaders, the solution to the standoff was simple. The ships must return their tea to England, just as the vessels docking in New York and Philadelphia had. But the governor's ties to the consignees complicated the situation in Boston, putting them in a stronger position even as these same connections intensified the anger directed their way. Moreover, a legal conundrum had arisen: the law required any ship entering Boston Harbor to pay the duties on its cargo within twenty days. Otherwise, the customs service would seize the cargo, unload it and sell it to collect duties owed. The *Dartmouth*'s twentieth day would arrive on December 17.

While the tea ships rode at anchor, several towns met to support Boston, among them Cambridge, Charlestown, Dorchester, Marblehead, Medford, Lynn and Lexington.[18] All opposed permitting the tea to be unloaded, and all endorsed ongoing efforts to force the consignees to resign. Of those surrounding towns, the resolution from Lexington's December 13 town meeting ranked among the most articulate, detailed and incisive, according to the *Boston Gazette*.[19] Reverend Clarke's authorship accounts for its consistency with the town's earlier positions.

The resolution begins with a detailed exposition of the dangers the Tea Act posed to American rights. It attacks the favoritism inherent in consignees' selection by the governor, a method that confirmed Whig fears of unelected placemen gaining power, "task masters[,] Pensioners" and the like put in positions to control colonial destinies. The town reiterated suspicions that the tea monopoly represented a dangerous shift in trade practices, one that threatened to "monopolize one [commodity] after another, until in the Process of Time the whole Trade will be in their Hands, and by their Consignees, Factors Etc., they will be the sole Merchants of America."

The Townshend tea tax itself did not escape censure, condemned as an illegal Parliamentary effort to reach into "the Purses of Industrious Americans." The statement warns that once the tea was unloaded and the tax paid, "the Rights and Liberties of Americans will be forever Sapped and Destroyed."[20] This entering wedge of taxation threatened a way of life, once paid "the Badge of Our Slavery [will be] fixed, the Foundation of our ruin surely laid." As the crisis deepened, the tone of Lexington's public declarations had become more strident. The tea statement revealed townspeople at their most alarmed to date.

Lexingtonians would oppose "landing, receiving, buying or selling, or even Using" East India tea. Under Reverend Clarke's stern eye, no resident wanted to be caught with teacup in hand, for the resolutions made clear that if one did transgress, he "shall be deemed, & treated by Us as Enemies to their Country."[21] The resolution goes on to label as "false & Malicious" any argument that smugglers of illegal tea prompted efforts to prevent the tea's removal from the *Dartmouth* to rid themselves of competition. Then, Lexington vowed prophetically that if required, "We shall be ready to Sacrifice our Estates, and everything dear in Life, Yea & Life itself, in support of the Common Cause." The resolution closed by warning town residents, once again, against purchasing or consuming any tea, British or Dutch, until Parliament removed the duty. Of the towns in eastern Massachusetts, only Lexington, Charlestown and Boston endorsed boycotting all tea.[22] The Tea

Act resolutions close by warning that any transgressor "shall by this Town be treated with Neglect & Contempt."[23] It would be perilous for an individual in a country town to oppose the minister's will without the support of others in his community.

A letter by "A True Whig" in the *Boston Evening-Post* took issue with the three towns that abandoned all tea. Could people live without tea entirely? To the author, giving up tea altogether increased the possibility of violating the boycott. "Let us Resolve what we can comply with, and then let us firmly abide by our Resolves." Further, the writer insinuated that Loyalists had contrived the plans in Boston, Charlestown and Lexington in order to subvert the boycott of British tea.[24] That had to be the only time anyone ever alluded to Reverend Jonas Clarke as a Loyalist, even if indirectly. Clarke must have been amused.

Lexington's resolutions had a singular effect in town. Immediately after town meeting, in a stunning action that foreshadowed the Boston Tea Party, residents gathered tea from their homes and burned it on the town Common, surely in the presence of an approving Reverend Jonas Clarke. This was the first such overt tea protest in the province, three days before the famous Boston affair. Newspaper reports noted that Charlestown planned to follow with a similar action, and later reports confirmed that the town indeed fulfilled its promise.[25] Thus, Lexington's action had set an example; Reverend Clarke's town stood in the vanguard of the radical movement.

Boston's event followed three days later. Jonas Clarke, who did not record Lexington's tea burning in his diary, recorded news of the Boston Tea Party.[26] Tea worth £9,659 had been hurled into the harbor and destroyed, a value in excess of $800,000 in today's currency.[27] Colonials

We are positively informed that the patriotic inhabitants of Lexington, at a late meeting, unanimously resolved against the use of Bohea Tea of all forts, Dutch or English importation ; and to manifest the sincerity of their resolution, they bro't together every ounce contained in the town, and committed it to one common bonfire.

A *Boston Gazette* article on the Lexington tea burning. *American Antiquarian Society.*

disguised as Mohawks dumped the crates of tea overboard on the evening of December 16. The event produced shock waves on both sides of the Atlantic. Unlike Lexington's tea destruction, this tea had not been paid for. The rapidly deteriorating relationship between Great Britain and its American colonies had suffered an irreparable blow.

Imperial retribution for the Boston Tea Party proved harsher than most Americans anticipated or believed warranted. Ultimately, the punishment's severity eliminated any hopes of reconciliation. On May 10, 1774, Jonas Clarke wrote, "News of the act to block up the harbor."[28] At once he understood its gravity: Parliament's decision to blockade New England's largest port threatened almost everybody's livelihood in and near Boston. Overseas commerce was the region's economic engine. The Boston Port Bill forcibly closed the harbor until the town compensated the East India Company for its losses and King George III felt satisfied that Massachusetts Bay had returned to its proper relation within the empire. Although a few Bostonians wanted to pay for the tea, public sentiment generally opposed doing so. Ultimately, no compensation was offered.

Following news of the blockade, the Boston Committee of Correspondence called a meeting with its counterparts to coordinate a response. Representatives from eight neighboring towns, including Lexington, joined Boston's committee on May 12. Samuel Adams presided.[29] As a result, a subcommittee chaired by Dr. Warren prepared a circular sent via express rider Paul Revere to Whig leaders in other colonies, reminding them that the crisis threatened the liberties of all. The circular letter called for an inter-colonial suspension of trade with Britain.[30] Soon the blockaded port received expressions of sympathy and support from Newport, New York, Philadelphia and other commercial centers, although agreements regarding inter-colonial economic sanctions proved slower in coming.

Three days later, as another consequence of the Tea Party, General Thomas Gage arrived in Boston to become military governor of Massachusetts Bay. At once, Gage moved the seat of government from blockaded Boston to the port town of Salem, where overseas trade continued unimpeded. The civilian governor, Thomas Hutchinson, set out for England in June but expected to return to his seat shortly. Yet even before he embarked, news reached Boston of further legislation to punish the recalcitrant colony. The British called this set of laws collectively the Coercive Acts. These acts, set to take effect in August, quickly became so obnoxious that Americans referred to them as the "Intolerable Acts."

One, the Massachusetts Government Act, continued the process of centralizing power in the governor's office by removing the lower house from any role in appointing the Governor's Council, the upper house of the legislature. Henceforth, the governor possessed the singular power to appoint his council. Even with a council controlled by the governor, the act reduced its powers. It placed solely in the chief executive's hands responsibilities previously shared with the council. Now Thomas Gage could appoint and remove judges and other administrative officers without consulting the council. Additionally, the task of appointing juries fell entirely within the province of the sheriff—a political appointee. Previously, juries had been chosen from lists provided by towns. The Government Act even limited town meetings throughout Massachusetts Bay to one in March—traditionally for the sole purpose of electing officials. In short, the Massachusetts Government Act amounted to a revocation of the 1691 Massachusetts Charter, the document considered the province's constitution. News of this sparked outrage across the province.

Meanwhile, Boston opposition had grown increasingly frustrated with local merchants who continued to import English goods unless every other colony joined the movement. Boston leaders finally acted alone, going so far as to demand that merchants cancel orders placed before the Port Bill's enactment. Spurred by the Coercive Acts, Boston on May 30 instituted a non-consumption agreement, called the Solemn League and Covenant. With recalcitrant merchants continuing to import British goods, Boston consumers enforced a market boycott from the demand side by refusing to patronize their shops. The goal was to bar economic intercourse with Britain until it repealed the Coercive Acts.[31] Boston's Committee of Correspondence communicated its decision throughout the colony while asking towns for support.

Lexington met on June 20 to discuss the matter, and three days later, it agreed to abide by the non-consumption agreement. Jonas Clarke's diary notes, "Meeting about the Covenant not to purchase English goods," although town records include no evidence of this meeting.[32] While country towns agreed with non-consumption's goal, only thirteen joined Lexington in committing to its implementation before September. Sensing mounting resistance to imperial authority, General Gage issued a proclamation condemning the Solemn League and Covenant.[33] Gage's opposition only increased the covenant's popularity.

The General Court's lower house did not cooperate. The House members not only proved unwilling even to consider setting aside funds to pay for the

destroyed tea, but they also rallied their towns to support Boston's defiance. Further, members supported a call for a Continental Congress, an inter-colonial deliberative body, to meet in Philadelphia to coordinate a collective response to the Coercive Acts.[34] When a frustrated General Gage tried to shut down the assembly, now seated in Salem, on June 17, that body locked the door, barring the governor's agent. Shut out, the agent could only post Gage's proclamation on the door, while inside, the assembly designated July 14 as the annual fast day and selected delegates to attend the upcoming Continental Congress set for September 1.

Because Governor Gage feared the Whig clergy's power to galvanize the people in opposing British authority, he had refused to issue a proclamation for the annual fast day. Perhaps because the governor opposed it, the day was most faithfully observed, with little activity in Boston's streets.[35] Brigadier Colonel Lord Hugh Percy had arrived in Boston shortly before the fast. Writing to his father a week later, Percy observed that no group was more "injurious to peace and tranquility of the province than the clergy." They "preached up sedition openly from the pulpits," according to his Lordship, who claimed that ministers only offered communion to those who signed the Solemn League and Covenant.[36] Percy's observation was based chiefly on Boston ministers, but one can only wonder at the influence country ministers had over their congregations.

In the religiously conservative country parishes, a day of fasting, humiliation and prayer would have been strictly observed. Reverend Clarke's notation in his diary reads, "Fast on the times," an indication that the day's focus was on the political crisis at hand.[37] His words have not survived, but the lecture of his stepfather-in-law, Reverend Samuel Cooke, was entitled, "Acts from England." Unlike traditional fast day lectures, Cooke's did not ascribe the current travails to waning piety. "We have not deserved this," he cried out, but his prescription for dealing with the problems echoed familiar themes: to save the colony from "being brought into absolute subjection" required a renewal of faith in God.[38] Israel suffered such trials, he noted, but through faith prevailed.

In June, even before the Coercive Acts took effect, Lexington town meeting instructed its House representative to exercise his influence so that "nothing there may be transacted…in conformity to any of the late Acts by Parliament."[39] In those months, Lexington defied the law, convening town meeting at its pleasure, as did other towns. Some, Boston included, technically observed the restrictions of the Massachusetts Government Act by repeatedly adjourning the March session and continuing it to future dates

to "finish business."[40] Only in Salem, seat of the provincial government, did Gage attempt to enforce the new law by sending two companies of the Fifty-ninth Regiment to prevent a second town meeting from convening. However, ultimately he had to back down.[41] On August 27, the general was warned that his life was in danger. With that threat, he moved his residence back to the safety of Boston and began fortifying Boston Neck.[42] British control of the countryside was rapidly slipping away.

With the Massachusetts Government Act, the very idea of provincial self-government became a mockery. Despite popular conceptions today, taxes alone did not drive events leading to the Revolution. Historian Ray Raphael made a compelling case for the Government Act as an underrated cause. While most heads of household met the property requirements to vote, the new laws severely restricted their vote's influence. Voters still chose local officials but were now severely restricted in public decision-making about anything else. Nor could Lexington's town meeting any longer legally address province-wide concerns. It elected its representative to the General Court, but that body's power was now curtailed. The House had no role in appointing the Governor's Council or appointing or funding judges or sheriffs. Those officials depended solely on the Crown now, as they made critical decisions directly affecting the security of landowners' property. In sum, the oppressive effects of the Massachusetts Government Act touched every home in the province. By doing so, it inflamed the countryside.

Prior to the Coercive Acts, Boston had taken the radical lead in opposing imperial policies. This time, resistance began in the colony's interior. On August 16 in Great Barrington, Berkshire County's shire town, a three-day ride west of Boston, 1,500 unarmed men prevented the county Inferior Court of Common Pleas from opening. It would have been the court's first day under the new Massachusetts Government Act. The court never opened under British law again. And this was a conservative district.[43] In Hampshire Country, another western district, several thousand townspeople prevented the Inferior Court of Common Pleas from opening its session on August 30.[44]

Earlier on August 27, 1774, in centrally located Worcester, fifty miles inland, a peaceful yet determined crowd of 1,500 to 3,000 traveled from surrounding towns to coerce Crown-appointed council members, or mandamus councilors, to resign their posts. Several, including Timothy Paine, eventually did so under duress. One councilor fled his home, while another, away at the time, never returned. The Worcester County Inferior Court of Common Pleas was scheduled to open on September 6, but residents

of Worcester and surrounding towns mobilized to prevent this. With 4,622 militiamen mustered from nearby towns, they peacefully thwarted the judges from taking their positions.[45]

Imperial authority had been effectively driven out of Berkshire and Worcester Counties, never to return.[46] Mandamus councilors in several other towns west and south of Boston felt the ire of local residents seeking their resignations, leaving them to comply or flee their homes. By fall, no mandamus councilor exercised authority outside of Boston. No longer did Boston have to stir its country cousins into action. Rural folk now appeared to be taking the lead.

On September 1, 1774, Reverend and Mrs. Clarke visited Reverend Cooke in Menotomy. Then and on the day following, Clarke recorded dramatic events that could only have intensified General Gage's growing anxieties. "Powder seized," Clarke noted, and on the following day, "mob at Camb[ridge]."[47] Those entries recorded Gage's proactive attempts to block a potential uprising by seizing provincial gunpowder stored at the Powder House in a section of Charlestown (today Somerville). News of British troop movements set off wild rumors that Massachusetts's citizens had been fired on and killed. War had begun! In response, a general rising of twenty thousand to forty thousand armed men from as far away as Worcester converged on Cambridge the following day, only to discover the rumors false. But the outraged farmers' numbers and demeanor intimidated judges and mandamus council members in Cambridge to resign their positions. Several fled across the Charles River to the safety of Boston. Meanwhile, throughout August, local residents in western and central Massachusetts continued to terrorize newly appointed officials, effectively foreclosing any semblance of imperial government there.[48] General Gage, who had earlier promised troops in Worcester to aid opening the courts, wisely decided against it. At this point, Reverend Clarke understood, as General Gage certainly did, that events were gaining a momentum all but impossible to reverse.

Spurred by the central and western counties' resistance, county conventions across the province voted to defy the Coercive Acts and close the courts, although British troops in Boston kept courts open there. Dr. Joseph Warren urged Samuel Adams in a letter to persuade the Continental Congress to oppose the Massachusetts Government Act.[49] Then the doctor dispatched courier Paul Revere on a six-day mission to deliver the Suffolk County Resolves to the Continental Congress meeting in Philadelphia. Along

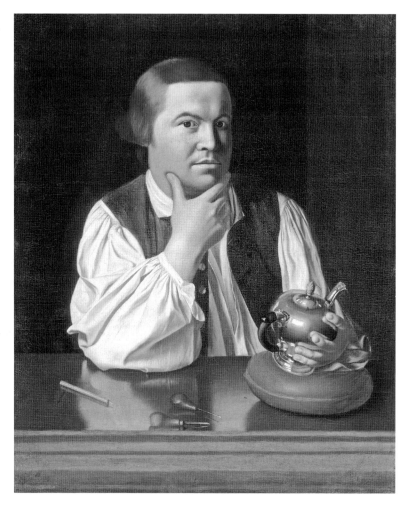

Paul Revere, 1768, by John Singleton Copley. *Museum of Fine Arts, Boston.*

with promising to boycott British goods, these resolves vowed to refuse tax payments to Britain and to support a Massachusetts government outside imperial authority until the Government Act's repeal. Revere arrived in Philadelphia on September 16.[50] Soon after, the Congress pledged support for the resolves.

Meanwhile, General Gage tried his best to avoid violent conflict. But earlier in 1774, while on a sabbatical in England, he had boasted to the king that he could subdue Massachusetts rebels with a mere four regiments. Now the general understood how mistaken he had been. His army of three thousand was confined to Boston, a peninsula connected to the mainland

by one slim, fortified neck of land. The surrounding countryside, the most densely populated in North America, had become increasingly hostile. Gage's reports to Lord Dartmouth, his immediate superior in England, voiced ever more alarm. The general recommended an overwhelming force be sent to awe the countryside into submission. Absent this force, the only alternative seemed to be to calm the public's angry mood with the Coercive Acts' suspension. His present army was too small to intimidate the opposition yet too large not to provoke it.[51] In a private letter dated November 2 to his longtime friend Lord Barrington, secretary of war, a position subordinate to Dartmouth, an exasperated Gage wrote, "If you think ten thousand men sufficient, send twenty, if one million is thought enough, give two; you will save both blood and treasure in the end."[52]

Such talk convinced the British ministry that the apprehensive Gage showed disturbing signs of weakness, seemingly cowed by mere country rabble who surely would scatter at the sound of musket fire. Had not Gage himself said the same to the king? Dartmouth recommended that the general arrest two or three Whig leaders, but Gage understood that the local leadership did not reside with a few at the top. Arresting two or three—Hancock, Adams, Warren—would only make them martyrs, while creating new leaders and setting off armed hostilities.[53] Further compounding Gage's dilemma, penned up in Boston, he commanded an army that also considered him weak because he treated the locals with fairness and respect.

Salem's tenure as the seat of government all but ended once Gage dissolved the General Court on June 17. Without its colonial legislature, Massachusetts had been relying on town meetings, county conventions and Committees of Correspondence for direction. On the day of the powder alarm, Gage issued writs for the House's next session in October. But he had to rescind those orders in the face of the country folk's outraged response to the seizure of their powder. Despite the cancelation, town meetings elected delegates to attend the General Court's assembly at Salem on October 5. When the governor failed to appear, the assembly reconstituted itself into a Provincial Congress, elected John Hancock its president and prepared to conduct business as the sovereign government of Massachusetts. It then adjourned to Concord to hold sessions in the courthouse there, beginning on October 11.

On September 15, Reverend Clarke noted militia drilling on the Common—"Showing arms"—as Lexington's daily life began to take on a more martial aspect. Captain Thaddeus Bowman led a poorly equipped and relatively inexperienced collection of would-be soldiers. On October

5, the day Gage failed to open the legislature's session in Salem, Clarke in Lexington wrote, "Training."[54] Even though the same notation can be found in October and November of preceding years, this one was freighted with meaning. Traditionally, New England militia trained four times a year, but directives from the Provincial Congress had increased the sessions' frequency.[55] Rather than defusing the rebellion, the seizure of provincial stores at the Charlestown powder house had driven the countryside to a more aggressive posture. During these clamorous times, Reverend Clarke provided a steadying influence in a parish that could see events trending in a direction unthinkable a year earlier.

On their way to the Provincial Congress in Concord, Dr. Joseph Warren and John Hancock stopped at Reverend Clarke's. Because their visit coincided with the local ministers' association meeting in Lexington, the day must have been a busy one.[56] Whether Clarke's meeting with Hancock and Warren included other ministers and what they talked about can only be conjectured. But the occasion presented a splendid opportunity for Whig leaders and members of the "black regiment" to share information. Clarke could apprise Warren and Hancock of local intelligence while learning of the Boston leaders' plans. Although the Provincial Congress after its first meeting removed briefly to Cambridge, it returned to Concord, where it met through the critical spring of the following year.

Now the de facto governing body of Massachusetts, the Provincial Congress recognized that it operated outside the law. Nevertheless, the Congress appointed a nine-man Committee of Safety, including three representatives from Boston, to summon and supervise town militias if circumstances warranted. Two of Boston's members were Clarke's October visitors, Hancock and Warren. It also appointed a Committee of Supply to procure military and other supplies for an army. Before adjourning on October 29, 1774, the Congress made several decisions regarding town militias and disseminated excerpts of its resolutions for towns to follow. Lexington devoted several subsequent meetings to these directives "to see what method the town will take to encourage Military Discipline and put them in a position of defense against their enemies."[57] The town now openly regarded General Gage and his army as "enemies."

The Provincial Congress directed that town's selectmen make sure their militia "be properly and effectually armed and equipped."[58] In response, Lexington devoted a November town meeting, continuing into December, to discuss its defenses. Ultimately, it voted to add two barrels of powder to its

stock, along with a "sufficiency of ball" and flint. It also decided to procure and mount two small cannons from Watertown and to purchase two drums. Ominously, town meeting voted to purchase a carriage, to be housed in the base of the freestanding belfry beside the meetinghouse, to transport the dead to the parish burial ground. To fund these extraordinary expenses, town meeting voted an additional tax totaling forty pounds—equal to one-half Jonas Clarke's yearly salary.

The Provincial Congress called for militias to "perfect themselves in military skill." On December 12, the militia was scheduled to meet, along with town meeting, but snow limited the turnout. Accordingly, the militia drill was rescheduled to December 28, when "the training bande & alarm liste men [will] appear at the Meeting house…for viewing arms & ammunition."[59] Typically on those occasions, Reverend Clarke attended to offer words of encouragement and inspiration. Militia sermons drew largely on Old Testament texts that illustrated principled opposition to oppressive authority. With the possibility of conflict mounting, these sermons became ever more strident, with many ministers exhorting their flock to resist the king's hated standing army outright.[60]

Lexington deferred one Provincial Congress directive until February, when the town militia elected new officers. John Parker, forty-five-year-old wheelwright, woodworker and likely French and Indian War veteran, replaced Captain Thaddeus Bowman as captain of Lexington's single large company.[61] Some towns had replaced officers who held Loyalist sympathies, but Bowman's politics accorded with the town. In fact, he served on the committee to draft a response to the Stamp Act in 1765 and was part of Lexington's Committee of Correspondence in 1772. Perhaps, at sixty-two, he did not appear to be the appropriate choice to lead a company into battle. Or perhaps he voluntarily relinquished his post without prodding after the Provincial Congress directive. In any case, such elections were the business of the militia to conduct.

Captain John Parker was large boned, with a long face and an intellectually engaged mind. His family included a wife and seven children—four girls and three boys. Sadly, Parker would be dead by September due to tuberculosis, a malady common in his family. His famous grandson Theodore Parker succumbed to the same disease. John Parker often availed himself of Reverend Clarke's library, for he loved to read, and in the process, he likely fell under Clarke's political sway. Parker subscribed to the Whig *Boston Gazette*. One of Clarke's sons later recollected that the Parkers and Clarkes were quite close despite the Parker family living several miles from the parsonage.[62]

The Provincial Congress ordered each town to separate "1/4 of its company, at least…into companies of 50 privates, at least, who shall equip and hold themselves in readiness to march at the shortest notice."[63] These smaller, younger and more mobile units became known as minutemen companies. But Lexington never created such a unit from its one company, maybe because of its militia's small size of 160. Or perhaps the town lacked direction to do so from regimental command. In December, Lexington had decided to issue bayonets to half the militia, perhaps an indication that it planned to form a minutemen unit pending orders that never came.[64] Town meeting referred to the company as a training band, the traditional Puritan name, and members themselves took that name or often referred to themselves simply as militia.

In keeping with the Continental Congress resolution, a December town meeting also voted to suspend commerce with Britain completely. The Continental Association, as the Congress's resolve was called, professed an abiding loyalty to the king with a continued desire to remain in the empire, but only under conditions existing at the French and Indian War's end. Because Lexington had already endorsed Boston's earlier Solemn League and Covenant, it hardly needed to endorse the Continental Association. It appears, however, that the town had yet to select a committee to enforce the Solemn League, as the Congress had recommended. In its boycott resolution, the Continental Congress included an enforcement mechanism called a Committee of Inspections. Accordingly, Lexington appointed "to see that the plans of the Continental ande Provincial Congresses are carried into executione [*sic*]."

On December 13, Paul Revere began a sixty-mile express ride to Portsmouth, New Hampshire, over roads still covered with snow, ice and slush. Boston Whigs believed that a plan was afoot to reroute a British ship to Portsmouth to take possession of munitions at Fort William, so once again Revere provided courier service, this time to warn allies to remove the one hundred barrels of powder from the poorly defended fort. This they did with little resistance from the six Regulars guarding the fort. The British ship purportedly heading toward Portsmouth proved instead to be bound for Boston. News of Revere's ride led the authorities to direct a ship to Portsmouth anyway, although too late to secure the powder.

Town records note that at the December meetings in Lexington, "Mr. Moses Harrington appeared & protested against the proceedings of the above Meeting."[65] The records do not explain the nature of Harrington's protest

or furnish evidence of his dissenting opinion in any other form. Recent town meeting decisions would have certainly tested the patience of any citizen loyal to the Crown, but the numerous Harrington clan served the American cause faithfully, including a son, Moses, who—along with twelve other Harringtons—became a member of Captain Parker's militia company.

Politics may not have entered Moses Harrington's objections. Like many poorer farming towns, Lexington seems to have had no authentic Loyalists to contend with. Town gentry's standard of living did not depart significantly from the rest of the population, its pew assignments and higher civic offices notwithstanding. Gentry and freeholder both earned their living off the land and thus shared similar economic interests. Even so, the role of Reverend Clarke and his predecessor, Reverend Hancock, cannot be underestimated in preserving town unity. Doctrinal divisions carried the potential to create long-festering animosities that could erupt during political crises. Reverend Clarke's influence in uniting his town as Whig did not emanate solely, or even mostly, from the pulpit; pastoral visits and other personal interactions with parishioners surely played their part. As Lexington entered the fateful spring of 1775, it did so with a unanimity instilled largely by its dynamic minister.

PRESENT AT THE CREATION

During the winter of 1774–75, donations of money, food and firewood poured into Boston from Massachusetts's towns and from colonies as far away as South Carolina, which sent large quantities of rice.[1] Even so, with its port closed and its residents largely jobless, Bostonians suffered from hunger and cold, especially the poor. That December, Lexington town meeting voted to offer help. The *Boston Gazette* reported on January 10, 1775, that cash and "sixty-one loads of wood" arrived from Lexington, a sizable contribution from a town of no more than 750 inhabitants.[2] To encourage such generosity, Reverend Jonas Clarke had donated his entire yearly twenty-cord wood allotment to help warm Boston through the harsh New England winter.[3] Stories filled the newspapers throughout the winter months that bore testimony to a kindness and collective responsibility knitting the colonies more closely together. Relieving the besieged city took on political as well as humanitarian urgency. Boston had to survive the Port Act's strangulations and resist British demands to pay for the destroyed tea and, above all, must not be forced to submit to unjust authority. The fate of the resistance depended on it.

Throughout that winter, General Thomas Gage, a Massachusetts military governor reduced to effective control of only the peninsula on which Boston sat, continued to receive reports of armed militia training in the countryside. Gage remained determined to defuse possible conflicts by confiscating colonial arms and materiel. "The Regulars attempt to seize

some Cannon at Salem, but are frustrated," wrote Jonas Clarke on February 26, 1775, a Sabbath day.[4] This attempt led to a tense standoff, one that came dangerously close to exploding into violence, between nervous Regulars intent on searching for cannons and indignant Salem citizens determined to stop them. Instead, Reverend Thomas Barnard, Salem's minister, mediated between British lieutenant colonel Alexander Leslie and the Salem authorities to constrict any search for cannons to a limited area. Accordingly, both sides saved face—and likely lives.[5]

Gage remained wary. The turnout of country people responding to September's Powder Alarm had revealed an impressive number of New Englanders willing to take up arms. The Provincial Congress sitting outside Boston, through its Committee of Safety and Committee of Supply, directed the accumulation of arms, munitions, medical supplies and food stores. On December 12, 1774, 400 Royal Marines arrived aboard the warships *Asia* and *Boyne* in Boston, bringing Gage's strength to 3,500 men—hardly a match for the 20,000 to 40,000 colonials capable of mustering in the countryside.[6] Gage understood that his forces stood woefully outnumbered. With little prospect of a significant troop increase, he tried to thwart his antagonists' military preparations. Within striking distance of Boston, two shire towns, or county seats—Worcester and Concord—served as repositories for the collection of colonial military supplies. In late August, Gage considered sending troops to Worcester to wrest authority from the Whig resistance. The massive rising of farmers in September had dissuaded the general from this tactical venture, but now he reconsidered.

In early March, Gage sent Captain John Brown and Ensign Henry de Berniere, a skilled artist, to map the route. Brown took his soldier manservant with him. The trio dressed as country people in brown shirts, with red bandanas around their necks and broad-brimmed hats. But they told whoever asked that they were surveyors studying road conditions. The apparent disconnect between their country clothes and their given educated station raised suspicions. Also, their inept attempts to travel incognito among the people resulted in, according to historian David Hackett Fischer, "a bizarre cultural collision between Britain's imperial elite and New England cultural folkways."[7] But although they fooled no one, the "undercover" scouts managed to complete their mission. Their report convinced Gage that terrain and distance rendered any military strike in Worcester out of the question.

In mid-March, the pair set out again "disguised" to map the road to Concord. And once again they fooled no one, although they managed to

return to Boston unmolested. The Concord route they recommended lay through Lexington's center. Communications from London, meanwhile, urged General Gage to be bold. The general determined to ease pressure from home and in Massachusetts by sending troops on a surprise raid to Concord to destroy colonial military stores and artillery collected there.

Until 1775, Colonial Secretary Lord Dartmouth had left tactical questions to leadership on the ground in Massachusetts Bay. But the British ministry's frustrations over America's continued recalcitrance led to some prodding. On January 27, 1775, Dartmouth wrote instructions for Gage's eyes only. Among other things, his dispatch relayed Britain's solicitor general's opinion that Massachusetts acted in open rebellion by virtue of its having illegally convened the Provincial Congress to replace the General Court and by that Congress's collecting taxes. Consequently, General Gage (ever conscious of the limits of the law) was legally sanctioned to impose martial law and arrest the "actors and abettors in the Provincial Congress."

Dartmouth promised reinforcements already en route from England and other parts of North America, eventually bringing Gage's command to more than four thousand men. Lord Dartmouth still left tactics to Gage's discretion but urged the cautious general to "take a more active and determined part" in quelling the incipient rebellion.[8] Of particular significance, he notified Gage that Major Generals William Howe, Henry Clinton and John Burgoyne were headed for Boston to "assist."[9] By now, General Gage surely realized that the competence of his civil administration and military command was being called into question back home. Although written in January, Dartmouth's letter did not reach the general until April 14, delayed because the cabinet awaited assurances from the House of Commons and because of the time required crossing the Atlantic.[10]

Of Gage's previous three attempts to seize munitions outside Boston, two had failed. Secrecy, the key to success, would be more difficult to maintain on the road to Concord. The general himself became part of the problem. Starting in March, he sent troops on maneuvers up to eight miles into the countryside to exercise them and to accustom the locals to soldiers moving about. But the redcoats' maneuvers caused great consternation among rural inhabitants, who complained about trampled fields and overturned fences. A Second Provincial Congress convened in Cambridge on February 1, but due to its proximity to British maneuvers, it adjourned to Concord. Reassembling on March 22, the Congress established an alarm system of two couriers each in Cambridge, Roxbury and Charlestown, with instructions to observe "when

sallies are made from the army at night" and "send couriers forward" to alert the countryside, especially towns storing arms and supplies.[11] Lieutenant John Barker of the King's Own Regiment observed the system firsthand on March 30 as "the 1st brigade marched into the Country at 6 o'clock in the morning." He reported, "Expresses were sent to every town near."[12] The alarm system would soon be put to momentous use.

The intelligence that General Gage received from his own spy network in Concord helped him plot a course of action. Missives from two well-placed sources regularly reported on the munitions caches' locations and on Provincial Congress deliberations. One even suggested that a night expedition to seize the munitions might win over wavering representatives. This spy likely was the Whig leader Dr. Benjamin Church, who served as a Provincial Congress representative and member of the Committee of Safety. The other acquired his knowledge of the munitions' locations perhaps via residence in Concord. He wrote his secret dispatches in French, no doubt as a cipher.[13]

Four brass cannons stolen from the Boston Artillery Company on September 16 became one British target in Concord. Local tradition eventually places the fieldpieces hidden at Colonel James Barrett's farm.[14] Gage benefited from information regarding dissensions in the Provincial Congress, about members' "irresolution" and divisions over raising an army before other New England colonies. On April 11, Gage learned from his Congressional source that a sudden blow might prove decisive.[15] Shortly thereafter, on April 14, Dartmouth's secret orders dated January 27 arrived, the very day the general's intelligence told him precisely the munitions' location in Concord.

The following morning, Gage removed his light infantry and grenadiers from regular duties under the pretext of learning new "exercises and new evolutions." Even Lieutenant John Barker of the Tenth Foot understood that to be "a blind" and remained certain that Gage had "something for them to do."[16] At last, on April 18, intelligence informed the general that although some rebel munitions and stores had been moved to nearby Leicester, significant amounts remained in Concord. Gage's other informer reported that the governing body had recessed and members left the village.[17] Lord Dartmouth had suggested opposition leaders be arrested, but Gage focused on weapons, munitions and food supplies, convinced that arresting Whig leaders would only inflame an already combustible situation.

Ten days before Dartmouth's January 27 instructions reached Boston on April 14, Gage had begun preparing his covert military expedition into Concord. On April 5, he had ordered Admiral Samuel Graves to prepare

his long boats to transport troops across the Charles River to Cambridge. Graves did so, but not without awakening colonial suspicions. With the port closed, idle Bostonians had little to do beyond observing the British garrison's movements. Local military preparations, including British scouts visibly inspecting roads to Concord, concerned Whig leaders enough for them to dispatch Paul Revere to Concord on April 8 to warn that a military expedition appeared imminent.

On April 16, Revere once again rode express, this time to the Clarke parsonage to meet with Samuel Adams and John Hancock.[18] Although it was Sunday, Parson Clarke would hardly have reproved the courier for traveling on the Sabbath. That it happened to be Easter mattered little, since Congregationalists regarded that religious occasion in the same light as Christmas, as a popish innovation. Revere brought news of military preparations back in Boston that suggested a march into the countryside. John Hancock, Clarke's guest and chairman of the Committee of Safety as well as president of the Provincial Congress, sent word for Concord to move its munitions and stores.

The Second Provincial Congress's sessions in Concord involved as many as two hundred representatives, who met in the courthouse. This shire town held court sessions periodically and therefore provided better accommodations than most towns could afford. Yet finding lodging for two hundred representatives challenged even Concord. For that reason—and his kinship to the Clarke family—the president of the Congress, John Hancock, and his fellow opposition leader, Samuel Adams, boarded at Reverend Jonas Clarke's house in Lexington beginning as early as March 30, a week after the Congress moved to Concord.[19] Their lodgings would have required a seven-mile commute to Concord's courthouse. But Adams and Hancock welcomed the relative safety of the parsonage.

With tensions rising and British troop strength growing, many Boston residents with Whig sympathies left for the country. General Gage found it increasingly difficult to maintain good relations between his soldiers and the town's discontented inhabitants, many unemployed due to the port's closing. From the redcoats' arrival, frustrated Bostonians had showered verbal abuse and withheld amenities from the redcoats. "We expected to have been in the barracks by this time, but the sons of Liberty have done every thing in their power to prevent our accommodation," wrote Captain W. Granville Evelyn to his father in October 1774.[20] Many resorted to drink, gladly supplied by Boston residents. Welsh Fusilier lieutenant Frederick Mackenzie recorded in his diary that the occupying army, out of boredom and with

alcohol available "at so cheap a rate," was "intoxicated daily."[21] The already alarming desertion rate among the British garrison accelerated.

Deadly smallpox had arrived during the winter, with mostly Americans affected, British natives in general having acquired a greater tolerance. Passage in and out of Boston had become increasingly difficult under the vigilant eye of Regulars manning the fort on Boston Neck.[22] Nevertheless, a stream of people laden with belongings left Boston each day. Only Loyalists preferred the armed British camp that the town had become, since only under the soldiers' protection did they feel safe.

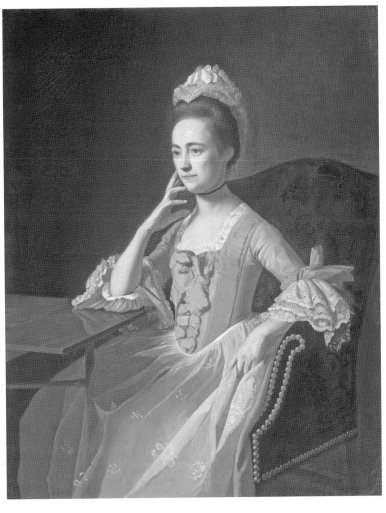

Dorothy Quincy, 1772, by John Singleton Copley. *Museum of Fine Arts, Boston.*

Because John Hancock had remained in Boston, rumors concerning his imminent arrest proliferated. Once he finally set out from his Beacon Street mansion to attend the Second Provincial Congress in Concord, he would not return to Boston until March 1776. With Hancock away, unruly British Regulars tore down his fence and broke windows in his house. But the scrupulous General Gage ordered the damage repaired.[23] Edmund Quincy, father of John Hancock's fiancée, Dorothy, worried about the safety of Whig sympathizers in Boston. When Lydia Hancock urged Dorothy to accompany her to be with John in Lexington, her father readily assented. John Hancock's Aunt Lydia and Dorothy arrived at the Clarke parsonage on April 7.[24]

So difficult was the situation for Whig sympathizers in Boston that the Provincial Congress feared residents might become hostages.[25] For his part, General Gage refused to arrest anyone for political reasons. Yet Lord Dartmouth's secret instructions forwarded the opinion of the attorney general and solicitor general of Great Britain that Massachusetts Bay was in rebellion. Fearing arrest, most of the Whig leadership had left Boston by the night of April 18. Of their number, only the intrepid Dr. Joseph Warren remained in the besieged port town.

Doubtless Jonas Clarke joined the April 16 meeting between Hancock and Adams after Revere broke the Sabbath with a ride to Lexington. The courier brought news of British troop movement in Boston, apparently in preparation for an expedition, and Reverend Clarke knew the mood and readiness of Lexington residents and those in nearby villages. He also possessed a political acumen that Whig leaders had learned to respect. As a practical matter, his parsonage stood near the Concord Road. Troops marching from Boston had to pass through the heart of Lexington along that very road, literally only yards away from the sleeping minister's guests. General Gage's written directions specifically ordered weapons, munitions and supplies destroyed in Concord. Special attention was paid to the brass cannons that Whigs had stolen from Boston Common. But colonials—including Warren, Dawes and Paul Revere—remained convinced that British orders included arresting Adams and Hancock. According to Revere's earliest accounts, Dr. Warren told him to relay to Hancock and Adams that the British mission's purpose was "to take them, Mess. Adams and Hancock or go to Concord to destroy the Colony Stores." Revere's last account, dated 1798, contains this warning from Dr. Warren.[26]

The two Whig leaders returning to the parsonage after their day's deliberations at the Provincial Congress found a village minister eager for news. The Congress agreed to keep its debates and resolutions secret once adjourning to Concord.[27] Regardless, Hancock and Adams could count on Clarke to understand the need for discretion. From his guests the parson must have learned a great deal. During their Concord sessions, the Provincial Congress discussed the conditions under which the militia would be mobilized; addressed the persistent complaints of British troops marching through fields, destroying walls and fences; and dealt with dissent, with some members clamoring for war while the more moderate urged restraint until other colonies joined the cause.[28]

Although the Clarkes frequently entertained overnight guests, boarding four additional adults over an extended period must have taxed the family's resources as well as Lucy's energy. Hancock and Adams shared a bed in the downstairs guest room facing the Common, today called the Hancock Adams Room. Dorothy Quincy and Lydia Hancock shared the upstairs southwest chamber, today the Dorothy Quincy Room. The other children crowded into the remaining space upstairs under the eaves. The Clarkes' two oldest girls, Mary (about to turn thirteen) and Betty (almost twelve), helped their mother with cooking and cleaning. At the time, the family included ten Clarke children, ranging in age from Thomas at fifteen to five-month-old Sarah. Nine resided at the parsonage, with Thomas in Boston apprenticed to his uncle Nicholas Bowes's bookstore. Even with the parsonage filled to capacity, more guests visited during the day.[29] Reverend Jonas Clarke's home had become Lexington's nerve center, both as a refuge and as headquarters.

On April 15, Reverend Dr. Samuel Cooper and his wife dined at the Clarke house. The Brattle Street minister did not intend to stay away from Boston long. According to a diary entry he wrote before leaving, Dr. Cooper planned no more than a brief country sojourn "for the Recruiting of my Health." His daughter remained in the city, hardly an indication that he intended a lengthy absence. But like Hancock and Adams, Cooper would not return to Boston until March 1776, when the British evacuated the port city once and for all. The busy Clarke household resonated with political conversation, made livelier by information that Dr. Cooper shared from his recent travels in the countryside. With boarders Adams and Hancock and members of Cooper's congregation in Boston also present, it must have been an interesting night. The following day, Dr. Cooper preached in Sudbury.[30]

Deacon Thomas Barrett, a member of the Concord Committee of Correspondence, and his daughter visited Reverend Clarke on April 17. The

sixty-eight-year-old Barrett's younger brother, Colonel James Barrett of the Middlesex Regiment, was responsible for hiding the weapons, munitions and food stores in Concord. Reverend Clarke perhaps became acquainted with the Barretts when he sent grains to be milled in Concord. James Barrett's large farm had a mill. With the countryside on alert, discussion surely turned to the stores and munitions in Concord. Although some had been moved to Leicester, most of the supplies remained in Concord. Two days later, in Concord, British soldiers would threaten James Barrett with death when he protested the Regulars' rough treatment of town residents.[31]

Under cover of darkness on Tuesday evening, April 18, 1775, General Gage set his plan in motion. Jonas Clarke noted a "fine rain" for the day, but the sky had cleared by this time.[32] Gage gave the command to Colonel Francis Smith, who was ordered to march eight hundred Regulars to Concord undetected—in retrospect, a dubious prospect. To intercept rebel express riders sent ahead to alert the countryside, British patrols had been deployed that afternoon along the principal country roads. Memories of Salem remained vivid, and Gage did not want a hostile populace standing between his troops and their destination. The general's written orders to Colonel Smith, who commanded a force of grenadiers and light infantry drawn from eleven regiments, detailed how the munitions and supplies were to be destroyed: "The Powder and flower must be shook out of the Barrels into the River, the Tents burnt, Pork or Beef destroyed in the best way you can devise."[33]

As seventeen-year-old Solomon Brown rode home to Lexington from the Boston market early that evening, he fell in with "nine British officers on the road, travelling leisurely, sometimes before and sometimes behind him." Although they meant to conceal their uniforms under great coats, a stiff wind exposed their red color and revealed their identity. Taking note, Brown galloped straight to Lexington's Munroe Tavern along the Concord Road (today Massachusetts Avenue), where he reported to proprietor William Munroe, who happened to be the militia's orderly sergeant. Munroe immediately "supposed they had some design upon Hancock and Adams." Accordingly, he hurried to the village center and at about seven o'clock deployed eight men as a guard around Clarke's house.[34] In his own narrative, written a year later, Jonas Clarke wrote that "eight or nine of the King's troops were seen, just before night, passing the road toward Lexington, in a musing, contemplative posture; and it was suspected that they were out upon some evil design."[35]

That same British patrol had continued along the Concord Road into Lexington center. Along the way, about a half mile before the Common, eighteen-year-old Rhoda Mead and her mother cooked dinner for her father and two brothers, ages sixteen and fourteen, expected home soon. Town tradition has it that to Rhoda's shock, three British Regulars stopped outside, dismounted and entered the Mead household, where they helped themselves to brown bread and baked beans still in the oven. The soldiers had not eaten since receiving Gage's orders earlier that day.[36] Having appropriated a portion of the Mead family dinner, they remounted and resumed their advance through the center. By nine o'clock, after news of the patrol had circulated through town, about forty militiamen had gathered at Buckman Tavern near the Common.[37]

Jonas Clarke's narrative does not recount his movements or those of his guests outside the parsonage. But his home lay so near the Common that Reverend Clarke, along with Hancock and Adams, surely joined the gathering near Buckman Tavern.[38] After some consultation, Nathan Munroe and Benjamin Tidd were dispatched to neighboring Bedford with news of the patrols.[39] Solomon Brown, Elijah Sanderson and Jonathan Loring were directed to follow the British soldiers, who appeared headed for Concord, as—in Clarke's words—it was "thought expedient to watch their motions."[40] When Solomon Brown objected that his horse had been traveling all day, Brown family tradition relates that "minister Clark replied to him that he would be provided for, and soon led out his own horse saddled and bridled for his use."[41] Horses were found for the other two riders, who also left in pursuit.

With a British patrol having passed through town and a guard posted around his house, Clarke and his guests returned to the parsonage to calm an increasingly anxious household and to prepare for an abbreviated night's sleep. The minister feared for his guests, worrying that "under the cover of darkness, sudden arrest, if not assassination, might be attempted."[42] Munroe's sentries kept vigil while some within the house tried to sleep.

Dr. Warren sent for Paul Revere at ten o'clock that night and informed the courier that William Dawes had already departed. Dawes needed to pass the British watch at Boston Neck to ride the longer, overland route to Lexington. Revere headed toward the same destination, but along the more direct route that the British soldiers would soon follow, overland from the Charlestown side of the Charles River. Revere understood that he needed to inform John Hancock and Samuel Adams in Lexington that the British intended "to take

them, or to go to Concord to destroy the Colony Stores."[43] Both Dawes and Revere carried the same message in case one was intercepted. Paul Revere had earlier arranged for lighted lanterns to be hung in the belfry of Christ Church in Boston's North End, the tallest steeple in town, to signal the direction and time the soldiers left Boston. Later, in his third account of the famous ride in a letter to Jeremy Belknap in 1798, Revere remembered wondering whether he or Dawes would even make it out of Boston, "for we were aprehensive it would be dificult to Cross the Charles River, or git over Boston neck." In that event, the lanterns would alert back-up riders waiting in Charlestown.[44]

Revere did get out safely. After rowing across the river to Charlestown, he borrowed a swift horse from Deacon Larkin and set off in a dash westward. The risks of running into Gage's patrols required the courier to take a more circuitous route than planned. Around eleven o'clock, he encountered two British officers, but having "set off on a very good Horse," he spurred the steed to elude them and proceeded through today's Medford via a detour along the Mystic Road. In North Cambridge, he took the Concord Road on to Menotomy (today's Arlington) and then on to the center of Lexington around midnight.[45] Having been there before, Revere rode straight to the parsonage.

His horse's hoof beats and the courier's shouting broke the stillness of the night. Sergeant Munroe and his sentries guarding the parsonage, maintaining quiet so that family and guests inside might sleep, commanded Revere to halt and be silent. "Noise!" Revere called out to the sentries. "You'll have noise enough before long. The regulars are coming out!"[46] Clarke from his upstairs window could not identify Revere in the darkness. But Hancock and Adams downstairs both recognized the courier immediately. Assuredly, they "weren't afraid of him."[47]

Having received Dr. Warren's message, Dorothy Quincy recollected, "Mr. Hancock gave the alarm immediately and the bell rung all night."[48] At that point, the alarm system, established earlier by the Provincial Congress, set about rousing the entire countryside with bells and signal guns. A half hour later, bearing the same message, Dawes arrived. Warren's message estimated that 1,200 to 1,500 of the king's troops had left Boston, a force far too large, the group agreed, for a mission to simply arrest a few Whig leaders. Instead, Clarke later wrote in his narrative of the events, it was "shrewdly suspected" that the troops "were ordered to seize and destroy the stores, belonging to the colony, then deposited at Concord."[49] The group in the parsonage determined that Hancock and Adams must nevertheless be moved at once to

safety, despite Hancock's reluctance to exit the center of action.[50] Meanwhile, Revere and Dawes set out for Concord.

By two o'clock that morning, some 120 of Lexington's militia had assembled near Buckman Tavern adjacent to the Common, with Captain John Parker at their head. Poor health and the day's excitement had disturbed his sleep that night. His tubercular symptoms had reached a difficult stage, since he died only five months later.[51] The forty-five-year-old wheelwright dispatched scouts east to determine the location and strength of the British force. Now he mustered his men on the Common, and Reverend Clarke as town minister, political leader and wise elder was no doubt present to offer a few inspirational words. While no sermon exists, ministers normally offered militia muster sermons even in times of peace.[52] Hancock and Adams would have found it difficult to resist following Revere and Dawes to Buckman Tavern to learn as much as they could in what historian David Hackett Fischer describes as an "an impromptu town meeting in open air," alongside Captain Parker and the militia on the Common.[53] The purpose of the gathering, as both Clarke and Parker later wrote, was "to determine what to do" in light of the information just received.[54]

Some historians have suggested that at this time Samuel Adams instructed Parker's company to make a stand but not to fire, hoping to draw the Regulars into a precipitous action. Author Arthur Tourtellot included Jonas Clarke with Adams in this planned provocation, since the parson understood

The second meetinghouse, built in 1713. *Lexington Historical Society.*

and strongly influenced his parish. No evidence exists of such a plot, but some questions persist regarding the reason the company decided to parade on the Common as the Regulars approached.[55]

Meanwhile, Revere and Dawes had set out before one o'clock in the morning on the seven-mile journey to Concord, before the militia assembled around two o'clock. Along the way, the two riders encountered Dr. Samuel Prescott of Concord. The physician was returning at that late hour from a visit with Miss Lydia Mulliken at her home in Lexington along the Concord road. Prescott represented himself as a high "Son of Liberty" and at once determined to join the express riders in seeing their message safely delivered. He reminded Revere and Dawes that he enjoyed the advantage of knowing the people of Concord, and his presence meant that the townsfolk would "give the more credit to what we said."[56] As it turned out, only Prescott made it all the way to Concord.

About two miles from Lexington center, the riders crossed the Lincoln line. There, near the Nelson homestead, Revere, Dawes and Prescott ran into the ill-disguised patrol that had earlier initiated the night's alarms when passing through Lexington. Under Major Edward Mitchell, the Regulars had already taken prisoners: Solomon Brown, Elijah Sanderson and Jonathan Loring, who apparently followed the patrol a little too closely. The three were, in Clarke's words, "examined, searched, abused, insulted."[57] Paul Revere, who rode nearest to the British, had noticed six Regulars on horseback in the shadows a bit too late. They caught up with him before his horse could spirit him away, but Dawes escaped into the woods after cleverly giving the impression that he was leading the Regulars into an ambush. Prescott lagged a little behind the other two. This and his superior knowledge of the local terrain allowed him to jump a stone wall and safely deliver the message to Concord.[58] Meanwhile, having detained and questioned Revere, the British soldiers led him and the three younger Lexington men back to the outskirts of Lexington and released them. To Paul Revere's great annoyance, the Regulars confiscated his borrowed horse, leaving him to find his way back to the parsonage on foot.

As dawn approached, Revere arrived to find Adams and Hancock still arguing. Reverend Clarke and Adams urged Hancock to be reasonable, but the merchant Patriot was determined not to "turn his back on these troops." He was cleaning his gun and readying his sword for combat. Adams reminded him that Whig leaders should not be engaged in military operations: "We are in the Cabinet."[59] Revere, newly arrived, added a

critical piece of information. His British captors had asked him the location of "Clarke's Tavern." Since no such place existed, they obviously had the parsonage in mind, as well as the notorious guests inside. Finally, Hancock and Adams agreed to let Sergeant Munroe escort them to Widow Jones's house, the parsonage of Woburn's Second Precinct (today Burlington).[60] Later, the two Whig leaders were warned to flee again, to Amos Wyman's home, even farther into Woburn.

Patriot scouts had been dispatched along various roads to ascertain the Regulars' location, but only one scout had returned between three and four o'clock in the morning after finding no soldiers about. His report led Captain John Parker to question the reliability of Revere and Dawes's message. He dismissed his men, ordering those who lived near the Common to go home but stay within earshot of William Diamond's drum, the call to reassemble.[61] About thirty militiamen retired to Buckman Tavern to wait. Elijah Sanderson, one of the released captives, having had a busy night, dozed by the fireplace, but most of the others found sleep hard to come by.[62]

General Gage had hoped that Colonel Smith's expeditionary force could complete its mission largely under the cover of darkness. The plan went awry, however, for several reasons. The troops were supposed to cross the Charles River at ten o'clock at night, but it took two hours to transport the eight hundred light infantry and grenadiers over to Lechmere Point in Cambridge, where they disembarked from the boats and, through logistical confusion, stood in water before getting to dry land. Once ashore, it took another two hours to form them up to march. The companies belonged to eleven different regiments, requiring time to get them shaped into traditional formation.[63] While they marched, their soaked leather boots shrank, furthering their discomfort. The Regulars had already been made jittery by the unusual amount of activity on their periphery. According to Ensign Jeremy Lister of the Tenth Regiment of Foot, "the Country people began to fire their alarm guns[,] light their Beacons, to raise the Country."[64] Not until five o'clock in the morning did a tired, hungry and anxious British expeditionary force enter Lexington. The sun was peeking over the horizon on this clear, crisp April morning.[65]

Meanwhile, because colonial scouts sent eastward to reconnoiter had been captured, Parker still lacked intelligence regarding the British location along the Concord Road. Then, suddenly at dawn, one scout, the son of former militia captain Thaddeus Bowman, appeared breathless at the Common with startling news that the troops were not a mile away. "So that with all of

the precaution, we had no notice of their approach," wrote Clarke. Parker quickly ordered William Diamond to beat the call to arms. Yet so promptly did the British reach the Common that many men who had earlier gone home did not return in time to join the two lines of militia hastily formed by Sergeant William Munroe. Even as a vanguard of redcoats marched around the meetinghouse at the head of the Common, Lexington militia were still falling into line.

What the colonial forces meant to achieve by their presence has been interpreted differently over time. In 1776, Clarke wrote that Parker's company had assembled on the Common "not with any design of opposing so superior a force, much less of commencing hostilities."[66] The minister expressed that opinion before independence had been declared, while Massachusetts regarded the British army as the aggressor against a harmless rural community. David Hackett Fischer aptly labeled that early period of interpretation one of "injured innocence."[67] Parker's company had probably gathered as a show of force, to convey their resolve to defend their town, presuming that matters would not come to that. Forming their lines at the farthest corner of the green, they may have expected the British to march by along the Concord Road that skirted the Common, leaving the Americans unmolested.

But Colonel Smith rode at the column's rear, with his second in command, Major Pitcairn, in front but behind the six-company vanguard. Smith had detached Pitcairn with six light companies to move at a faster pace, hoping to make up for time lost crossing the Charles River. Ahead of Pitcairn, at the Lexington Common, Lieutenant Jesse Adair, leading the three light companies farthest advanced, decided against following the road left of the meetinghouse and continuing on to Concord without confronting the armed men on the Common. Instead, he bore right, moving around the meetinghouse to confront and disperse Parker's company. Tactically, it made sense—do not leave a hostile armed force at one's rear. Strategically, however, Lieutenant Adair's decision was most unwise.

By now, Reverend Clarke, his family, Lydia Hancock and Dorothy Quincy watched nervously from the parsonage windows as events unfolded before their eyes. For guests and others in his family, the parsonage windows facing the Common afforded an unobstructed view, with only the minister's flat-lying farm between his house lot and the Common. Clarke positioned himself outside, "not more than 70 or 80 rods" from the action.[68] Captain Parker's militia company stood aligned between the parsonage and the

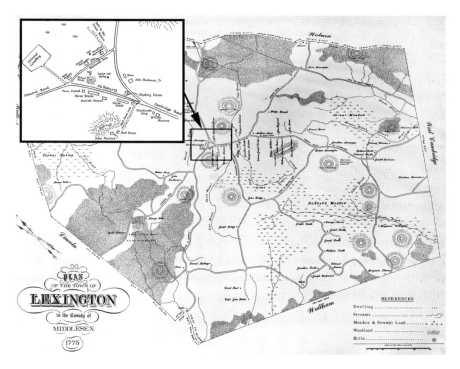

A map of Lexington, 1775, by S. Lawrence Whipple, with the town Common inset.
Lexington Historical Society.

redcoats. Reverend Clarke watched the sea of red approach his parishioners several yards from his meetinghouse, his pulpit and the town powder inside. Thus began a confrontation many dreaded and some desired, the logical outcome to the rhetorical warfare waged in pamphlets, newspapers and pulpits over recent turbulent years.

By the time Lieutenant Adair's force stepped onto the Common, Sergeant Munroe had formed his militia into two lines. Four militiamen remained in the meetinghouse acquiring ammunition, seventy-six provincials stood on the Common and others from several directions headed toward the sound of the drum.[69] The British expedition's second in command, Major Pitcairn, cantered to catch up to Adair's men before events got out of hand. Later, both sides agreed that when the major arrived, he ordered the militia to lay down their arms and leave the Common. Captain Parker steadied his men, but aware of the company's utterly inferior position militarily, he eventually directed the "Militia to disperse."[70] The Americans fell out, Clarke wrote, although some "not so speedily as they might have done."[71] Neither side disputed that the company had begun to disperse, but the fact that they kept

their muskets may have infuriated the British. Most had their backs to the Regulars when a shot rang out. Jonas Parker, Ebenezer Munroe and John Munroe (among others, perhaps) remained and fired. James Brown, once off the Common, along with Solomon Brown, not a militia member, fired from behind a stone wall.[72] Several others also returned fire after having moved off the Common. Who fired that first shot continues to be disputed, with a definitive answer unlikely.

Five days after the skirmish, the Provincial Congress ordered depositions be taken from American participants and witnesses. These were intended to convince critical audiences, such as the Continental Congress in Philadelphia and the British reading public, that Lexington citizens had been victims of British aggression. The sworn statements varied little in detail, some even signed by several men and one by thirty-four of them. All laid the blame on the Regulars; most insisted that a British officer had given the order to fire. In his report to General Gage, Major Pitcairn claimed that the shot came from the Lexington side, from behind a stone wall on his right flank. Other Regulars, in letters and diaries, agreed that the first shot had come from the direction of Buckman Tavern or the nearby stone wall. Reverend Clarke, among others, said that he saw a mounted officer fire "a pistol towards the militia while they were dispersing." To Clarke, there was an inherent "absurdity in the supposition" that Lexington's militia would initiate hostilities, given the obvious mismatch in men and firepower.[73]

Neither side disputes that the adversaries exchanged fire afterward, most coming from the British. Depositions of survivors taken fifty years later, in 1824, added further details. They reported that several militiamen stood their ground and returned fire. In 1776, Clarke wrote indignantly, "[S]o far from firing first upon the king's troops, it appears, that but very few of our people fired at all." He went on to report that because of the "heavy but close fire on our party…Eight were left dead on the ground!" Nine were also wounded.[74] By now, the Regulars had broken ranks to pursue the militia over a stone wall through Clarke's farm. With the Regulars dispersed, Colonel Smith finally arrived from the rear and ordered a drummer to beat the call to fall back into formation. The Regulars then brought forth a cheer of "huzzah" from the British to celebrate their victory, a common military practice but one that offended the Reverend Clarke. He would challenge the appropriateness of celebrating a "conquest" involving "800 disciplined troops" having attacked unprovoked "60 or 70 undisciplined Americans, who neither opposed or molested them."[75] Clarke's righteous indignation was no doubt sincere. But in 1776, he also must have been mindful of the

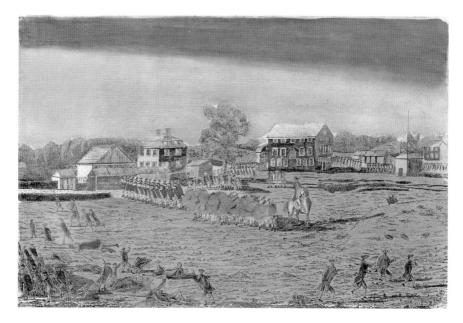

An engraving by Amos Doolittle, *Plate No. 1*, that shows the battle near the second meetinghouse. *Lexington Historical Society.*

need to remind the other colonies, whose representatives sat at the Second Continental Congress in Philadelphia, that the bloodshed resulted from imperial aggression, not the Lexington militia.

From the parsonage, Clarke's family and guests saw the action suddenly turn in their direction once shots rang out. Dorothy Quincy, who stood at the upstairs window facing the Common, remembered that one of the first British shots "whizzed by" Lydia Hancock's head. Another musket ball flew between Mrs. Clarke and thirteen-year-old Mary, her oldest daughter.[76] Upon hearing Parker's order to "get off the green," many militia turned and exited the Common over a stone wall and across the Clarke farm toward the parsonage. British Regulars pursued them with fire in their eyes, some running, with officers on horseback. Only Colonel Smith's late arrival instilled discipline. Dorothy Quincy recollected that two wounded men were carried to the parsonage, one grazed on the head and "more scared than hurt" and the other wounded in the arm.[77]

Years later, Betty Clarke recollected that soon after the battle, Reverend Clarke determined to move his family and remaining guests to safety. Lydia Hancock was in tears, while cool-headed Dorothy Quincy helped the minister hide family valuables in the yard from possible looters if the

Regulars returned. John Hancock's carriage arrived so that his aunt and fiancée could join him and Adams in Woburn. Hancock also requested the salmon that had been cooking when he left so abruptly. Sometime later, Betty recalled that "Grandfather Clarke sent down men with carts" from Hopkinton to get the children, except for Jonas, Betty and the baby Sarah, who remained with their mother and father. Betty likely conflated the hours, and sometimes days, into one sentence.[78] Clarke wrote in the account book portion of his diary that he "sent Mr. Jeremy Stimpson to take Polly, Lucy, Lydia, and Patty to my father's at Hopkinton."[79] Those family members did not return to Lexington until June 17.[80]

The British were largely frustrated in their search for munitions and food stores in Concord. They recovered none of the brass cannons stolen from the Boston Common's gun house in September. They did uncover three iron cannons, destroyed the cannon carriages and disposed of ball, but most military supplies had been moved to other locations within Concord after Revere's earlier alarm of April 7. Regulars destroyed several barrels of flour discovered in various houses and shops. Meanwhile, the alarm system brought militia companies from surrounding towns such as Lincoln, Groton, Carlisle, Acton and Bedford, in addition to the four Concord companies. They had begun gathering on the Punkatasset Hill beyond the Concord River, one mile north of the town center. When Regulars back in the center village lit a bonfire from muskets confiscated from townspeople, the militias on the distant hills assumed the British had set houses on fire. "Will you let them burn the town down?" a Concord officer cried to Colonel James Barrett, in overall command of the Middlesex County forces.[81]

Barrett was a Concord man whose farm had held a large munitions cache. At that moment, his wife was sullenly allowing British detachment to search the farm, but Barrett knew they would find nothing of value since the firearms had been moved. He steadied his angry men to refrain from firing until fired upon, as Captain Parker had done in Lexington. This had been a directive from the Provincial Congress's Committee of Safety. It was a jumpy Regular who fired the first shot, perhaps as a warning, followed in quick succession by a British volley. With that, the militia opened up on three British companies near the North Bridge that awaited the detachment returning from the Barrett farm. The ninety light infantry under attack by four hundred Massachusetts men saw three of their number slain, with several more hobbled with wounds, and quickly understood the numerical

disadvantage. The frightened detachment fled back to the main body in the village. The crisp morning was warming up.

Around noon, General Smith hastily formed up his men and set out on the treacherous fifteen-mile return march to Charlestown. Militiamen from surrounding towns continued to stream into Concord. The parched, hungry, weary British soldiers soon learned that their route to the safety of Boston passed through a gauntlet of Americans firing at them from behind houses, trees, stone walls and any other cover the countryside provided. When the British reached Lincoln, the road turned at an angle near the Nelson House. Captain Parker's re-formed company awaited them to mete out revenge for the earlier carnage in Lexington. That the Lexington company had rejoined the fight after the earlier deadly skirmish showed remarkable courage. Local militia hounded Smith's men all the way back to Lexington.

Early the previous night before the dawn encounter, the activity Colonel Smith had observed in the darkness of Concord Road had alerted him that the element of surprise had been lost. Wisely, he had dispatched a courier to Boston to request reinforcements. After some delay, four regiments of about 1,350 men, under Colonel Earl Percy, left Boston at about nine o'clock that morning. Percy would later report that he marched his troops along the Concord Road through Menotomy and on into Lexington. Before long, Percy's men would confront the sight of Colonel Smith's weary, disheveled force straggling toward them.

Understanding that this battered expedition was "exhausted & fatigued & having expended almost all of their ammunition," Percy deployed his troops near Munroe Tavern in Lexington along the Concord Road, commandeering the tavern itself as a field hospital to accommodate Smith's wounded. Upon seeing the Regulars approach her home, Anna Munroe, wife of tavern owner and orderly sergeant William Munroe, fled immediately with their children.[82] For what Percy anticipated would become a rear-guard action, he ordered two six-pound cannons placed on the high ground overlooking the Common to provide cover for Smith's men. Once Smith's men reached the safety of Percy's line, a cannon shot "had the desired effect," scattering the militia. This first cannon fire of the American Revolution tore through the roof of Jonas Clarke's meetinghouse.

Smith's exhausted expedition rested and received medical attention behind Colonel Percy's line. The militia, meanwhile, reassembled to fire at the British from behind any available cover. Percy later wrote that "there was not a stone-wall, or house, though before in appearance evacuated, from whence the Rebels did not fire upon us."[83] He ordered three houses

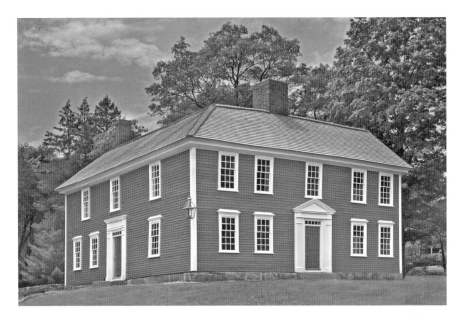

Munroe Tavern was commandeered as a field hospital to treat British soldiers. *Paul Doherty photograph.*

burned to drive out sniper fire. Lieutenant Mackenzie of the Welsh Fusiliers supported Percy's decision to torch the houses because "we were fired upon from all quarters, but particularly from the houses on the roadside." Mackenzie wrote later that the "three or four [houses] near where we first formed" were burned to prevent provincial sniper fire coming from them.[84] The house in which Dr. Samuel Prescott had courted Lydia Mulliken the previous night was torched. By now, Percy realized that he had misjudged the American opposition's size and therefore had insufficient ammunition. With many treacherous miles yet to be covered, this unexpected larger force threatened his retreat. Percy stationed Smith's men ahead of him and set out in an easterly direction along Concord Road, his own regiments marching in the rear for protection.

While Earl Percy's account written for Gage described the day in tactical terms, Reverend Clarke's, written a year later, addressed his narrative to a much wider audience. Clarke's remains the only account of Percy's mission written by a Lexington resident, and it contains facts gathered after subsequent investigation, since Clarke probably did not witness events around Munroe Tavern. Clarke wrote that once safe behind Percy's lines, Smith's men entered some homes and pilfered them. What Percy considered

necessary to American snipers from windows Reverend Clarke viewed as a crime: "Rage and revenge had taken the reins, and knew no bounds!" In addition to setting houses afire, the enemy, according to Clarke, engaged in plundering. "Clothing, furniture, provision, goods, plundered, broken, carried and almost ruined."[85]

The minister's account had propaganda value, but it also expressed the viewpoint of Lexington witnesses to an action they considered outside the normal bounds of eighteenth-century warfare. Mackenzie admitted that American homes had been entered by redcoats "enraged and at the suffering of an unseen Enemy."[86] Later, by the time the British marched through Menotomy, looting and even worse outrages occurred, as the discipline of weary troops under constant fire disintegrated. There, both sides took on the day's heaviest casualties. Twenty-five Americans perished, while eight were wounded. The British lost forty dead and eighty wounded.[87] Percy's soldiers entered houses "from which the [sniper] fire proceeded, and put to death all those found in them."[88] The British would later protest that firing from behind trees and stone walls also went beyond norms of eighteenth-century warfare, since only "savage" Indians fought in that manner.

The different town militias had been raised early in the morning, well before breakfast. Some thirsty, hungry, exhausted Americans still in Lexington found their way to Reverend Clarke's parsonage late in the day. Clarke and his family spent a few hours serving bacon, cider and brown bread to all who could fit, many sitting on the floor and eating with their fingers. Food was served until the household exhausted its victuals.[89] When safe to do so, Clarke sent young Jonas to Reverend Cooke's parsonage for a report on the Menotomy damage. Then, with Betty and his wife, Lucy, bearing little Sarah in her arms, Reverend Clarke ventured over to the meetinghouse.

Inside lay the eight men killed on the Common. As Betty Clarke recounted it, they lay "all in boxes made up of four Boards Nailed up, and after Pa prayed." The family watched as coffins were placed in carts and transported to the graveyard, where they were laid to rest in a common grave. The day had clouded over and become misty. Reverend Clarke and "neighbors" covered the coffins with "pine or oak bows" to hide them from feared British desecration should they return.[90] It had been a devastating day for the parish yet historic in the future nation's history. As Clarke walked with his wife and daughters back from the graveyard, conflicting emotions likely unsettled him: sadness for the fallen militia's families, fear that British retribution would be swift and hard and hope that his town had initiated a course that might lead to a satisfactory resolution, perhaps even independence.

When the long day ended, British casualties numbered 73 killed, 174 wounded and 25 missing.[91] Moreover, Gage's army was now bottled up in Boston, besieged by an enormous militia army in control of Charlestown, Cambridge and Boston Neck. The rising in the countryside brought militia from the far reaches of New England. Twenty-three towns experienced casualties on April 19. Jonas Clarke recorded in his diary for that day, "Regulars fired upon our Men, in Lexington, killed 10 of this Town & 30 of other Places & wounded many, Burnt houses, etc."[92] In all, the American casualties numbered 94—50 killed, 39 wounded and 5 missing.[93]

British casualties were sometimes discovered in surprising places. Before the battle, Samuel Sanderson had transported his wife, Mary, their daughter and a child boarder to Mary's father's house in the northeastern part of town. The daughter of William Munroe Jr., Mary Sanderson came from a proud Lexington family of Scottish heritage. Her Scottish burr remained an easily detectable quality of her speech. The Sanderson home stood adjacent to Munroe Tavern, so Samuel had been wise to move his family. The damage British soldiers had inflicted on hers and her neighbor's homes appalled and angered Mary. This turned to fury as she reentered her dwelling once her husband cautioned her that a wounded British prisoner lay in their bed. Mary refused to go a step farther, insisting that she would "do nothing for him." For all she cared, "he might starve." She demanded to know why her husband did not "knock him on the head." The town, however, adhering to the protocols of war, insisted that the prisoner be fed and medically treated. Finally, Mary relented, but her visible hostility led the wary prisoner to ask someone to taste his food and tea before he ate and drank.[94]

Samuel Adams and John Hancock set out for Philadelphia on April 26, 1775. Since news of Lexington and Concord had preceded them, along the way cheering crowds lined the streets. Upon entering New York on May 6, they received a hero's welcome. Hancock had left his aunt and his fiancée, Dorothy, with his friend Thaddeus Burr in Fairfield, Connecticut, where later in August, John and Dorothy would marry. Massachusetts's delegates, including John Adams, Robert Treat Paine and Elbridge Gerry, joined the full Congress that spring as it fashioned a response to the bloodshed in Massachusetts. The Battle of Bunker Hill took place soon after on June 17.

Although Congress created a Continental army and appointed a general in chief, delegates representing moderate colonies such as New York and Pennsylvania continued to promote avenues of reconciliation with Britain. In July 1775, John Dickinson of Pennsylvania composed the Olive

Branch Petition, requesting that George III intercede personally between Parliament and the colonies to settle contentious issues. Moderates hoped that Parliament would satisfy colonial concerns over trade regulations so that they might resume the relationship with England enjoyed before 1763. Massachusetts and other radical colonies indulged the moderates' efforts while remaining convinced that the king would never intercede. Predictably, George III ignored the colonial appeal.

The Clarke household worried about family members who remained in the besieged provincial capital. Lucy's brother, William Bowes, now a Loyalist, presumably welcomed the British garrison's protection there. A year earlier, Bowes had sued his cousin John Hancock for a debt owed, and while Hancock remained away from Boston, the sheriff delivered to Bowes more than £3,000 worth of goods from Hancock's store and £350 worth of Madeira from his wine cellar.[95] But Bowes's brother Nicholas, the bookseller on Cornhill Street, was no Loyalist, and Reverend Clarke's son Thomas apprenticed with him. The Clarke family could not rest easy until Thomas came home.

On April 20, Committee of Safety member Dr. Joseph Warren wrote to General Gage requesting safe passage for those who wanted to leave Boston. Gage did not reply directly to Warren but did negotiate a deal with the selectmen through which Bostonians could exchange their arms for safe passage with their belongings out of town. Later, however, under pressure from Boston Loyalists, Gage reneged on the deal. The Loyalists believed that once their supporters evacuated from Boston, American Whigs would be free to attack the city. So, even with arms collected, Gage was slow to issue permits, and the only way out of Boston was by passing British sentries on the Neck, permit in hand.[96] It appears that Nicholas Bowes attempted to leave but was rebuffed. Perhaps he believed he had the paperwork needed. On May 1, Reverend Clarke "went to Roxbury with Team, Carriage, etc. to fetch Brother Nicholas Bowes and Family—but was disappointed."[97] Finally, more than two weeks later, on May 17, "Mrs. Bowes and children came here, as also Thomas Clark."[98] Young Thomas had returned from Boston to Lexington with the Bowes family, but Nicholas decided to remain in the city.

The previous winter, 1774–75, had been particularly harsh, with firewood and food scarce in the city, and the surrounding countryside was increasingly hostile. One reason Gage had agreed to let Whig sympathizers leave in May was to conserve food and fuel for the army. Moreover, despite repeated appeals to London, only one British ship bearing food had sailed into

Boston Harbor. Nicholas Bowes remained in the city, perhaps voluntarily, to settle accounts or to secure property that he would be forsaking for an indeterminate time. Finally, although not before August 17, Reverend Clarke recorded that "Brother N. Bowes came out of Boston."[99] He likely brought some fascinating stories.

Through the weeks following the bloodshed in Lexington, Reverend Clarke hosted his regular stream of visitors. Reverend William Gordon, Roxbury's minister, visited in order to conduct research that would lead to the first published account of hostilities in Lexington and Concord; in 1788, Gordon published a three-volume account of the American Revolution.[100] Among Boston Whigs who boarded with Clarke in those weeks was Ebenezer Hancock, John's younger brother and Lucy's cousin, who had slipped out of Boston disguised as a fisherman.[101]

Fourteen-year-old Jonas joined Captain Parker's company, serving in Cambridge five days after the battle.[102] Although a fifer, the position still put Jonas in harm's way so that his fife could be audible to his company.[103] Fife notes and drumbeats transmitted orders, such as advance and retreat, to infantry units during battle. Ultimately, his parents' decision to let the boy serve may have hinged on the service's brevity. The detachment from Parker's company served only until May 10. When a larger Lexington force entered Cambridge on June 17, the day of the Battle of Bunker Hill, young Jonas was not there.[104]

Although no doubt relieved that his son remained safely at home, Reverend Clarke would be grief-stricken at the loss of his mother the same day as the Battle of Bunker Hill. Mary Clarke died at sixty-nine in Hopkinton on June 17.[105] Scarcely had the minister buried his mother when his father became mortally ill, dying on June 30 at seventy-one. On the same day George Washington arrived in Cambridge to assume command of the New England militias assembled into an army, Reverend Clarke buried his father. Thus, although keeping informed of the rapidly changing political and military situation in and around Boston, Lexington's minister was also occupied with settling his father's estate. Times were of great import, both in Clarke's public and private life.

THE WAR'S TOLL

Two events converged to end the siege of Boston on March 17, 1776. American general Henry Knox, a former book-selling competitor of Nicholas Bowes, led his army to perform the extraordinary feat of transporting cannons more than 150 snow-covered miles of mountainous terrain from the recently captured Fort Ticonderoga in upstate New York to Dorchester Heights above Boston Harbor. By March 2, the American army had the artillery trained on the British fleet. A timely and violent storm forced Colonel Hugh Percy to abandon his attempt to remove the threat. This fortunate weather event forced General William Howe, now in command of the British garrison, to surrender Boston, embarking with desperate Loyalists for Halifax, Nova Scotia. General Washington and his army next marched south to protect New York City, but the overmatched American forces were obliged to leave that port in British hands. The best that can be said of the New York campaign is that Washington avoided his army's capture.

In Lexington, on the Sunday after the British evacuation from Boston, Jonas Clarke took as his text 1 Samuel 7:12. In it, the prophet Samuel, after persuading the Israelites to abandon their sinful ways, builds an altar to God and then defeats the Philistines. Developing the theme of God as champion of his people once they follow the virtuous path, Reverend Clarke went on to quote Exodus 14:25: "The Lord fighteth for them against the Egyptians." The message was clear: repentance and moral reform in New England prepared the way for divine providence to do its work. At the end of his

Map of Boston and its environs after the battle. *Library of Congress.*

sermon, the minister became unusually explicit in underscoring the reason for Boston's deliverance from tyranny. "And who preserved our Ancestors in their immigration to this land? And who in the present Contest—still more unnatural and more unjust hath protected us?"[1] Washington's army supported by Knox's cannons, as well as a timely providential storm, had functioned as God's instruments on behalf of his chosen people.

The British departing Boston Harbor dynamited Fort William on Castle Island for good measure, reducing it to rubble. They left a city devoid of adequate food or firewood, its people suffering from smallpox, dysentery and famine. The omnipresence of the virus in England had routinely exposed most British soldiers during childhood, leading to their immunity as adults. Moreover, General Howe earlier had inoculated the few vulnerable men and then quarantined them aboard ships in Boston Harbor.[2] His attentiveness allowed the British garrison to reach Halifax without bringing smallpox with them.

With immunity less common in America, residents became far more susceptible to the deadly disease, especially the young, because smallpox

had not visited Boston recently. Only American survivors of an earlier virus could be considered safe; Washington's poxed face bore witness to his own exposure as a young man. Now, fearing his army's infection after the British evacuation, the general sent one thousand immune troops into Boston to bar residents from returning from their eleven-month exile and to clean buildings.[3] But keeping Bostonians from their homes proved impossible. The increased movement in and out of town elevated the danger of its spread.

The transplanted Bostonians found the landscape radically changed. Most shade trees had been burned for fuel. Homeowners gazed at shutterless windows and weed-filled gardens bereft of fences. Some homes had been turned into barracks. General William Howe even converted the Old South Meeting House into an indoor riding school by ripping out the pews. In anticipation of an American invasion, many streets remained "fortified" with branches, carts and even iron balls covered with spikes strewn on the ground to impede approach on horseback.[4] General Washington wrote to a relieved John Hancock in Philadelphia that his Beacon Hill mansion "had received no damage worth mentioning."[5] Others in Jonas Clarke's circle, Nicholas Bowes and Reverend Samuel Cooper among them, returned to Boston to pick up the neglected pieces of their former lives. The rebuilding soon commenced.

The battle's commemoration on Lexington Common began with a sermon on April 19 the next year. The town began this earliest remembrance in a format repeated until war's end. The custom followed a Boston tradition of marking previous events of political resistance. Puritans during the Great Migration, for instance, brought with them England's custom of celebrating November 5. Called Guy Fawkes Day back home, it celebrated the timely frustration of a Catholic plot to destroy Parliament with explosive gunpowder in 1605. Boston residents renamed it Pope's Day and marked it with orchestrated parades, the pope burned in effigy and battles between competing North End and South End gangs. Later, August 14 became a festive day on the Whig calendar, commemorating the date when Boston rioters forced Andrew Oliver to resign his post as stamp commissioner in 1765.

But the annual commemoration of the Boston Massacre most closely resembled Lexington's remembrance, both in its violent genesis and in the observance's format. Since 1771, leading citizens of Boston, including John Hancock and Dr. Joseph Warren, had delivered annual orations on March 5, Massacre Day. Whig leaders printed and distributed these partisan speeches for their propaganda value. As with the Boston Massacre, the same leaders

now labeled the Lexington affair a massacre. Reverend Clarke considered it so, in his diary noting observance of the event one year later, "Lecture to Commemorate the Massacre in Lexington, etc. I preached."[6] The Boston Massacre precedent likely informed a decision by Lexington to sponsor an annual sermon to honor the fallen.

Reverend Jonas Clarke's 1776 sermon or lecture initiated the series that followed each April 19 until 1783. Clerical colleagues such as John Marrett of Woburn, Henry Cummings of Billerica, Zabdiel Adams of Lunenburg and Clarke's father-in-law, Samuel Cooke of Menotomy, preached subsequent sermons from Lexington's pulpit. For the town and the larger community, those anniversary sermons became an annual demonstration of public memory that served to frame the war and contribute to a nascent nationalism. The sermons reminded the audience of the civic virtue and sacrifice required to carry the country to victory. Of the battles waged in that long interval, Lexington's was the only one commemorated as early as the following year.[7]

With the final one in 1783 a single exception, very little survives to document these public events aside from the sermons themselves. The commemorations seemed to have been largely country concerns, not meriting coverage in Boston newspapers or manuscript material. The diary of Woburn's Reverend John Marrett does note that the minister attended Reverend Jonas Clarke's 1776 sermon on a "fair and windy" day with "a very crowded audience." Lexington "militia mustered" for the occasion.[8] We are left to imagine a Common bustling with activity, with an overflow audience packed into the meetinghouse listening to Reverend Clarke speak about events occurring beyond its windows a year before.

With community outrage and pain still raw, Reverend Clarke's sermon did not disappoint. It excoriated British behavior. One dead victim had lived in Woburn, but seven of the eight had been Clarke's parishioners. Two more of Lexington's militia met their death in battle later that same day. At every meal throughout the year since, families had confronted empty chairs, and now the town's minister spoke for the grieving.

Thus, Reverend Clarke may be excused for indulging in a little hyperbole. He entitled his remarks, "The Fate of Blood-Thirsty Oppressors, and God's Tender Care of His Distressed People." His text was Joel 3:19–21, chosen because the verses include a pertinent prophecy: God shall avenge "violence against the children of Judah" by Egypt and Edom "because they have spilled INNOCENT BLOOD."[9] Early on, the preacher reminded his listeners that violence done to Israel arose from their own sins. Israel's oppressors,

The Fate of Blood-thirsty Oppressors, and GOD's tender Care of his distressed People.

A

S E R M O N,

PREACHED AT LEXINGTON,

APRIL 19, 1776.

To commemorate the *MURDER, BLOOD-SHED* and *Commencement of Hostilities*, between *Great-Britain* and *America*, in that Town, by a Brigade of Troops of GEORGE III, under Command of *Lieutenant-Colonel SMITH*, on the Nineteenth of APRIL, 1775.

TO WHICH IS ADDED,

A BRIEF NARRATIVE of the principal Transactions of that Day.

By JONAS CLARK, A. M.

PASTOR of the CHURCH in LEXINGTON.

Those Things doth the LORD hate :—*A proud Look, a lying Tongue,* and *Hands that shed innocent Blood.* PRO. vi. 16, 17.
——— *Quid non mortalia pectora cogis,*
Auri sacra fames ?———
Quis talia fando,
Myrmidonum, Dolopumve, aut duri miles Ulyssei,
Temperet a lachrymis ?——— VIR. ÆNEID.

MASSACHUSETTS-STATE: BOSTON:
PRINTED BY POWARS AND WILLIS.
M, DCC, LXXVI.

"First Anniversary Sermon 1776," Jonas Clarke. *Lexington Historical Society.*

Egypt and Edom, simply functioned as "rods in God's hand." Lexington's parishioners, and by extension New Englanders, must continue to purify their hearts. With the people's sincere efforts, God would "cleanse and avenge their innocent blood" as when he laid waste to Egypt and Edom.[10]

Clarke's sermon compares Israel to New England by asserting that oppression had driven the children of Judah from Egypt just as the Stuart kings drove Lexington's ancestors from England. He recounts General Gage's military expeditions, including the Powder Alarm and the Salem affair. When Reverend Clarke turns to the battle outside his meetinghouse, his language becomes more strident. The British soldiers who invaded Lexington were "more like murderers and cutthroats than the troops of a Christian king." They "shed INNOCENT BLOOD!" without remorse. Pointing beyond the windows, he claims inability to describe adequately the horror on "yonder field" on that "awful morn."[11] He assures his audience that God, as he did for the children of Judah, will avenge the innocent blood spilled that day. To Reverend Clarke, when militias acted as God's instrument on April 19, his vengeance had begun; witness the "unexpected" British evacuation of Boston and the expedition currently launched in Canada. The emotional sermon ends with a caution that New England, like Israel, had invited calamity by straying from the pious path, and that requires "a general repentance and thorough reformation."[12]

In time, Lexington residents sought a memorial more enduring than yearly sermons: a free-standing monument to their friends and kin. Accordingly, in February 1777, town meeting selected a committee to "compute the cost of a suitable and decent monument to set over the graves of our brethren who fell as victims to the British tyranny on April 19, 1775."[13] Because they lay in the church cemetery, the proposed monument would be located there.[14] With the war still in its early stages and its outcome in doubt, no one could be certain that the Lexington battle would have larger significance. Thus, Lexington's first thought was to provide town funds rather than ask for provincial aid. Yet the colonies were sinking more deeply into the debts of wartime. On May 22, 1777, town meeting asked the committee to suspend its scheduled monument report until the next meeting. But economic concerns dominated subsequent meetings. In short, it appears that acute economic woes diverted town finances from memorializing their fallen brethren.[15] The issue would not be taken up again until 1791.

The American forces had swelled to ten thousand men from four New England colonies by the time the siege of Boston was lifted in March 1776. During those early, anxious days, Reverend Jonas Clarke provided moral

and spiritual support to local militias with visits, sermons and prayers. In late May, he noted that he "went to Cam[bridge], Watertown and Medford," seemingly all in one day.[16] And he performed manual labor in service to the cause. On June 3, he "went to Boston with Madm & ye Castle to work" for several days.[17] While Lucy likely remained in Boston, Reverend Clarke took the ferry to Castle Island, the site of Fort William, which the British had left in ruins. There he helped construct defensive earthworks. Clarke's colleague Reverend John Marrett joined them to work alongside his own town's militia. Marrett's diary recorded on June 3: "Went to the Castle with Woburn militia to intrench."[18] Fear of the British fleet's return made Bostonians intent on strengthening fortifications on the harbor islands. Militia and civilian volunteers also reinforced Deer Island's defenses at the northern entrance. The Castle Island earthworks aimed to protect the harbor from attack from the south.

Thomas and Jonas, at ages sixteen and fifteen respectively, appeared fascinated by activities swirling around them. On two occasions, they rode together to Watertown, where the Provincial Congress had moved and stationed troops. Reverend Clarke's two oldest sons did their military service. Young Jonas may have enlisted again in January 1776 to serve as a fifer for two months in Cambridge.[19] In March 1776, Thomas joined the Lexington company under Captain John Bridge as part of the siege that ultimately drove the British out of Boston.[20] Then he enlisted for a three-year term in 1777, serving in Colonel Jeduthan Baldwin's regiment of artificers, erecting barracks, repairing boats and performing other carpentry, wheelwright and blacksmith duties. Thomas did not serve out his enlistment, however, as records indicate that he deserted in 1779.[21] It is impossible to know why the twenty-year-old forsook his obligations prematurely. Far from rare, desertions hampered the Continental cause increasingly as conditions of soldiers' lives worsened. Surely, 1779 proved a difficult year for the American forces, with depreciating currency tripling and quadrupling costs while pay remained static and meager supplies ran shorter. Further, artificers were not commissioned members of the Continental Line and suffered from second-class status, reflected in pay and respect.

Without concessions forthcoming from Britain, the American populace began to warm to the idea of independence. Thomas Paine's *Common Sense*, a popular pamphlet that moved the public mind toward severing ties, was published in January 1776 and sold 100,000 copies in three months. American resistance had progressed beyond the rejection of Parliament's

right to legislate for the colonies; Paine's polemic proposed separating from the king as well. His *Common Sense*, really a political sermon, used the familiar analogy with Israel, in Paine's case to show that monarchy was incompatible with the Old Testament. Israel had at one time requested a king, and God showed his displeasure over that choice. America must throw off the last vestige of its connection with the British empire, "for monarchy in every instance is the Popery of government."[22]

Britain intensified American efforts toward independence by enacting the Prohibitory Act, embargoing all trade to the American colonies and declaring American ships enemies eligible for seizure on sight. By the spring of 1776, even delegates from moderate colonies received authorization from constituents to vote for independence at the Second Continental Congress. Although the Massachusetts provincial government had earlier released its delegates to vote as they saw fit, it preferred an explicit endorsement of independence. On May 10, the Massachusetts Provincial Congress determined to ask towns to meet, debate and instruct their representatives on their positions in the matter.

Massachusetts towns did so, and in the process, some wrote their own declarations of independence.[23] On May 23, Lexington held a meeting to consider the Provincial Congress's request. It deferred to "the Wisdom and prudence of that August assembly the Honorable Continental Congress," but the town's resolution went on to state that if the Congress deemed it necessary "for the safety of these colonies" to declare independence, the residents of Lexington stood "ready with our Lives & and fortunes to Support them in the Measure."[24] Many other towns were not so prompt, and some, like Barnstable, voted against independence. Regardless, by the time the Second Continental Congress received the approbation of Massachusetts's citizens on July 3, it had already voted for independence.

Soon after, another decision of great moment faced Massachusetts, that of drafting a constitution for the Commonwealth. Predictably, the Third Provincial Congress meeting earlier in Watertown on July 1775 had declared General Thomas Gage no longer the lawful governor. Fearing challenges to its legitimacy, the Provincial Congress (in reality an ad hoc Revolutionary legislature) ordered that a General Court be elected under the colony's charter of 1691. Massachusetts's voters proceeded to elect a House of Representatives, which in turn appointed a council. Absent a governor, executive power devolved on that twenty-eight-member council. It proved to be a cumbersome executive mechanism. Critical issues such as currency

devaluation, revenue to pay soldiers and reopening the courts demanded immediate action. Further, governing through the charter without a chief executive raised questions of legitimacy.

Given those problems, Pittsfield's minister, Reverend Thomas Allen, led a movement from western Massachusetts. Allen traveled throughout Berkshire County preaching "the gospel of constitutional government." The House of Representatives must move quickly, he said, to create a state constitution. Berkshire County had yet to reopen its courts, and Whig leaders there questioned the legitimacy of the current government. Under Reverend Allen's influence, the county hoped for a constitution radically different than eastern Massachusetts's vision. Indeed, western Massachusetts was apprehensive of domination by the east, both by its wealth and its higher population density.[25] In Lexington, Reverend Jonas Clarke wanted a state constitution as well and soon. Most importantly, he required one that derived its power and legitimacy from the people. Moreover, he insisted that any such framework explicitly enumerate individual rights that the state government could not abridge.

It took three attempts to draft a state constitution. The first had called for the House to act as a convention to draft the document. Once written, the House would presumably ratify it, inasmuch as that body comprised the towns' duly elected representatives. But many questioned the legitimacy of a constitution created in that manner. On September 17, 1776, the House requested more direction from each town as to how best to proceed.

Although Lexington chose a committee of seven to draft its response to the request, Jonas Clarke surely took the lead. On October 21, 1776, Lexington's committee submitted its response, listing its objections to the proposed drafting and ratification methods. Foremost among them was that "all Government originates from the people"; despite House members' popular election, they were "not elected for the Purpose of agreeing upon & enacting a Constitution of Government for this state." Ever fearful of corruption, the resolution thought the precedent of representatives assuming new responsibilities ex post facto was "dangerous to a People's liberties."[26] A strong majority of towns agreed with Lexington's disapprobation. Massachusetts was obliged to try again.

Leery of the ongoing smallpox epidemic, Reverend Clarke stayed clear of Boston until November. Finally, on November 19, 1776, the parson brought Lydia and Jonas to town in the family chaise and the next day returned with Thomas, who had presumably renewed his apprenticeship.[27] Jonas and

Lydia likely stayed with family friends or relatives. On November 29, Betty accompanied her father on a day trip to Boston, but seventeen days later, he recorded, "Betsy not well." The following day the ill-fated daughter's skin broke out in a rash.[28] How she contracted smallpox is unclear. If she caught the virus in Boston, she should have experienced physical symptoms such as headache and nausea earlier. The incubation period is commonly twelve days—fourteen days at the outside—from initial exposure to rash.[29] However contracted, deadly smallpox now entered the Clarke household. The minister inoculated himself three days later.[30] But it was unlikely that he inoculated only himself, as he remained in the parsonage and his family would require similar protection. He contracted his survivable case of smallpox on January 2 due to the inoculation. Once ill, he became contagious. "Mad'm very bad," he recorded one week later. Lucy had been ill earlier, so she was likely inoculated at the same time as her husband. Two days later, she was feeling better.

Reverend Clarke's illness from inoculation proved severe enough to disrupt Sunday meetings for an entire month. He canceled the December 22 and 29 meetings. Because the first date fell only two days after inoculation, before symptoms would have appeared, the previous day's "severe storm, snow" likely caused the cancelation.[31] On the third week, the town commissioned supply ministers to ensure that the parish would not endure three weeks without Sunday service.

On January 22, Clarke reported cleaning the house, likely to rid it of contagion, indicating that the family was clear of the virus.[32] Four days later, he preached a sermon for the first time in nearly a month.[33] Clarke's household had survived inoculation and could be considered immune from future infection. Once again they had avoided the recurrent tragedy that had plagued the earlier Clarke household when the minister was growing up in Newton.

The need for a state constitution persisted, all the more so because most other states were completing their governing frameworks in 1776 and 1777. As pressure for one intensified, the General Court made a second attempt. If the House of Representatives as an ad hoc constitutional convention was unacceptable because representatives were not elected for that purpose, leaders resolved to make the dual roles explicit. In the May 1777 House elections, towns chose their representative(s) with full knowledge that they simultaneously elected a delegate to the state's Constitutional Convention. Several towns, including Boston, objected to the plan at the outset.

Nevertheless, in June, the newly elected lower house resolved itself into a convention that met periodically over a nine-month period. By February, this body had produced the "Constitution of 1778," sending towns copies for the required two-thirds voter ratification.

A month earlier, Lexington had approved the Articles of Confederation, the earliest federal framework of the United States. As with most Americans, Lexington residents regarded the Articles as less important than their local and state government, where decisions immediately affecting their lives happened. Along with approving the Articles, town meeting recommended a more reasonable provision for amending it, since the Articles of Confederation placed an impossibly high bar for such action: the unanimous consent of the states. Ultimately, that inability to alter the federal framework necessitated calling a national convention in Philadelphia in 1787 initially charged with revising the Articles. The meeting evolved that summer into the federal Constitutional Convention, where delegates determined to create an entirely new framework, one that has endured to this day.

The Massachusetts Constitution of 1778 was doomed from the start. The controversial dual roles of House members predisposed some towns to oppose it. But many towns also found fault with its contents. It did not include a bill of rights. The Declaration of Rights contained in the recently ratified Virginia Constitution had become a model for proscribing protections guaranteed in the 1689 English Declaration of Rights, a document revered by most Massachusetts residents. Ever mindful of corrupting influences in government, the Whig tradition insisted on guarding against human fallibility. In New England, the Calvinists' conviction of humanity's sinful nature only served to underscore this. After all, corruption had perverted a British government that American Whigs once believed was the world's best.

Again Lexington prepared a resolution. One historian, acknowledging Clarke's obvious imprint, noted that Lexington's resolution was the "ablest of the town papers drawn up by clergymen."[34] It began with arguments consonant with social contract philosophy. "In immerging [sic] from a State of Nature, into a State of well-regulated Society, Mankind gave up some natural Rights in order that others of Greater Importance" to the society's "Well-being safety & Happiness" could be secured. It was necessary, then, to formally enumerate those "Greater" fundamental rights that government must protect. The constitution's failure to include a Declaration of Rights stood chief among its structural flaws.

Two-thirds of the towns had to approve the Constitution of 1778 for it to be ratified. Although 129 of 300 towns, including 20 from the district of

Maine, did not list voting returns, the constitution failed across the state by 9,972 votes to 2,083. Lexington showed the political unity it had displayed since before the Revolution by casting 172 nays and no yeas.[35]

Like many American towns, Lexington experienced wartime hardships, intensified by an increasingly inflated currency and demands of meeting the local enlistment quota. As Massachusetts printed paper currency to fund wartime expenses, prices continued to rise while resources diminished. People balked at being paid in paper currency, since its value declined so rapidly. As a consequence, town meeting decided in 1781 to pay men who were helping Lexington meet its military quota in cattle. Fifteen cows per soldier was the suggested bounty.[36]

Jonas Clarke's salary became another casualty of hard economic times. Two years earlier, the town had formed a committee to assess how far it had fallen into arrears with Reverend Clarke.[37] Lexington had increased its minister's annual salary to £120 as compensation for the escalating inflation. But Clarke had not been paid for at least a year, possibly longer. Instead, he was subsisting on "money expended from his father's estate." Now the town hoped to make amends. As testimony to the state of currency at the time, it appears that Lexington allocated to its minister the seemingly enormous but inflated sum of over £5,000.[38] In June 1780, Reverend Clarke donated £300 "towards raising men required of this town for the army." The amount was almost four times his salary before the hyperinflation began. Later, in town meeting, the clerk recorded "money being worth ¼ of what it was."[39] Reverend Clarke had returned a portion of his salary to help the town meet its quota for soldiers—a quite generous contribution, albeit in inflated currency.

In 1779, the General Court, still burdened with legitimacy questions while waging war and governing a newly independent state, made a third attempt at framing a constitution. By calling for a state Constitutional Convention of delegates elected solely for that purpose, it answered previous criticisms. The legislature designated Boston in September 1779 as the place and time for the convention's opening.[40]

This time, town meeting appointed Reverend Jonas Clarke to be Lexington's delegate, for no town resident had thought and written more about governance over these critical years than its estimable minister. The appointment constituted a major step in the parson's civic career; for the first time, his influence in affairs outside the meetinghouse would be publicly

acknowledged. Why it became acceptable for Reverend Clarke to step from the shadows is not clear, but as a pastor representing his town, he was hardly alone. Massachusetts towns selected twenty-nine clergymen to attend the convention. Surely, the question of public support of churches, an important issue for the convention, warranted ministers' overt participation. To be sure, many ministers had had significant covert civic roles. That Lexington regarded Reverend Clarke as its obvious choice indicates that his hand had been guiding Lexington's secular politics earlier. Notably, town meeting drew up no instructions to guide its representative.

When it opened on September 1, the convention assigned a committee of 30 to compose a draft constitution for the 312 delegates to consider. As a practical matter, Samuel and John Adams and James Bowdoin drafted the document, with John Adams, the most serious scholar of government, its primary author. Adams had completed his draft for the convention's review when it opened its second session on October 28.[41] Adams's work reflected his beliefs in the merits of a mixed government of three co-equal branches, each able to check the others to limit misuses of power.

The Declaration of Rights dominated the second-session convention's time before it adjourned on November 11. Article III, in particular, which endorsed public support of ministers, consumed time in the meeting hall and space in the newspapers; this was hardly surprising, given the ministers attending and religion's centrality in Massachusetts. The article proposed the continued use of tax revenue to support a majority church, namely Congregational. The article's stated premise read, "The happiness of a people, and the good order and preservation of civil government" depend "upon piety, religion and morality." Thus, government must properly sponsor teachers of those virtues. As might be expected, minority churches such as Baptists and Anglicans had previously opposed the practice and, over the years, had managed to win tax exemptions. Of the twenty-nine ministers representing their towns, several spoke for minority sects. Congregationalists contended that abatements to other sects increased their own tax burden. Article III left the decision about granting exemptions to town selectmen. But for many, the article's intent conflicted with the right of conscience preserved in Article II.[42]

Delegate attendance declined as the November 12, 1779 adjournment date approached, and it did not improve when the convention resumed on January 28. A particularly harsh winter made traveling by road or water difficult, leaving as few as eighty delegates in attendance, mostly from eastern Massachusetts, who exerted disproportionate influence. Each day's session

opened with a prayer, and Reverend Clarke drew the honor for the critical third session, dealing with the Framework of Government.[43] The convention appointed Clarke to several subcommittees that reconsidered draft articles when the convention deadlocked. One article he helped write concerned which public offices an individual might hold simultaneously. Because it posed a threat to the separation of powers, plural office holding had been an ongoing grievance against the British imperial government.[44] Article XXX stated, "The legislative department shall never exercise the executive and judicial powers, or either of them." The convention surely remembered that Lieutenant Governor Thomas Hutchinson also held the position of chief justice of the Superior Court of Judicature.[45]

In March, the convention printed and distributed the completed document to towns for ratification. A two-thirds majority was required. In what proved to be a messy process, towns were encouraged to debate the framework and submit suggestions for revision along with their vote. The convention promised to consider incorporating these changes in its final session, beginning on June 7. This did not happen. Dealing with the multiplicity of views expressed while tabulating votes proved a practical impossibility. Instead, the convention counted every "yes" vote accompanied by amendments as simply "yes." Thus, the resultant two-thirds vote could be regarded as dubious, since many towns voted "yes" contingent on alterations that were ignored.[46]

Lexington devoted four town meetings to considering the proposed constitution. The town's paramount concern appeared to be protections against government encroachment on individual rights. Residents voted objections to several instances of wording within the Declaration of Rights and the Framework of Government, recommending that language be strengthened from "ought not" to "shall not" regarding freedom of the press and quartering of soldiers.

Much discussion centered on the governor. Executives had been absent from Massachusetts for several years, and neither royal governors nor the king awakened agreeable memories. Other state constitutions either omitted a governor altogether, as in Pennsylvania, or, as in Virginia, created a weak one without veto power. The more conservative Massachusetts convention, dominated by the propertied classes, created a popularly elected governor with considerable independence and strength, including veto power over legislation.

As for the governor's qualifications, Lexington under Reverend Clarke's guidance insisted the language concerning his faith be changed from "Christian Religion" to "Christian Protestant Religion." In case the

convention misunderstands, town meeting attached a definition of Protestant, contrasting "the Pious, noble, and truly heroic stand" of Luther with "the blasphemous absurdities of the Church of Rome." Lexington no doubt had the Stuart kings in mind, in particular James II, whose Catholicism remained discreet while the Duke of York but exercised openly once king. His duplicity had led directly to the Glorious Revolution of 1688.

Reverend Clarke's participation in creating a state government served as a crowning civic achievement. In May 1781, Clarke earned another honor, this time of a clerical nature, in delivering the annual election sermon. The minister's audience was the legislature and Governor John Hancock, as well as most Massachusetts clergy, gathered for their yearly convention. By all accounts, Reverend Clarke gave a rousing ode to patriotism. The sermon celebrated the Massachusetts Constitution's recent ratification as an agreement the people freely entered. "It is in Compact, and in Compact alone, that all government is founded." For Reverend Clarke, political power always emanated from the people. The "inherent Claim of Dominion, or governmental Authority over any other Man, or Body of Men is now an artifact of another age." But Clarke cautioned that people must be worthy of the trust. "While the social compact subsists, the whole state, and all its Members, are bound by it, and a sacred Regard ought to be paid to it."[47]

The British army never returned to Massachusetts. But in 1776 and 1777, the war shifted to the Middle Colonies and later to the South. The war went badly for the Americans. Aside from Washington's success at Trenton in late 1776 and Princeton in 1777, his army suffered defeats, desertions and a dearth of supplies. But to the north, American general Horatio Gates's victory at the Battle of Saratoga in 1778 landed a French ally, doubtless the single most important factor in the eventual outcome; the French army and navy proved decisive in the climactic Battle of Yorktown in 1781.

While the British government debated the implications of the Yorktown defeat, 1782 saw the suffering of American towns reach a critical stage. Privations brought by a war begun near Reverend Clarke's meetinghouse had bankrupted many communities. That year, Lexington could not meet town expenses. The town even refrained from electing a representative to the General Court. Lexington's destitute condition moved Reverend Clarke to make yet another monetary contribution from his modest personal funds.

On a personal note, the Clarkes enjoyed good news. Joy visited the Clarke family when oldest son Thomas married Sarah Conant of Charlestown in November 1782.[48] Having apprenticed as a bookbinder with Uncle

Nicholas Bowes in Boston, twenty-four-year-old Thomas was ready to set out on his own. Like Governor John Hancock, he chose business over his father's clerical path. One can only speculate why none of Reverend Clarke's sons chose a career in the ministry. Perhaps the clergy's continued decline in status dissuaded them. Finances—especially since the two oldest sons came of college age during the war years—could have rendered the decision moot. Or perhaps Thomas simply sought the greater prosperity of a life in commerce. In 1786, Thomas Clarke was inducted into the Ancient and Honorable Artillery Company, the organization to which his great-grandfather and father had given election sermons.[49] By 1795, he was among five merchants specializing in wholesaling and retailing paper for hanging and staining in Boston.[50] Eventually, in 1809, Thomas became town clerk, holding that post until Boston was incorporated as a city in 1822. Rather than follow his father's path, he followed that of his mother's cousin—that is, of course, without the inherited wealth.

Negotiations began over the terms of peace in 1782. Although the French sought to use the Treaty of Paris to further their national interests against the British, Benjamin Franklin, John Adams and the American peace mission deftly maneuvered around these machinations to negotiate terms the defeated foe could accept and that benefited the Americans. The pact was signed in September 1783, and four months later, Congress ratified it on behalf of the government established under the Articles of Confederation.

But by April 19, 1783, news of the cessation of hostilities and British recognition of American independence had already reached Massachusetts. Reverend Zabdiel Adams of Lunenburg, a kinsman of John and Samuel Adams, came to Lexington to preach the last annual anniversary sermon. With Governor John Hancock's confirmation that the long war had ended, a larger commemoration seemed warranted. At five o'clock in the morning, eight cannons fired to commemorate the eight men who died on the Common, the first blood spilled. Governor Hancock, who had walked the same path late one April night eight years earlier, strode to the Common from the Clarke residence. There, the *Salem Gazette* reported that "upwards of sixty Gentleman (principally of the clergy) were escorted by the militia company commanded by Capt. [William] Munroe" to the meetinghouse to attend Reverend Adams's sermon.[51]

The provisional treaty reached America in May. The part concerning the disposition of the abandoned Loyalist lands became controversial at once. According to the treaty, this new nation's government promised to "earnestly

recommend to the Legislatures of the respective states" that Loyalist land be returned to its owners. But land politics was a local matter, and so through instructions to their representatives, towns made clear their opposition. Although no Loyalists owned land in Lexington, its town meeting, at Jonas Clarke's direction, resolved that it would be "both unnatural and unjust that such Persons would share in the Privileges which to their utmost they have endeavored to destroy."[52]

The war that had begun outside Reverend Jonas Clarke's meetinghouse had finally ended in 1783. In that year, Clarke turned fifty-three. His oldest children had matured to the age of independence themselves. Nonetheless, the Clarke family now included two additional children. After baby Sarah, herself born just a few months before the battle on April 19, 1775, Isaac Bowen arrived in June 1779 and Henry in November 1780, bringing the parson's offspring to an even dozen. Lucy bore her last two children when she was forty-two and forty-three. Thomas had left the house. Jonas had also left the crowded house for good, moving to Portland, Maine, at least by 1784. But nation-building had only begun, and Reverend Clarke would remain engaged politically as the days of independence from England advanced.

OLD AGE IN A NEW NATION

That Lexington experienced difficulty electing a constable did not indicate a sudden dearth of civic virtue but rather an abundance of economic distress. Massachusetts notes issued in 1778 had sunk to one-fortieth of their value by 1780.[1] A New England town constable's duties included collecting taxes, an onerous task for anyone empathizing with his neighbors' financial difficulties. Each Lexington resident appointed to the position from 1782 to 1786 declined to serve. Finally, in 1786, Lexington separated the office of tax collector from constable to fill the position. As he had done when first ordained in 1755, after the French and Indian War, a financially strapped Jonas Clarke in 1782 contributed once again, this time six pounds and thirteen shillings, to augment Lexington's depleted funds.[2]

As the war wound down in 1783, the new national government faced problems that threatened its very survival, not the least being disunity among and within the states. These difficulties, especially the ongoing financial strains, tried cities and towns in every state, Massachusetts no less than others. In Lexington, an aging Reverend Jonas Clarke participated all the more actively in civic life. Into his sixth decade at age fifty-three and chronically ill, his household would soon change profoundly.

After the war, Massachusetts resolved to stabilize its economy by retiring its debt. Unlike most states, the Commonwealth voted to fund its devalued bonds at full value, as Treasury Secretary Alexander Hamilton later directed the national government to do in 1790. Advocates of Massachusetts's fiscal

policy professed to be motivated by a long-range interest in establishing the state's credit, thus benefiting the greater good in the long term. But the policy's short-term benefit accrued to any eastern mercantile elite who gambled that the state would pay the notes at full value. Many had purchased the devalued notes from destitute holders at less than their original worth. Militia veterans, paid for their service in state paper, had long ago sold the notes for a fraction of face value due to pressing short-term needs.

Exacerbating the developing crisis, the legislature now ordered any debts be paid in hard currency, or specie, a scarce commodity anywhere in the state save commercial centers. For several years, the economy had operated largely on devalued paper money or on barter. Although revenue to retire the debt came partially from impost and excise taxes collected from commerce, most accrued from increased poll and property tax assessments that the constable collected from local citizens. From 1782 to 1786, the state needed to raise £265,000 in hard currency, the very dates during which Lexington struggled to fill the constable's office.[3]

Hard currency existed in shortest supply in western Massachusetts, where, in 1786, the event known as Shays' Rebellion erupted in late August. A decade after the Declaration of Independence, former Continental army captain Daniel Shays led insurgents to shut down courthouses in western and central Massachusetts and as far east as Concord to prevent property foreclosures due to delinquent taxes. The sudden rebellion shook propertied interests to the core, and not only in Massachusetts. An alarmed George Washington of Virginia wrote to Benjamin Lincoln of Massachusetts to ask, "Are we to have the goodly fabrick that eight years were spent in rearing pulled over our heads?"[4]

Fearful that the rebels might seize the Springfield Armory, Governor Bowdoin in January 1787 enlisted a private army of 4,400 men. Eastern businessmen funded the recruitment effort. Even so, the governor, who had raised troops without legislative authorization, fell short of a full complement, with most who did respond coming from Massachusetts's eastern counties. About 800 who joined hailed from Middlesex County, including Lexington's Captain William Munroe. Eventually, the rebellion melted away, with 150 rebels taken prisoner.[5] But Bowdoin paid a price. In 1787, the voters overwhelmingly returned Clarke's kinsman John Hancock to the governor's seat. Hancock helped heal the wounds by pardoning leaders whom Bowdoin had refused to forgive; the previous governor had already executed two.

Lexington town meeting had little use for the rebellion, considering it as an affront to public order under the "most excellent [Massachusetts]

Constitution." In May 1787, with Jonas Clarke's guidance, it instructed its House member to use his influence to "have the authority of Government kept up." The instructions further recommended, "All of the offenders be punished according to their deserts." As for fiscal matters, even with hard money's scarcity, the town opposed inflating the currency; it cautioned its representative not to "assent to any Emission of paper money." Lexington set as a priority the restoration of "public credit in this Commonwealth." Although the village made common cause with the mercantile class to maintain the rule of law, it instructed its representative to "use your influence" to ensure "that the Massachusetts bank in the Town of Boston be Annihilated," an order that implied a suspicion of monied interests.[6]

In December 1787, Lexington chose Benjamin Brown as its representative to the January 9 Massachusetts convention charged with ratifying the new national constitution.[7] Brown's selection rather than Reverend Clarke at first glance appears puzzling. No one better understood Lexington's mind on constitutional matters, since Clarke had largely shaped those political tendencies. But a conflict apparently existed in the busy parson's schedule. Instead of traveling to Boston for the convention, he "set out for the Vineyard" on January 18 to preach at the ordination ceremony of Reverend Jonathan Smith in Chilmark on Martha's Vineyard.[8] It has been said that Clarke participated in more ordinations than any of his contemporaries.[9] Sometimes his clerical and civic duties conflicted. It is not clear whether Clark chose a clerical duty over a civil one or simply honored a previous commitment. But the distance the commitment required the fifty-seven-year-old pastor to traverse is quite clear.

For his solitary winter journey, Clarke's diary notes on January 18 that he traveled in his chaise, pulled by a single horse, the 77 miles from Lexington to Sandwich. There he likely boarded a few days with Reverend Jonathan Burr, husband to one of Reverend Cooke's daughters. On January 21, the minister "arrived at Martha's Vineyard" and made his way to Chilmark, completing his 111-mile journey. He preached at the January 23 ceremony and promptly left the island for Falmouth and traveled back to Sandwich, proceeding on to Duxbury and Pembroke before finally arriving home.

Once home on January 27, after covering the more than two-hundred-mile round trip, the exhausted traveler penned in his diary, "Returned home Deo Gratia!"[10] Solitary journeys like this were not unusual. In November 1793, Clarke traveled to another ordination ceremony on Cape Cod, to

Harwich, one hundred miles away.[11] In addition, he made annual trips to visit his several children who lived in Maine.

Like most towns in Massachusetts, Lexington did not instruct its ratification representative.[12] Instead, it left Brown to make his own decision after hearing arguments in Boston. Brown understood his neighbors' views on the issues being discussed, having absorbed principles of republican government while attending town meetings that considered the several Massachusetts constitutions. His fellow townsmen would have known Brown's political inclinations when they chose him. In the end, he voted to ratify.[13] Once the promise of a Bill of Rights was proffered, Lexington favored it.

While the new nation was striving for political and economic stability, Jonas Clarke's home life met with several abrupt adjustments. First, Thomas Clarke, the minister's mentally troubled brother, came to live at the parsonage in May 1786. Thomas had been residing near his sister in Hopkinton with a Mr. Morse, for whom he performed manual labor. But Morse later appears to have sold his home and moved.[14] Thomas's last residence had been with Abijah Stone in Framingham.[15] How much Thomas's presence altered the parsonage's equilibrium would have depended on the nature of his mental illness. But during the last four years of his life, Thomas resided at the Clarke home with only Betty and Sarah; thus, only two women managed his "insanity." He died in 1809.[16]

Soon after Thomas arrived in 1786, four Clarke children married and left the parsonage. But scarcely had the first, Mary, wed on March 31, 1789, when Reverend Clarke's wife and helpmeet of over thirty years died.[17] Lucy had been stricken the day before the wedding, although the family expected her illness to quickly pass. The minister's diary noted the marriage of his oldest daughter and added, "Mrs. Clark better." But a fever persisted through the week. Finally, on April 6, a distraught minister wrote, "Mrs. Clark died!!!"[18] She was fifty-three. Reverend Clarke's sister, Mary, stayed at the parsonage to lend her support in the widower's grief. Lucy was buried three days later ("Mrs. Clark interred!-!-!").[19] The outpouring of condolences from the town, including twenty pounds to pay for Mrs. Clarke's funeral, gratified the bereaved. Clarke, himself fifty-eight years old, surely understood that his life was entering a different stage.[20]

Lucy's burial was temporary. Her husband intended to transfer her remains to the tomb reserved for previous Lexington ministers John Hancock and Benjamin Estabrook and their families. But the tomb first needed to be repaired. Clarke and his children set to work making the interior acceptable

A portrait of daughter Mary "Polly" Clarke.
Lexington Historical Society.

for the family's matriarch. In September, the minister reinterred Reverend John Hancock and his wife in new coffins, built by joiner John Mulliken.[21] One chilling entry reads, "Gathered up the Bones and Remains of the Rev. Mr. Hancock Madam and Son—and put them into three new Coffins."[22] Finally, on September 19, after further repairs, "Moved the dear Remains of Mad. Clarke into the Tomb!-!-!"[23] Even in the cramped space available, the pain of personal loss leaps from the page. In a letter to his son Jonas, Reverend Clarke spoke of Lucy as the "Dearest of Friends."[24]

All four daughters who married—Mary, Lydia, Lucy and Martha—wed ministers, as had their mother and her sisters. Mary (often called Polly) married Reverend Henry Ware of Hingham. A Unitarian theologian, Ware eventually became the prestigious Hollis Professor of Divinity at Harvard College. Reverend Clarke, daughter Betty and his younger children Sarah and Harry made frequent trips to Hingham to visit the Wares, taking the packet boat from Boston. Mary remained haunted by her mother's death so soon after what had promised to be a happy transition to married life. One month later, she wrote to her sisters, "I dream almost every night of seeing mama dying or dead."[25] To her aunt Mary Cotton in Hopkinton, she observed a year later that "sickness, death and grave were the first objects that arrested my thoughts and attention once I was united in the happiest state of life. I was bereaved of the best of mothers."[26]

The parsonage underwent further depletions soon after. Three more weddings followed Lucy's death. In the summer months of 1789, between her death and the repair of her tomb, Reverend Clarke attended in rapid

succession the weddings of Lucy and Lydia, in June and August, and of Jonas in July, now residing in Wells, Maine. Lucy's was the first on June 17. Ten days earlier, Reverend Clarke had written to young Jonas that the wedding would be either canceled or postponed because of Mrs. Clarke's death and "our lonely and melancholy situation." "We will make no wedding," he declared.[27] But there was a change of heart, perhaps influenced by the groom. The wedding did take place within a fortnight.[28]

Twenty-two-year-old Lucy married Reverend Thaddeus Fiske of West Cambridge, now Arlington. Earlier, after taking his undergraduate degree at Harvard, Fiske had taught school in Lexington and likely was mentored by Clarke. In this case, as with Reverend Jonas Clarke and Lucy Bowes in

A miniature watercolor of daughter Lydia. *Lexington Historical Society.*

1753, an attraction grew between young Mr. Fiske and young Miss Clarke, who often shared the same dinner table.[29] Another of Reverend Clarke's colleagues became a son-in-law. The same pattern would soon be repeated.

That August, twenty-one-year-old Lydia married Reverend Benjamin Greene, who had begun his pastorate in Medway the year before.[30] Greene had succeeded Thaddeus Fiske as Lexington's schoolmaster during the latter's time at Harvard. Like Fiske, he boarded at the parsonage, and like Fiske, he married a Clarke daughter.[31] But after five years, Greene moved to Berwick, Maine, to begin a law practice. Reverend Clarke could enjoy regular visits from Lucy, living in an adjacent Maine town, but Lydia spent her remaining years in what by eighteenth-century standards was a distant seventy-five miles away.[32]

Between Lucy's and Lydia's weddings came that of Jonas in July. Jonas married Miss Sarah Watts of Portland, Maine. He had moved to Portland in 1784 to establish a store on Exchange Street. Two or three years later, he moved to Wells, where he began to rise in prominence as a merchant.[33] Wells was a Maine port and collection district (the area where Jonas lived would formally become Kennebunk in 1820). Late in his second term, President John Adams appointed Clarke customs collector there, but the official commission never arrived. In 1801, the newly elected Republican president Thomas Jefferson, coming upon the appointments the previous administration had made but left undelivered, hesitated to fulfill the wishes of his Federalist adversary. He wrote to Secretary of the Treasury Albert Gallatin, "Is Jonas Clark, proposed as collector of Kennebunk, a Republican? His having been nominated by our predecessor excites a presumption against it." Jefferson added, "We must be inflexible in appointing Federalists."[34] This partisan pronouncement seemed to bode ill for young Jonas. But Gallatin appears to have convinced the president otherwise. Jonas Clarke was a Federalist, whose political views diverged from his father, as events would later show. Ultimately, Jefferson chose not to oppose delivering the commission (as he did Adams's judicial appointments in the landmark *Marbury v. Madison*).[35] Jonas quickly rose as a leading citizen of the northern frontier town; later, he became justice of the court of common pleas and judge of probate for York County.

The Clarke sons hoped to capitalize on rapidly growing Maine's opportunities in shipbuilding and commerce. Early in 1785, brother Peter, twenty years old, had joined the Clarke exodus to Maine, becoming a merchant in Saco. No doubt older brother Jonas, not far away in Wells, helped Peter establish himself.[36] William, a year older than Peter, may

have already moved to Maine or another favorable location for overseas commerce. In 1803, President Jefferson appointed William Clarke consul for Emden, an important seaport in the German state of Hanover.

In five months, Reverend Clarke had endured Lucy's death and attended four of his children's weddings. In the days that followed, the parsonage seemed strangely empty, with young Jonas and Peter already gone and oldest son Thomas married a few years earlier. Soon Martha left home as well. In 1791, Martha Clarke married an Episcopalian minister from Salem, Reverend William Harris, who later became president of Columbia College.[37]

With nuptials the order of the day, even Reverend Clarke appeared to have marriage prospects in 1790. His frequent visits to the Hingham parsonage to visit daughter Mary and her husband, Henry Ware, brought him into regular contact with the unmarried daughter of the previous minister. Abigail Gay, daughter of Reverend Ebenezer Gay, a year older than Reverend Clarke, never married and was perceived by some to be a good match. Mary Cranch of Braintree reported to her sister Abigail Adams that "tis said that Parson Clarke of Lexington will take Miss Nabby Gay."[38] Of course, this may have been gossip begun by wishful thinkers who did not know the mind of Jonas Clarke. Regardless, the match never came to fruition.

One can sense a father's delight as Jonas Clarke wrote, "All the Sisters Home once more!"—the girls' visits coinciding in 1791.[39] For decades, Clarke had enjoyed a rich family life, and now life in the parsonage had changed. Only unmarried Sarah and Betty remained living at home. Several months after Lucy died, in 1789, Reverend Clarke took in help, Sarah Binney, to fill the housekeeping void left by his wife's death and the departure of three daughters.[40] In 1791, he was sixty-one years old and aware that, like his country, he had entered another stage in life. His young nation had a bright future, but the minister's youth was behind him. Still, his influence in Lexington was never greater than throughout the turbulent 1790s and into a new century.

Another event of great moment for the town occurred two months after Reverend Clarke deposited Lucy's remains in her tomb. Newly elected president George Washington included Lexington in his New England tour. Upon becoming chief executive, President Washington had resolved to visit every state in the Union, and as a southerner, he determined to visit New England first as a unifying gesture.[41] In an age without electronic communication or polls, the president intended to both gauge

public opinion and, by showing his face, solidify the authority of the national government.

Washington planned to visit Lexington on October 26, 1789. But the president was taken ill with "a cold and inflammation in the left eye," which, along with the day's inclement weather, led him to postpone the visit.[42] On October 29, he left Boston for a tour of the Massachusetts North Shore and spent four nights in Portsmouth, New Hampshire, from October 31 to November 3. He stopped in Lexington on his return trip south. On the night of November 4, he lodged in Haverhill, leaving early the next morning, delaying at Abbots Tavern in Andover for breakfast and then passing "through Bellariki [Billerica] to Lexington where [he] dined, [and] viewed the spot on which the first blood was spilled."[43]

The president took his afternoon meal at Munroe Tavern. An entry in Jonas Clarke's diary provides the lone surviving primary documentation of the dinner location.[44] During a special 100th anniversary, William Munroe's great-grandson James Phinney Munroe provided a speculative description by means of a letter putatively from Sarah Munroe to her cousin Mary Mason. Although the letter is unquestionably fictional, Munroe maintained that it "contains nothing—except for the minor character sketching—for which I did not have either contemporary authority or the most reliable tradition." Munroe family lore was largely responsible for the latter. Some parts of the letter furnish details that can be corroborated by Clarke's diary; other parts cannot be confirmed beyond doubt.

The letter claims that Reverend Clarke traveled to Boston on Friday, October 23, to ask about Governor Hancock's health and to introduce himself to President Washington. This may be how Lexington learned when the president intended to visit. Munroe's letter goes on to say that Reverend Clarke, on Sunday, October 25, dedicated several sermons to preparing his parishioners' "hearts" for Washington's visit the following day, the visit that had to be canceled. Both seem likely, and a visit to Boston can be corroborated by Clarke's diary, albeit on October 24.[45] Moreover, Munroe later describes the president's November 5 meeting with Reverend Clarke at the Common, along with the town selectmen, the town representative to the General Court and a full complement of Lexington battle veterans. Washington greeted Reverend Clarke, according to the letter: "Our distinguish'd and dear Friend the Hon. Governor has told me much of his fearless Kinsman."[46] Although the greeting would hardly have been delivered in just those words, logic and Munroe family tradition support the presumption that something similar did occur.

In March 1793, Lexington town meeting voted to build a new meetinghouse. Despite some nostalgic misgivings about replacing a building that had played a central role in Lexington's early development and in its launching of the Revolution, the vote favored a new church, according to Clarke, "with great Unanimity."[47] Several factors produced this overwhelming support. No doubt many in town, especially younger parishioners, wanted their church to conform to modern taste, including a prominent steeple. More important, as a practical consideration, the town's population had grown since its construction in 1714. By 1793, the meetinghouse was cramped and overflowing on Sundays, when virtually the entire town population gathered there.[48]

Jonas Clarke sat on the building committee, which began meeting at the parsonage the very day after town meeting had approved its construction.[49] After dispute over the structure's location, the direction it should face and the color it should be painted, the town voted to place it "twenty feet back of the sills of the old house," farther toward today's Harrington Road, facing "half-way between south and southeast." The pea-green church's front porch and bell tower faced Buckman's Tavern, and the other two porches opened on the building's sides. This meetinghouse boasted stone posts connected by a chain that allowed for tethering horses, as well as horse blocks on each porch to assist ladies in mounting their pillions to take seats behind their

The third meetinghouse. *Lexington Historical Society.*

gentlemen.[50] Lexington historian Edwin Worthen estimated that the new meetinghouse allowed for 60 percent more area than its predecessor.[51]

On March 30, 1794, Lexington's minister of almost forty years preached a final time in the old meetinghouse. After that, he used the schoolhouse for services until the new building could be occupied.[52] Jonas Clarke must have experienced mixed feelings on that last day, after almost forty years of careful tending to his growing parish. Age would limit his tenure in the new meetinghouse. Scanning the final congregation he addressed in the old one may well have conjured thoughts of his younger days, of seeing his wife and young children primly seated in front.

On June 11, the town began raising the new building, always an arduous and even dangerous endeavor. The next day, Clarke wrote, "Raising the New Meeting House No fatal Accidents Deo Gratia!!"[53] (The reasonableness of his fear was borne out in 1806, when six people were "much injured" raising Benjamin Wellington's house.)[54] Finally, on January 15, 1795, with a moderate snowstorm falling outside, Reverend Clarke's large voice filled the new meetinghouse for the first time.[55] Another ecclesiastical era had begun in Lexington.

The politically contentious 1790s caused the formation of the nation's first political parties, with division focused on the extent of the central government's power. The French Revolution in 1789, Jay's Treaty in 1795 and the quasi-war with the French in 1798 exacerbated the growing partisan schism. Federalists, led by Secretary of the Treasury Alexander Hamilton, interpreted the language of the Constitution broadly. This perspective enabled a powerful government to protect private property and impose order over potential disturbances. Republicans, headed by Secretary of State Thomas Jefferson, interpreted the Constitution more strictly, limiting the national government's scope and reserving the remaining powers to the states. In general, Republicans stood for small government and the common man, whereas the urban elite favored the Federalists.

During the ongoing French Revolution, Republicans tended to sympathize with the democratic motives of the overseas revolutionaries. Federalists supported the British mixed-government model, in which the people (the Commons) and the aristocracy (the Lords) work together to preserve order. The French Revolution's "leveling" tendencies—its desire to eradicate class distinctions—appalled and frightened Federalists. Parties were then considered sinister, with both Federalists and Republicans convinced that their opponents plotted to destroy the country. Federalists portrayed Republicans

as aspiring to create a government like the French insurgents, which by then had devolved into bloody anarchy. Republicans interpreted the Federalists' program as one that threatened to lead inevitably to monarchy and tyranny.

Although Federalists held sway in New England, especially in Boston, their dominance soon eroded. Republicans found support among mechanics and artisans in the cities and among small farmers in the countryside. Lexington had its share of poor to middling farmers—the demographic Jefferson idealized as purest in virtue and whose political empowerment he believed critical to maintaining a free society. Lexington had initially favored the Constitution but now believed the Federalist interpretation to be dangerous to personal liberties.

Reverend Clarke remained the town's political leader. One local critic who had no roots in town had earlier called him "the clerical Democrat who snores over sermons at Lexington."[56] In the eighteenth century, "Democrat" had a pejorative connotation, roughly equivalent to someone advocating mob rule. Clarke, like earlier radicals Samuel Adams and Virginia's Patrick Henry, remained wary of an energetic government that made decisions about local affairs from afar. Although Clarke favored the Constitution's ratification because disorders such as Shays' Rebellion exposed the Articles of Confederation's weaknesses, he remained wary of national power. Only states and localities should exercise direct authority over people's lives.

The French Revolution led to open warfare between Great Britain and France in 1793. As a neutral nation, the United States hoped to profit by trading with both belligerents, but events rendered that difficult and dangerous. Since the two American political parties favored different nations in the war, partisan tensions mounted at home. A polarizing moment came in 1795 when the terms of a treaty that American emissary John Jay had negotiated with the British became public. The purpose of Jay's Treaty was to avert another war with England, a prospect clearly disadvantageous to a struggling infant nation. But anger in the United States had steadily grown because the British navy seized hundreds of American merchant ships attempting to exercise their neutral trading rights in the Caribbean. Worse, they pressed American sailors into British naval service, a long-standing annoyance dating back to the press riots on the Boston waterfront. Further, the British had never actually evacuated their forts in the Old Northwest, in the Great Lakes region, and Americans suspected that British soldiers were encouraging Indian attacks on western settlers out there. Moreover, residual complaints existed on both sides of the Atlantic regarding issues connected with the Treaty of 1783.

In America, Jay's Treaty with Great Britain roiled public discourse once its terms became public. The Jeffersonian Republican camp, already predisposed to view the English with suspicion, raged over perceived capitulations to them and an abrogation of the earlier 1778 French alliance. Reverend Jonas Clarke and almost all of Lexington fell into that category. On August 24, 1795, a committee of five, this time officially including Reverend Clarke, met at the parsonage for the first of three meetings to respond to the treaty. The group settled on essentially a petition of protest, inasmuch as the U.S. Senate had already ratified the treaty one month earlier. Lexington's petition joined others sent to President Washington from cities, towns and counties throughout the nation. Perhaps Governor Samuel Adams intended to forward the Massachusetts petitions bundled together because Clarke traveled to Boston to "present the Proceedings of the Town on the Treaty to the Governor."[57] Governor Adams opposed Jay's Treaty as well.

Lexington's resolution begins by charging advocates of Jay's Treaty with subordinating United States interests to those of Great Britain. Unlike treaties with France and the Netherlands, this accord lacked a "fair and perfect reciprocity." The treaty addressed American grievances over Britain's seizure of U.S. ships and goods considered contraband. Lexington viewed the outcome as hardly an equitable resolution. It objected to the expanded list of articles, "not explicitly contraband of war by the known and established law of nations," now liable to be seized by the British navy. Most vexing, the list included timber and naval stores—tar and resin, products that New England considered to be "an important branch of the trade" and whose seizure would cost the region dearly. Especially "degrading and humiliating" were the terms for commercial relations between the two nations. The British were accorded status that today would be considered most favored nation status, with tariff rates for British exports to equal those granted to Holland and France, the Americans' valued allies in the Revolutionary War. Yet it restricted critical Caribbean trade by stipulating that American ships bound for British West Indian ports could not exceed seventy tons.

Clarke's committee also took issue with terms under which Britain retained forts in the Great Lakes region. Jay's Treaty stipulated that such forts be evacuated by June 1796, and in the meantime, the British must stop "fostering and encouraging if not actually supporting a long expensive war with the Indians." The British retained sovereignty within the area surrounding and including the forts, despite their being situated on American territory. Thus, any settlers and traders within the forts' jurisdictions fell under British

protection and continued to retain their property, at "liberty to remain or remove, to sell or retain."[58]

Of note, Reverend Clarke's son Jonas had taken the opposing position when Wells, Maine, debated Jay's Treaty two months earlier. One of the town resolutions' four authors, the younger Clarke viewed the treaty far more favorably. It had removed an ongoing source of grievance, as without it "our commerce unprotected by a navy" would continue to be subject to "unlimited" seizures by the British fleet. This would have presented a continuing threat to "our national honor and fidelity so essential to the peace and prosperity of a rising nation."[59] That young Jonas Clarke was a Federalist, or at least had Federalist leanings, should not be too surprising. He was a seaport merchant who prospered when trade with England and other countries was unfettered and peace reigned among nations. Thus, he took a position consistent with the interests of the merchant class, a position shared by most commercial towns in Massachusetts.

Father and son held opposing views on another public issue two years later, when relations with France brought America to the brink of full-scale war. France and Great Britain had remained antagonists, with the United States maintaining neutrality in the conflict despite France's crucial aid during the American Revolution. Thanks to Jay's Treaty, the British now enjoyed the same favored trade relations with the United States as the French. The French government interpreted such favoritism as an affront. The Federalists believed that the nation's financial (and political) debt to the French, dating from the American Revolution, had been owed solely to the French Crown. Because revolutionaries had since beheaded their monarch, the United States considered the debt no longer valid. Consequently, in 1796, the French began to seize American merchant ships, 316 of them over the next eleven months. The French government's later demand during the Adams administration—in the so-called XYZ Affair—that American envoys be allowed to negotiate an easing of tensions only if they paid a bribe brought the two nations to the brink of war.

On March 19, 1798, President Adams countermanded a previous order forbidding the arming of merchant vessels at risk of seizure at sea. Such vessels would be armed henceforth. Lexington town meeting registered its opinion two weeks later, to be forwarded to its representative in Congress. Reverend Clarke's guidance in creating the resolution became his last contribution to a public paper.[60] The memorial opposed arming merchant vessels because "it will commit the peace of the Nation into the hands of any and every Master and commander so armed." The resolution concluded

that "time and patience under unjust suffering do more for Nations" than provocative actions in cases like these.[61]

Young Jonas in Maine and two other signatories of a letter to President Adams took the opposite view. It conveyed its "entire approbation of the measures adopted by...the Supreme Executive."[62] Again, the position was hardly unusual for a seaport town with a merchant fleet vulnerable to armed French marauders. Fortunately, such disagreements on political matters between father and son did nothing to disrupt their close personal relationship.

In December 1798, tragedy struck. Reverend Clarke learned that his son Peter was aboard a U.S. merchant vessel bound for Cadiz, Spain, when a French ship seized it a few days out of Charleston, South Carolina. Peter landed in a prison on the Caribbean island of Guadalupe. There he was made to subsist on two ounces of meat and a half pound of bread per day. In confinement, the young man contracted a disease that, upon his release, led to his death aboard a ship bound for Newburyport, Massachusetts.[63] President Adams's arming of American merchant vessels aimed at preventing precisely that type of outrage. Peter was the first son or daughter whom Reverend Clarke outlived, a tragic prospect for a parent.

In 1777, the poor wartime economy had thwarted Lexington's attempt to raise funds for a monument. The town tried again in 1791. The annual anniversary sermons commemorating the battle had long ceased, the last given at the end of the war in 1783, but the pain and pride still dwelled in the town's living memory. Further, Lexingtonians realized that the event had earned a place of major significance in the national identity. Accordingly, on April 4, 1791, the village chose a committee to "present a memorial or petition to Congress."[64] On the committee were Reverend Jonas Clarke and Joseph Simonds, Lexington representative to the Massachusetts legislature. Unfortunately, it was among many requests for funding of monuments commemorating war heroes at the time. Congress endorsed most but funded almost none. No record survives of any consideration the national government extended to Lexington's request. It likely died in committee.

Town meeting returned to the question in 1795, and on May 2, it chose a committee of three to revisit raising funds.[65] After deliberation, the committee urged the town to erect a monument over the graves "or in any other place" and "to grant money for the same."[66] The alternative site was the first suggestion of a more prominent location. The town Common—the village focal point and the battle's location—seemed promising, all the more so the following year, when the town moved its

school building from Schoolhouse Hill, leaving a vacancy at a slightly raised elevation on the Common.

Having earlier been ignored by the federal government, Lexington now turned to Massachusetts for help. In 1797, Joseph Simonds, who had served as an ensign in Captain Parker's company, convinced the state legislature to fund a suitable monument. Having noted that an earlier request to Congress had "miscarried," the petition made clear that Lexington requested simply a "decent and durable" memorial, nothing ostentatious or expensive. (Later generations would deplore the monument's plainness.) Simonds argued for the greater propriety of a monument erected under "the patronage of the General Court of the Commonwealth of Massachusetts than a single town," inasmuch as "the cause of liberty is a public cause."[67]

The General Court accommodated the town's request, allocating the sum of $200 for the purpose of preserving "for posterity a record of the first efforts made by the people of America for the establishment of freedom & independence."[68] The funding subsequently proved insufficient and was supplemented the following year with an additional $200. The entire sum went to Thomas Park, stonecutter, to pay for his work. Even that sum proved inadequate. Thus, the state allocated yet a third sum, of $295.92, "to perpetuate the memorable battle fought there," to be paid directly to Mr. Park, whose expenses had "amounted to nearly $700" in all.[69]

The monument took the form of a granite obelisk, then a familiar shape for venerating fallen heroes. The large slate tablet provided for a lengthy inscription by a familiar author. Who could more appropriately contextualize the monument's meaning than Reverend Jonas Clarke? Clarke's inscription listed the eight militiamen who died on the Common on "the morning of the ever memorable" April 19, 1775. Citing the battle's importance in forging the nation's identity, he termed the martyrs' blood spilled in asserting and defending their "native rights" to be the "cement of the Union of these states." The Revolution had begun here. "The Die was Cast!!!"[70]

Expenses connected with the enterprise beyond the stonecutter's commission taxed the town's resources, but residents willingly bore the further cost. The first item on the town warrant in March 1799 sought funding for "raising the monument."[71] This included ropes to raise the monument and refreshments for volunteers who regraded Schoolhouse Hill, which had a broader base then but had become no more than a knoll. The granite obelisk remains there today, on the Common's southwest corner, its slate tablet replaced with one of marble in 1835. It is the earliest such

The Revolutionary monument, 1799. *Paul Doherty photograph.*

Sacred to Liberty & the Rights of mankind!!!
The Freedom & Independence of America,
Sealed & defended with the blood of her sons.

This Monument is erected
By the inhabitants of Lexington,
Under the patronage, & at the expence, of
The Commonwealth of Massachusetts,
To the memory of their Fellow Citizens,
Ensign Robert Munroe. Mess.rs Jonas Parker,
Samuel Hadley. Jonathan Harrington Jun.r
Isaac Muzzy Caleb Harrington and John Brown
Of Lexington. & Asahel Porter of Woburn,
Who fell on this field, the first Victims to the
Sword of British Tyranny & Oppression.
On the morning of the ever memorable
Nineteenth of April. An. Dom. 1775.
The Die was cast!!!
The Blood of these Martyr's,
In the cause of God & their Country,
Was the Cement of the Union of these States, then
Colonies; & gave the spring to the spirit. Firmness
And resolution of their Fellow Citizens.
They rose as one man. to revenge their brethren's
Blood and at the point of the sword to assert &
Defend their native Rights.
They nobly dar'd to be free !!
The contest was long, bloody & affecting.
Righteous Heaven approved the solemn appeal;
Victory crowned their arms; and
The Peace. Liberty & Independence of the United
States of America, was their glorious Reward.
Built in the year 1799.

The face of the Revolutionary monument, 1799. *Paul Doherty photograph.*

monument of commemoration to the common soldier erected in the newly formed United States.[72]

July 4, already the nation's most important holiday, would have seemed the logical time to dedicate the new memorial. According to Jonas Clarke's diary, however, "public prayers" and an oration by the minister's son-in-law Reverend Thaddeus Fiske of West Cambridge took place on July 3, and volunteers "finished raising the monument" the following day.[73]

Fiske began his speech with an apology, fearful that it might not meet expectations. He had written it on short notice and was standing "in

the place of another" of "superior abilities, knowledge and experience," who was unable to speak because of "indispositions and infirmities."[74] No doubt Fiske was alluding to Reverend Jonas Clarke. In late May, Clarke was beset with gout in his hand and foot.[75] He suffered from gout for much of his adult life, but the diary's final volume reveals a deteriorated handwriting characteristic of the gout-ridden elderly. He was sixty-eight when he began that final volume. During much of June, he noted "confined" and even missed Sunday meeting on one occasion.[76] His maladies did not prohibit him from traveling to Boston on June 26 to get General Court's approval for his inscription.[77] That Reverend Clarke was unable to be the featured speaker for this historic Lexington event, one in which he played such a critical role, must have struck residents as the end of an era.

Entering a new century, Reverend Clarke remained physically active, traveling to Berwick and Wells, Maine, and to Hingham to visit his children and grandchildren. In fact, he would outlive another son and a daughter in addition to Peter. Bowen died suddenly in 1800, and Mary Ware died in Hingham on July 13, 1805.[78] Their father's health continued to decline, sometimes keeping him indoors for considerable spells. Gout and "canker sores" on his legs often flared up. Increasingly, neighbors helped with his farm tasks, although he went on with his daily labor when he could. In June 1805, his strength had declined to the point that he hired James Wyman to work "half time"—that is, every other week.[79] His youngest son, Harry, no longer lived at the parsonage. Harry had earlier helped manage older brother Jonas's affairs when he began customs collector duties at Kennebunk in 1801. Harry later served as one of Jonas's deputies. It was difficult for Reverend Clarke to part with Harry, the parsonage growing ever quieter.[80] Only Betty, Sarah, brother Thomas and the help, Sarah Binney, were left for company now.

On August 24, 1805, Reverend Clarke noted, "Finished haying."[81] He would live fewer than three months longer, until Friday, November 15, although without any further account in his diary of the passing days. A newspaper obituary that December assured that Lexington's venerable minister "continued the performance of his parochial duties, until within a few weeks of his death."[82] The likely author of the obituary, Waltham's Reverend Dr. Jacob Cushing, observed in his funeral sermon that the beloved figure was "for several of his last days, by reason of another disorder, unable to discourse, perhaps incapable of reflection."[83]

On November 19, four days after Jonas Clarke's death at age seventy-four, a procession of family and friends walked from the parsonage to the meetinghouse, where Cushing delivered his eulogy.[84] The obituary noted that Reverend Clarke never delivered dry lectures but rather discourses delivered with "uncommon energy and zeal." Moreover, the late parson faithfully performed

The Hancock-Clarke tomb. *Lexington Historical Society, Paul Doherty photograph.*

his pastoral and parish duties and was generous to students and guests alike, despite chronic illnesses and only modest financial means during his long pastorate. Regarding the minister's role in the Revolution, "He was not behind his brethren in giving his influence on the side of his country, in opposition to its oppressor." Reverend Cushing observed that Clarke's "heart was wrung with anguish" at the sight of his "beloved parishioners killed not far from his door."[85]

Reverend Jonas Clarke had been a fixture at the center of Lexington's spiritual and political life for half a century during years that included the nation's earliest critical challenges. He was the only pastor most of his parishioners had ever known, and by then, his voice, demeanor and care for their spiritual health had touched thousands of lives. Although in his final years his influence may have waned, the congregation's older members ensured that his many contributions to the town, the place where a nation was born, would endure.

Historians credit contingency to varying degrees with the shaping of historical events. And indeed, it was chance that located Jonas Clarke in the proper place and time to make his significant contributions: in a New England village some twelve miles from a provincial capital around which critical events swirled. But other clergymen less resolute than he, less committed to the welfare of their people and the future of their country, might have followed a different course of action when confronting growing troubles between their colony and England. As for Jonas Clarke himself, he would have credited none of his achievements to his leadership or the force of his character, least of all to random contingency. Lexington's Patriot parson would have understood beyond

all doubt that the merit of his role in shaping his village's history—and therefore the history of a nation even then taking form—was due to divine providence alone.

NOTES

KEY

JCD = Jonas Clarke Diary, vols. 2, 4 and 5, LHS archives.
LTMSR = Records of Town Meeting and Selectmen, Lexington, Massachusetts, typescript copies, LHS archives.
LHS = Lexington Historical Society.
PLHS = *Proceedings in the Lexington Historical Society*, vols. 1–4, published by Lexington Historical Society.

PROLOGUE

1. Betty Clarke, "Extracts of Letter of Miss Betty Clarke," *PLHS* (1914), 4:92.
2. John Ware, *Memoir of the Life of Henry Ware, Jr.*, vol. 1 (Boston: American Unitarian Association, 1880), 5.
3. See Douglass Adair and John A. Schultz, eds., *Peter Oliver's Origin and Progress of the American Rebellion* (Berkeley, CA: Stanford, 1961).

CHAPTER 1

1. Jonas Clarke spelled his family name with an *e* at the end. His parents and other members of his family did not.
2. Samuel Francis Smith, *The History of Newton* (Boston: American Logotype Company, 1880), 212.
3. John Clark, *Records of the Descendants of Hugh Clark of Watertown, Mass.* (Boston: printed for author, 1866), 18.

4. Ibid., 17.

5. Ibid., 19.

6. Ibid., 22.

7. Ibid., 31.

8. Smith, *History of Newton*, 211–12. Quotation on 211.

9. Ibid., 117.

10. John Langdon Sibley, MA, *Biographical Sketches of Graduates of Harvard University in Cambridge, Massachusetts* (Cambridge, MA: Charles William Sever, 1873), 12:177.

11. Smith, *History of Newton*, 215.

12. Alexander Young, *A Discourse on the Life and Character of the Reverend John Thornton Kirkland: Delivered in the Church on Church Green, May 3, 1840* (Boston: C.C. Little & J. Brown, 1838), 31.

13. Smith, *History of Newton*, 207.

14. Ibid., 208.

15. Francis Jackson, *A History of the Early Settlement of Newton, County of Middlesex* (Boston: Stacey and Richardson, 1854), 131.

16. Benjamin Peirce, *A History of Harvard University from Its Foundation in the Year 1636 to the Period of the American Revolution* (Cambridge, MA: Brown, Shattuck and Company, 1833), 204.

17. Smith, *History of Newton*, 219.

18. Jackson, *History of the Early Settlement of Newton*, 131.

19. Peirce, *History of Harvard University*, 205.

20. Robert Gross, *The Minutemen and Their World* (New York: Farrar Straus and Giroux, 1976), 19–20.

21. Ina Mansur, *A New England Church: 1730–1834* (Freeport, ME: Bond Wheelwright Company, 1974), 59.

22. Ibid., 53.

23. William Barry, *A History of Framingham, Massachusetts* (Boston: James Munroe and Company, 1847), 114–15.

24. Jackson, *History of the Early Settlement of Newton*, 132.

25. John Hancock in Lucius Robinson Paige, *History of Cambridge, Massachusetts, 1630–1877* (Boston: Houghton and Company, 1877), 346.

26. Mansur, *New England Church*, 51.

27. James W. Schmotter, "Ministerial Careers in the Eighteenth-Century New England: The Social Context, 1700–1760," *Journal of Social History* 9, no. 2 (Winter 1975): 250.

28. Ibid., 252.

29. Ibid., 257.

30. One contemporary diarist, William Bentley, pastor at Salem, commenting on Clarke's death, noted, "For several years he desisted from any preparation for the pulpit in his studies." See William Bentley et al.,

The Diary of William Bentley, Pastor of the East Church, Salem, Massachusetts (Salem, MA: Essex Institute, 1911), 3:200.

31. Peirce, *History of Harvard University*, Appendix, 125.

32. Albert Matthews, "'Varia': A Glimpse of Harvard in 1750," *Harvard Graduates' Magazine* (June 1918): 702.

33. Sibley, *Biographical Sketches*, 12:210.

34. Ibid., 12:177.

35. Peirce, *History of Harvard University*, 217.

36. Josiah Quincy, *The History of Harvard University* (Boston: Nichols, Lee and Company, 1860), 2:97.

37. Peirce, *History of Harvard University*, 220.

38. Quincy, *History of Harvard University*, 2:90.

39. William M. Fowler Jr., *The Baron of Beacon Hill: A Biography of John Hancock* (Boston: Houghton Mifflin, 1980), 26.

40. Ibid., 30.

41. Charles W. Akers, *Called Unto Liberty: A Life of Jonathan Mayhew, 1720–1766* (Cambridge, MA: Harvard University Press, 1964), 25.

42. Houghton Library, Harvard University, "Records of the College Faculty, Vol. I, 1725–1752," 305, 314, 280, 310, 313, 331.

43. Quoted in Sibley, *Biographical Sketches*, 12:204.

44. Peirce, *History of Harvard University*, 245.

45. Houghton Library, Harvard University, "Records of the College Faculty," 11, 30.

46. Carlos Slafter, *A Record of Education: The Schools and Teachers of Dedham, Massachusetts, 1644–1904* (Dedham, MA: Transcript Press, 1901), 58.

47. Letter, Jonas Clark to Thomas Clark, December 14, 1753, LHS.

48. Jonas Clarke's account book, in *Historical Papers Owned by Lexington Historical Society in Four Volumes*, LHS.

49. Samuel Sewall, *The History of Woburn, Middlesex County, Mass. 1640, to the Year 1860* (Boston: Wiggin and Lunt, 1868), 328–29.

CHAPTER 2

1. Charles Hudson, *History of Lexington, Mass.*, vols. 1 and 2 (Boston: Houghton Mifflin, 1913), 1:16–18.

2. Ibid., 1:20. Population estimate on page 477.

3. Ibid., 1:34.

4. Harry S. Stout, *The New England Soul: Preaching and Religious Culture in Colonial New England* (New York: Oxford, 1986), 17–18.

5. A copy of the Records of the Church of the First Congregational Society in Lexington copied by Miss Bathsheba Whitman, 1854. The entry was dated 1696.

6. Hudson, *History of Lexington, Mass.*, 1:45.

7. J. William T. Youngs Jr., *God's Messengers: Religious Leadership in Colonial New England, 1700–1750* (Baltimore, MD: Johns Hopkins University Press, 1976), 71.

8. Richard D. Brown, *Knowledge Is Power: The Diffusion of Information in Early America, 1700–1865* (New York: Oxford University Press, 1989), 70.

9. Salem and Concord are two examples. See Paul Boyer and Stephen Nissenbaum, *Salem Possessed: The Social Origins of Witchcraft* (Cambridge, MA: Harvard University Press, 1974), and Gross, *Minutemen and Their World*.

10. Youngs, *God's Messengers*, 29.

11. Sibley, *Biographical Sketches*, 3:404.

12. Carlton A. Staples, "Two Old Time Ministers," *An Address in Commemoration of the Ordination and Settlement of John Hancock, November 2, 1698, Over Cambridge Farms Parish [Now Lexington] in the First Parish Church Lexington Mass Nov. 2, 1898* (Arlington, MA: C.S. Parker & Son, 1900), 6.

13. Hudson, *History of Lexington, Mass.*, 1:311.

14. Ibid., 1:313.

15. Youngs, *God's Messengers*, 23–24.

16. *A Sermon Preached*, Boston, 1726, quoted in Stout, *New England Soul*, 165.

17. Dean Grodzins, *American Heretic: Theodore Parker and Transcendentalism* (Chapel Hill: University of North Carolina Press, 2002), 14.

18. John Hancock, MA, *Rulers Should Be Benefactors* (n.p.: printed by B. Green printer to His Excellency and Council, 1722), 3. Found in "Early American Imprints, Series 1, No. 2340 (filmed)," available online at infoweb.newsbank.com.

19. Ibid., 5.

20. Ibid., 3.

21. LTMSR, April 1, 1715.

22. Staples, "Two Old Time Ministers," 7.

23. Ann Grady and Deane Rykerson, "The Hancock Clark House Renovation Report" (Lexington, MA, 2007), 5.

24. Hudson, *History of Lexington, Mass.*, 2:266.

25. Fowler, *Baron of Beacon Hill*, 8–10.

26. W.T. Baxter, *The House of Hancock: Business in Boston, 1724–1775* (Cambridge, MA: Harvard, 1945), 77.

27. Grady and Rykerson, "Hancock Clark House Renovation Report," Lexington, MA, 11–12. Ann Grady and Dean Rykerson also show evidence that Ebenezer planned a building project at the same time.

28. Abram English Brown, *John Hancock: His Book* (Boston: Shephard and Lee, 1898), 4.

29. Hudson, *History of Lexington, Mass.*, 1:56.

30. Sewall, *History of Woburn, Middlesex County*, 329.

31. Hudson, *History of Lexington, Mass.*, 1:477.

32. Josiah Parker, town clerk recording vote, May 19, 1755, LHS.

33. Letter to the Lexington congregation, July 26, 1755, LHS.

34. LTMSR, May 28, 1753; August 26, 1754.

35. Jonas Clarke account book, LHS.

36. First Parish Records, LHS, "Negro Servant to Madame Hancock," September 9, 1759.

37. Jonas Clarke's account book, *Historical Papers Owned by Lexington Historical Society*, 78, 82.

38. Abram English Brown, *History of the Town of Bedford, Middlesex County, Massachusetts* (Bedford, MA: self-published, 1891), 12.

39. The marriage appears in both the Arlington (page 62) and Lexington (page 106) vital records. But a notation in Reverend Cooke's diary listing marriages reveals that he performed the marriage in Arlington (then Menotomy). Diary found at Arlington Historical Society, Arlington, Massachusetts.

40. Edwin Worthen Jr., "Jonas Clarke of Lexington: An Account of His Life and Service to the Town, 1730–1805," unpublished paper, 1969, 5.

CHAPTER 3

1. *Vital Records of Newton, Massachusetts* (Boston: New England Historic Genealogical Society, 1902), 437.

2. Clark, *Records of the Descendants of Hugh Clarke*, 31–32.

3. Letter to Mary Cotton, April 20, 1754, LHS.

4. Rebecca Jo Tannenbaum, *Health and Wellness in Colonial America* (New York: ABC-CLIO, 2012), 14.

5. Letter to Thomas Clark, December 14, 1753, LHS.

6. Hudson, *History of Lexington, Mass.*, 2:112.

7. Letter to Mary Cotton, April 4, 1782, LHS.

8. *Lexington, Mass.: Record of Births, Marriages and Deaths to January 1, 1798* (Boston: Wright & Potter Printing Company, 1898), 170.

9. JCD, vol. 2, March 2, 1767.

10. Letter, Robert Clapp to James P. Munroe, May 15, 1896, found in the LHS vertical file. The letter expresses some confusion as to which volumes were missing. But today, LHS holds the second, fourth and fifth volumes, having purchased them from Mary Very of Framingham in 1932.

11. Carlton Staples, "Cambridge Farms," *PLHS* (1905), 3:40.

12. JCD, vol. 2, February 10, Mrs. Buckman; February 17, John Buckman; March 7, Widow Raymond; March 29, John Muzzey; April 3, Eliza Lawrence; April 11, Jonathan Trask.

13. Ibid., vol. 2, April 14, 1768.

14. Stout, *New England Soul*, 28.

15. JCD, vol. 2, Winship death, April 16; private fast, April 26; John Munroe death, April 27.

16. The restored gravestone can be found in the First Parish burial ground, Lexington, Massachusetts.

17. Letter to parents, October 26, 1758, LHS.

18. Hudson, *History of Lexington, Mass.*, 2:113.

19. Mina Goddard, "Custodian's Story," unpublished paper, 12–13, LHS. Betsy is the name Jonas Clarke used for his second oldest daughter. When written about by others, she is called Betty.

20. Laurel Thatcher Ulrich, "Martha Ballard and Her Girls: Women's Work in Eighteenth-Century Maine," in *Work in Early America*, ed. Stephen Innes (Chapel Hill: University of North Carolina Press, 1788), 81.

21. JCD, vol. 2, September 29, 1774, *passim*.

22. Letter to parents, January 29, 1764.

23. Copy of Probate Inventory, Jonas Clarke, Lexington, December 12, 1805, LHS. The house contents in 1805 may not reflect what the Clarkes owned in the 1750s and 1760s, but families tended to keep items over their lifespan, unlike today's disposable material culture.

24. Laurel Thatcher Ulrich, *Goodwives: Image and Reality in the Lives of Women in Northern New England, 1650–1750* (New York: Oxford University Press, 1980), 29.

25. JCD, vol. 2, January 1, 1767; December 9, 1767, *passim*.

26. Ulrich, *Goodwives*, 157–58. Quotation on 157.

27. Jane C. Nylander, *Our Own Snug Fireside: Images of the New England Home, 1760–1860* (New Haven, CT: Yale University Press, 1994), 90.

28. Letter to parents, January 29, 1764, LHS.

29. JCD, vol. 2, March 5, 1767. Jonas Clarke refers to Betty as Betsy.

30. Ibid., March 6, 1767, LHS.

31. Ibid., March 9, 13, 14, 1767. This quotation is from March 26, LHS.

32. Letter to parents, February 22, 1768, LHS.

33. Staples, "Two Old Time Ministers," 12. In this, Staples said that Betty was "badly disfigured." Never having met her, he must have learned the extent of the scars from residents who had, LHS.

34. JCD, vol. 2, May 24 and 29, 1769.

35. Ibid., June 15, 1773. Thomas was fourteen and Jonas thirteen. The others were either too young or had yet to be born.

36. Mary Fuhrer, "Reckoning with the Parkers: Three Generations of Artisan Trade in Colonial and Early Republic Lexington (1736–1856)," unpublished monograph, April 2005, 3.

37. Jonas Clarke's account book, *Historical Papers Owned by Lexington Historical Society*, 17. In 1758, he paid Tidd for thirteen days' work from July until December 2.

38. Alice M. Baldwin, *The New England Clergy and the American Revolution* (Durham, NC: Duke University Press, 1927), 128, n25.

39. JCD, vol. 2, August 24, 1805.

CHAPTER 4

1. William Ware, "Jonas Clarke," in *Annals of the American Pulpit*, ed. William Buell Sprague (New York: R. Carter and Brothers, 1857–69?), 514–19. Quotations, 8:515. William Ware's contribution was written in 1850.

2. Staples, "Two Old Time Ministers," 15.

3. John Quincy Adams and Charles Francis Adams, *Life in a New England Town, 1787, 1788: Diary of John Quincy Adams while a Student in the Office of Theophilus Parsons in Newburyport* (Boston: Little Brown Company, 1903), 124.

4. Staples, "Two Old Time Ministers," 12–13.

5. Hudson, *History of Lexington, Mass.*, 1:42.

6. Carlton A. Staples, "Sketch of the History of Lexington Common," *PLHS* (1890), 1:20. A diagram showing the floor plan can be found on page 16.

7. Grady and Rykerson, "Hancock Clark House Renovation Report," 87.

8. Ware, "Jonas Clarke," 8:515.

9. Stout, *New England Soul*, 220.

10. Staples, "Two Old Time Ministers," 10.

11. Jonas Clarke Sermons, Jonas Clarke, Box 1, LHS. The number more commonly given is 2,179. But this was the number of the last sermon in William Ware's possession. Clarke's records show that this sermon was not his last one.

12. Stout, *New England Soul*, 48. Thursday lectures began after the initial stages of the Great Migration.

13. JCD, vol. 2, lecture days, *passim*; Cooper visit, September 30, 1767; Boston lecture, October 8, 1767.

14. JCD, vol. 2, *passim*.

15. Jonas Clarke Papers, *passim*, LHS.

16. Youngs, *God's Messengers*, 21.

17. Hudson, *History of Lexington, Mass.*, 2:65.

18. *Bowen's Boston News-Letter and City Record*, January–July 1826, 1:1, American Periodical Series online, page 155EL.

19. JCD, vol. 2, *passim*.

20. *A Sermon, Preached at the Ordination of the Reverend Mr. Joseph Estabrook, to the Pastoral Care of the Church of Christ in Athol, November 21, MDCCLXXXVII* (Worcester, MA: Isaiah Thomas, [1788]); *A Sermon Preached at the Ordination of the Reverend William Muzzy, to the Pastoral Care of the Church of Christ in Sullivan, New Hampshire, February 7, 1798* (Keene, NH: John Prentiss, 1799).

21. *Bowen's Boston News-Letter and City Record*, January–July 1826, 1:1, American Periodical Series online, page 155EL.

22. *Columbian Centinel*, "Obituary," December 21, 1805, 1.

23. John Hancock's commonplace book quoted in Youngs, *God's Messengers*, 57.

24. John Von Rohr, *The Shaping of American Congregationalism, 1620–1957* (Cleveland, OH: Pilgrim Press, 1992), 44.

25. Ware, "Jonas Clarke," 8:515.

26. James Phinney Munroe, *A Sketch of the Munro Clan...Together with a Letter from Sarah Munroe to Mary Mason Descriptive of the Visit of President Washington to Lexington in 1789* (Boston: George H. Ellis, 1900), 58.

27. Ibid., 64.

28. Von Rohr, *Shaping of American Congregationalism*, 45–46.

29. Lyman Abbot, in Richard D. Brown, "Spreading the Word: Rural Clergymen and the Communication Network of 18th-Century New England," *Proceedings of the Massachusetts Historical Society* 94, third series (1982): 1–14.

30. Ware, "Jonas Clarke," 8:515.

31. Jonas Clarke, *The Fate of the Blood-Thirsty Oppressors and God's Tender Care of His Distressed People. Preached at Lexington* (Boston: Powers and Willis, 1776).

32. Sibley, *Biographical Sketches*, 12:211.

33. LTMSR, March 15, 1756, 184–85; March 7, 1757.

34. Hudson, *History of Lexington, Mass.*, 1:n416–17.

35. Fred Anderson, *A People's Army: Massachusetts Soldiers and Society in the Seven Years' War* (Chapel Hill: University of North Carolina Press, 1984), 38–39.

36. Von Rohr, *Shaping of American Congregationalism*, 195.

37. Sermon, Reverend Jonas Clarke in Lexington, January 1756, LHS.

38. Stout, *New England Soul*, 167–70.

39. Ibid., 244.

40. Sermon preached the morning of July 23, 1763, at Lexington. Found in Congregational Library, Boston, Massachusetts.

41. Stout, *New England Soul*, 251.

42. "Proclamation" from George III to Governor Francis Bernard, July 27, 1763, LHS.

43. Quoted in Sibley, *Biographical Sketches*, 12:213–14.

44. Anderson, *People's Army*, 117–19.

45. Hudson, *History of Lexington, Mass.*, 1:417.

46. Fred Anderson, *The War that Made America: A Short History of the French and Indian War* (New York: Penguin, 2005), 243.

47. Mary Fuhrer, "Reckoning with the Parkers: Three Generations of Artisan Trade in Colonial and Early Republic Lexington (1736–1836)," unpublished monograph, April 2005, Appendix.

CHAPTER 5

1. Stout, *New England Soul*, 28.

2. Quoted from Parkman's Diary in Youngs, *God's Messengers*, 60.

3. T.H. Breen, *The Marketplace of Revolution: How Consumer Politics Shaped American Independence* (New York: Oxford, 2004), 167.

4. Jonas Clarke, AM, *The Best Art of Dress: or, Early Piety Most Amiable and Ornamental. A Sermon, Preached at Lexington, to a Religious Society of Young Men, on Lord's-Day Evening Sept. 13, 1761* (Boston: D. and J. Kneeland, 1761), 9, 10, 12.

5. Clarke and Simonds were named as subscribers in their articles on their houses' burglaries. Parker used the *Gazette* as a cover for his account book. See Fuhrer, "Reckoning with the Parkers."

6. *Boston Evening-Post*, May 27, 1771, 3. The announcement states that a rider will carry messages from Boston to Fitchburg. It lists stops in each town. For Lexington, it was Buckman's Tavern.

7. Joel Tyler Headley, *Chaplains and Clergy of the Revolution* (New York: Scribner, 1864), 76; Samuel Adams Drake, *History of Middlesex County* (Boston: Estes and Lauriett, 1880), 2:16; Ware, *Memoir of the Life of Henry Ware, Jr.*, 1:4.

8. JCD, vol. 2, June 28, 1768.

9. Ibid., vol. 2. The calculation excluded 1775 and 1776 because travel to Boston from "the country" was limited for parts of those years.

10. Ibid., October 7, 1773.

11. Fowler, *Baron of Beacon Hill*, 49.

12. Baxter, *House of Hancock*, 145.

13. Fowler, *Baron of Beacon Hill*, 146.

14. JCD, vol. 2, September 21 and 17, 1767.

15. Ibid., September 30, 1767; October 8, 1767; April 15, 1775.

16. Charles W. Akers, *The Divine Politician: Samuel Cooper and the American Revolution in Boston* (Boston: Northeastern University Press, 1982), 144–45, 30, 90.

17. Copy of Probate Inventory, Jonas Clarke, Lexington, December 12, 1805, LHS.

18. Baldwin, *New England Clergy*, 22.

19. Stout, *New England Soul*, 7. Quotation on page 252.

20. Daniel Leonard, *Massachusettensis: or a Series of Letters, Containing a Faithful State of Many Important and Striking Facts, which Laid the Foundation of the Present Troubles in the Province of the Massachusetts-Bay* (London: J. Matthews, 1776), 14. These were letters that had been published in the *Massachusetts Gazette*, 1774–75.

21. Stout, *New England Soul*, 4.

22. Leonard, *Massachusettensis*, 14.

23. Adair and Schultz, *Peter Oliver's Origin and Progress*.

24. *Boston Gazette*, "Dialogue Between an Pensioner and a Divine," July 25, 1768, 2.

25. Adair and Schultz, *Peter Oliver's Origin and Progress*, 29.

26. Richard Archer, *As If in an Enemy's Country: The British Occupation of Boston and the Origins of Revolution* (New York: Oxford University Press, 2010), 8–9.

27. Hudson, *History of Lexington, Mass.*, 1:69.

28. Edward Everett, *An Address Delivered at Lexington, the 19th (20th) of April, 1835. Charlestown, Mass* (n.p.: William Wheldon, 1835), 9.

29. Ware, "Jonas Clarke," 514–19. Quotations, 8:517.

30. Mina Goddard, "Custodian's Story," unpublished paper, 1920, LHS.

31. Baldwin, *New England Clergy*, Appendix, 185–88.

32. Hudson, *History of Lexington, Mass.*, 1:69–70.

33. Mary Babson Fuhrer, "Analysis of Lexington Tax Assessments and Valuations," in NHM Exhibit Research Project, March 2003, National Heritage Museum archives.

34. Mary Babson Fuhrer, "The Revolutionary Worlds of Lexington and Concord Compared," *New England Quarterly* 85, no. 1 (March 2012): 92, n30 and n31.

35. Hudson, *History of Lexington, Mass.*, 1:70.

36. *Boston Evening Post*, May 27, 1765, 2.

37. *Boston Gazette and Country Journal*, September 16, 1765, 4.

38. Hudson, *History of Lexington, Mass.*, 1:70.

39. Ibid., 1:71.

40. The *Boston Gazette and Country Journal* reported on May 20, 1765, on page 3 that petitions sent from several colonies were to be read in Commons during deliberations concerning the Stamp Act approval. But MPs entrusted with the petitions "chose to defer the presenting of the same to the House of Commons till the Stamp Bill was bro't in."

41. Hudson, *History of Lexington, Mass.*, 1:71.

42. Ibid., 1:72.

43. *Boston Evening-Post*, August 19, 1765, 3.

44. Akers, *Called Unto Liberty*, 201–5.

45. Pauline Maier, *From Resistance to Revolution: Colonial Radicals and the Development of American Opposition to Britain, 1765–76* (New York: Norton, 1991), 61–65.

46. JCD, vol. 2, May 16, 1766.

47. "Great Britain: Parliament—The Declaratory Act; March 18, 1766." Available at Yale Law School Avalon Project, http://avalon.law.yale.edu/18th_century/declaratory_act_1766.asp.

48. JCD, vol. 2, July 24, 1766.

49. Edward M. Griffin, *Old Brick: Charles Chauncy of Boston, 1705–1787* (Minneapolis: University of Minnesota Press, 1980), 142.

CHAPTER 6

1. *Boston Gazette*, August 31, 1769, 1.

2. Maier, *From Resistance to Revolution*, 114.

3. Arthur Meier Schlesinger, *The Colonial Merchants and the American Revolution, 1763–1776* (New York: Columbia University Press, 1918), 107n.

4. Ibid., 108.

5. *Boston Gazette*, January 11, 1768. Listed were Sandwich, Truro, Abington, Lexington, Bolton and Grafton.

6. LTMSR, December 28, 1767.

7. Schlesinger, *Colonial Merchants and the American Revolution*, 110.

8. Maier, *From Resistance to Revolution*, 116.

9. William M. Fowler Jr., *Samuel Adams: Radical Puritan* (New York: Longman, 1997), 79.

10. Benjamin L. Carp, *Rebels Rising: Cities and the American Revolution* (New York: Oxford University Press, 2007), 46–49.

11. *Boston Gazette, Boston Evening Post, Boston Post Boy, Boston Newsletter*, July 4, 1768.

12. Fowler, *Baron of Beacon Hill*, 50.

13. JCD, vol. 2, June 24, 1768.

14. Ibid., July 4, 1768.

15. Jonas Clarke, *A Sermon Preached to the Ancient and Honorable Artillery Company in Boston, New England June 6, 1768: The Importance of Military Skill* (Boston: Kneeland & Adams and Bowes, 1768), 14.

16. Anne Rowe Cunningham, *The Letters and Diary of John Rowe, Boston Merchant* (Boston: W.B. Clarke, 1903), 164.

17. Richard D. Brown, "The Massachusetts Convention of Towns, 1768," *William and Mary Quarterly* 26, no. 1, third series (January 1969): 103. Many towns from Barnstable, Hampshire and Berkshire Counties were absent, reflecting shallow support for the Whig cause in western and parts of southern Massachusetts.

18. Ibid., 95.

19. Hudson, *History of Lexington, Mass.*, 1:73.

20. Ibid., 1:75.

21. Ibid., 1:74.

22. Richard L. Bushman, *King and People in Provincial Massachusetts* (Chapel Hill: University of North Carolina Press, n.d.), 204–6.

23. Mary Babson Fuhrer, "The Revolutionary Worlds of Lexington and Concord Compared," *New England Quarterly* 85, no. 1 (March 2012): 114.

24. JDC, vol. 2, September 29, 1768.

25. Ibid., October 1 and 2, 1768.

26. Archer, *As If in an Enemy's Country*, 106.

27. John Richard Alden, *General Gage in America* (Baton Rouge: Louisiana State University Press, 1948), 163–64.

28. Ibid., 166.

29. Schlesinger, *Colonial Merchants and the American Revolution*, 120.

30. Fuhrer, "Reckoning with the Parkers," 40 graph. Parker sold twenty-eight spinning wheels in 1767 and 1768. From 1758 to 1774, excluding 1767–68, he sold thirty-four. Not all were sold to Lexington residents.

31. *Boston Gazette*, August 31, 1769, 1.

32. Mary Beth Norton, *Liberty's Daughters: The Revolutionary Experience of American Women, 1750–1800* (Ithaca, NY: Cornell University Press, 1980), 166.

33. *Boston Gazette*, August 31, 1769, 1.

34. LTMSR, February 16, 1769.

35. *Boston Gazette*, March 27, 1769, 2.

36. Norton, *Liberty's Daughters*, 167.

37. Adair and Schultz, *Peter Oliver's Origin and Progress*, 63–64.

38. Archer, *As If in an Enemy's Country*, 127.

39. Ibid., 116.

40. Ibid., 105.

41. Hiller B. Zobel, *The Boston Massacre* (New York: Norton, 1970), 173–77.

42. *Boston Evening Post*, February 26, 1770, 3.

43. Zobel, *Boston Massacre*, 178.

44. Alden, *General Gage in America*, 178.

45. Zobel, *Boston Massacre*, 215.

46. Carp, *Rebels Rising*, 51.

47. Hudson, *History of Lexington, Mass.*, 2:112–13.

48. Richard D. Brown, *Revolutionary Politics in Massachusetts: The Boston Committee of Correspondence and the Towns, 1772–1774* (New York: Norton, 1970), 38–39.

49. Ibid., 47.

50. Bushman, *King and People*, 172.

51. Brown, *Revolutionary Politics in Massachusetts*, 67.

52. Ibid., 71–72. Quotation on page 72.

53. Ibid., 75.

54. Ibid., 88.

55. Hudson, *History of Lexington, Mass.*, 1:79.

56. Ibid., 1:80.

57. Brown, *Revolutionary Politics in Massachusetts*, 95–96.

58. Ibid., 98.

59. Ibid., 97n.

60. Hudson, *History of Lexington, Mass.*, 1:81.

CHAPTER 7

1. JCD, vol. 2, April 5, 15, 25, May 3, 1773.

2. *Boston Gazette*, May 24, 1773, 3.

3. JCD, vol. 2, August 28, 1773.

4. *Boston Gazette*, September 6, 1773, 2.

5. *Boston Post-Boy*, August 23, 1773, 3.

6. *Boston News-Letter*, September 16, 1773, 2.

7. Irene Quenzler Brown and Richard Brown, *The Hanging of Ephraim Wheeler* (Cambridge, MA: Harvard University Press, 2003), 232.

8. JCD, vol. 2, quotation on September 10, 1773.

9. Ibid., October 7 and 20, 1773.

10. Steven Wilf, *Law's Imagined Republic: Popular Politics and Criminal Justice in Revolutionary America* (New York: Cambridge University Press, 2010), 44.

11. Stuart Banner, *The Death Penalty: An American History* (Cambridge, MA: Harvard University Press, 2009), 131.

12. Benjamin L. Carp, *Defiance of the Patriots: The Making of the Boston Tea Party & the Making of America* (New Haven, CT: Yale University Press, 2010), 13–14.

13. Carp, *Defiance of the Patriots*, 71.

14. Ibid., 20–21.

15. Cambridge Town Meeting Resolutions printed in *Boston Post-Boy*, November 29, 1773.

16. *Boston Post-Boy*, November 15, 1773, 3.

17. Brown and Brown, *Hanging of Ephraim Wheeler*, 162.

18. *Boston News-Letter*, December 2, 1773, 3 (Cambridge); *Boston Evening-Post*, December 6, 1773, 4 (Charlestown); *Boston Evening-Post*, December 6, 1773, 4 (Dorchester); *Essex Gazette*, December 7, 1773, 79 (Marblehead); *Boston Gazette*, December 10, 1773, 4 (Medford); *Essex Gazette*, December 28, 1773, 89 (Lynn).

19. *Boston Gazette*, December 20, 1773, 1.

20. Hudson, *History of Lexington, Mass.*, 1:82.

21. Ibid., 1:83.

22. *Boston Evening-Post*, February 7, 1774, 2; *Boston Evening-Post*, January 10, 1774, 1.

23. Hudson, *History of Lexington, Mass.*, 1:84.

24. *Boston Evening-Post*, January 10, 1774, 1.

25. *Essex Gazette*, December 14, 1773, 83. The article uses an extract from a letter that dates the tea burning on December 11, but every other report dates it as December 13.

26. JCD, vol. 2, December 17, 1773.

27. Carp, *Defiance of the Patriots*, 140; Charles Bahne, "How Much Was the Tea in the Tea Party Worth?" found in J.L. Bell, "Boston1775" blog, December 18, 2009.

28. JCD, vol. 2, May 10, 1773.

29. Brown, *Revolutionary Politics*, 186.

30. Ibid., 187.

31. Fowler, *Samuel Adams*, 127.

32. JCD, vol. 2, June 20 and 23, 1774.

33. Schlesinger, *Colonial Merchants and the American Revolution*, 323–24.

34. Alden, *General Gage in America*, 207–8.

35. Akers, *Divine Politician*, 181.

36. Charles Knowles Bolton, ed., *The Letters of Hugh, Earl Percy: From Boston and New York, 1774–1776* (Boston: Goodspeed, 1902 Legacy Reprint), 29.

37. JCD, vol. 2, July 14, 1774.

38. Benjamin Cutter and William Richard Cutter, *History of the Town of Arlington, Massachusetts, 1635–1879* (Boston: David Clapp and Son, 1880), 43.

39. LTMSR, June 13, 1774.

40. Ray Raphael, *The First American Revolution: Before Lexington and Concord* (New York: New Press, 2002), 90.

41. Ibid., 94.

42. Alden, *General Gage in America*, 212.

43. Raphael, *First American Revolution*. Raphael argues on pages 51–52 that the Revolution began when central and western Massachusetts residents shut down courts and forced Crown-appointed officeholders to resign their posts.

44. Ibid., 97–99.

45. Ibid., 131–32.

46. Ibid., 76–80.

47. JCD, vol. 2, September 1 and 2, 1774.

48. Raphael, *First American Revolution*, 1.

49. Ray Raphael, *Founders: The People Who Brought You a Nation* (New York: New Press, 2009), 155.

50. David Hackett Fischer, *Paul Revere's Ride* (New York: Oxford University Press, 1994), 27.

51. Alden, *General Gage in America*, 220–21.

52. From Clarence E. Carter, ed., *The Correspondence of General Thomas Gage with the Secretaries of State and with the War Office and the Treasury*, vol. 2 (New Haven, CT: Yale, 1933), 658–59.

53. Alden, *General Gage in America*, 222.

54. JCD, vol. 2, September 15 and October 5, 1774.

55. Richard L. Boucher, "The Colonial Militia as a Social Institution: Salem, Massachusetts, 1764–1775," *Military Affairs* 37, no. 4 (December 1973): 125; Fischer, *Paul Revere's Ride*, 154.

56. JCD, vol. 2, October 10, 1774.

57. LTMSR, November 3, 1774.

58. *The Journals of the Provincial Congress in 1774 and 1775* (Boston: Dutton and Wentworth, 1838), 48.

59. LTMSR, December 12, 1774.

60. Stout, *New England Soul*, 288.

61. Bill Poole, "Captain John Parker: A Brief Biography." This is a biography written for the Lexington Minutemen Company reenactors. Parker's veteran status cannot be supported by documentation—only family tradition and his company's deference. Available at http://www.lexingtonminutemen.com/uploads/1/6/2/4/16242256/captain_john_parker_biography_2_column.pdf.

62. Elizabeth Parker, "Captain John Parker," *PLHS* (1890), 1:43–44.

63. *Journals of the Provincial Congress*, 47.

64. Lexington Company was part of the Middlesex First Regiment of Foot. In *We Stood Our Ground*, historian Alex Cain argued that the regiment's commander never issued orders to form minuteman units. He believes that the plan to supply bayonets supports his theory. Alex Cain, *We Stood Our Ground* (Westminster, MD: Heritage Books, 2004), 46.

65. LTMSR, December 27, 1774.

CHAPTER 8

1. Schlesinger, *Colonial Merchants and the American Revolution*, 315.

2. *Boston Gazette*, "Donations Since Our Last," January 10, 1775, 3.

3. Ware, *Memoir of the Life of Henry Ware, Jr.*, 4.

4. JCD, vol. 2, February 26, 1775.

5. Fischer, *Paul Revere's Ride*, 63.

6. Alden, *General Gage in America*, 221.

7. Fischer, *Paul Revere's Ride*, 81.

8. Alden, *General Gage in America*, 241.

9. Ibid., 239.

10. Ibid., 238.

11. *Journals of the Provincial Congress*, March 22, 1775, 513.

12. Elizabeth Ellery Dana, ed., *The British in Boston: Being the Diary of Lt. Barker*, reprint ed. (North Stratford, NH: Ayer, 2002), 27.

13. Allen French, *General Gage's Informers*, reprint ed. (Cranbury, NJ: Scholar's Bookshelf, 2005), 3–33.

14. Jim Hollister, "Rare Revolutionary Cannon Returns to Minuteman Park," *Concord Magazine*, available at http://www.concordma.com/magazine/spring05/cannons.html; J.L. Bell, "The Boston Regiment in Late 1774," "Boston1775" blog entry, August 30, 2006, http://boston1775.blogspot.com/2006/08/boston-regiment-in-late-1774.html.

15. French, *General Gage's Informers*, 22.

16. Gage, "General Orders," in Dana, *British in Boston*, 29.

17. French, *General Gage's Informers*, 25–26.

18. Paul Revere to Jeremy Belknap in Paul Revere, *Three Accounts of His Famous Ride* (Boston: Massachusetts Historical Society, 1968). Clarke uncharacteristically failed to note this visit from Revere in his almanac diary.

19. JCD, vol. 2, March 30, 1775. Clarke noted that Adams and Hancock were "here" on this day but not when they left. Given the need for accommodation over an extensive time, I assume they stayed most or the entire time.

20. G.D. Scull, ed., *Memoirs and Letters of Captain W. Granville Evelyn, of the 4ᵗʰ Reg ("King's Own") from North America, 1774–76* (Oxford, UK: James Parker and Company, 1879), 23.

21. Frederick Mackenzie, *The Diary of Frederick Mackenzie*, vol. 1 (Cambridge, MA: Harvard University Press, 1930), 6.

22. Elizabeth A. Fenn, *Pox Americana: The Great Smallpox Epidemic of 1775–1782* (New York: Hill and Wang, 2001), 46–49.

23. Ellen Woodbury, *Dorothy Quincy: Wife of John Hancock* (New York: Neale Publishing, 1905), 56.

24. JCD, vol. 2, April 7, 1775.

25. French, *General Gage's Informers*, 19.

26. Revere, *Three Accounts*.

27. This happened on March 22, 1775. *Journals of Each Provincial Congress*, 109.

28. Ibid., 112–44.

29. JCD, vol. 2, April 15, "Mr. Cooper and Wife"; April 17, "Mr. Homer & Wife. Thomas and Miss P. Barrett."

30. Akers, *Divine Politician*, 195–96.

31. Ezra Ripley, *A History of the Fight at Concord on April 19, 1775* (Concord, MA: Allen and Atwill, 1827), 20.

32. JCD, vol. 2, April 18, 1775; Fischer, *Paul Revere's Ride*, 311.

33. French, *General Gage's Informers*, 29–30. Quotation on page 30.

34. Deposition (taken on March 7, 1825) of William Munroe in Hudson, *History of Lexington, Mass.*, 1:A541.

35. Jonas Clarke, "Narrative of the Battle of Lexington," appended to a sermon preached on April 19, 1776, in Hudson, *History of Lexington, Mass.*, 1:A526.

36. Elisabeth Harrington, "A Few Words for Our Grandmothers," *PLHS* (1890), 1:51. This was a story told to the author.

37. Deposition (taken on March 7, 1825) in Hudson, *History of Lexington, Mass.*, 1:A549.

38. Dorothy Quincy remembered Hancock traveling to the Common at that time. *New England Historical and Genealogical Society Register* 8, "Reminiscences

by Gen. Wm. H. Sumner" (April 1854): 187. She did not mention anyone accompanying him.

39. Deposition (taken in March 7, 1824) of Nathan Munroe in Hudson, *History of Lexington, Mass.*, 1:A547. Munroe noted that Captain Parker sent them. But most accounts do not place Parker on the Common until later.

40. Clarke, "Narrative of the Battle of Lexington."

41. G.W. Brown, "Sketch of the Life of Solomon Brown," *PLHS* (1900), 2:124.

42. Clarke, "Narrative of the Battle of Lexington."

43. "The Deposition: Corrected Copy," in Revere, *Three Accounts.*

44. "To Jeremy Belknap," written in 1798, in Revere, *Three Accounts.*

45. Fischer, *Paul Revere's Ride*, 108.

46. William Munroe Deposition (1825) in Hudson, *History of Lexington, Mass.*, 1:A541.

47. Fischer, *Paul Revere's Ride*, 110.

48. *New England Historical and Genealogical Society Register*, "Reminiscences by Gen. Wm. H. Sumner," 187.

49. Clarke, "Narrative of the Battle of Lexington," 1:A527.

50. *New England Historical and Genealogical Society Register*, "Reminiscences by Gen. Wm. H. Sumner," 187.

51. Parker, "Captain John Parker," 1:46.

52. Stout, *New England Soul*, 287. Reverend William Emerson gave a rousing sermon on March 13, 1775, at a Concord militia muster. See Stout, *New England Soul*, 289.

53. Fischer, *Paul Revere's Ride*, 151.

54. Clarke, "Narrative of the Battle of Lexington," 1:A528. Parker manuscript deposition in LHS archives.

55. See Arthur Bernard Tourtellot and Harold Murdock, "The Real Samuel Adams and Real Life," May 18, 2008, on the blog "Boston1775," www.Boston1775.net. J.L. Bell makes a cogent case for Hancock being more likely to initiate such a scheme, if ever one was afoot.

56. Revere to Belknap.

57. Clarke, "Narrative of the Battle of Lexington," 1: A527.

58. Revere to Belknap.

59. William Munroe, "Deposition" (1825), in Hudson, *History of Lexington, Mass.*, 1:541.

60. *New England Historical and Genealogical Society Register*, "Reminiscences by Gen. Wm. H. Sumner," 187.

61. Fischer, *Paul Revere's Ride*, 180.

62. Deposition of Elijah Sanderson, December 17, 1824, found in Hudson, *History of Lexington, Mass.*, 1:541.

63. Fischer, *Paul Revere's Ride*, 117.

64. Jeremy Lister, *The Concord Fight: Being the Narrative of the Tenth Regiment of Foot During the Early Months of the Siege of Boston* (Cambridge, MA: Harvard University Press, 1931), 23.

65. Fischer, *Paul Revere's Ride*, 311. Harvard professor John Winthrop took a temperature reading of forty-six degrees at 6:00 a.m.

66. Clarke, "Narrative of the Battle of Lexington," 1:A528.

67. Fischer, *Paul Revere's Ride*, 327–28.

68. Clarke, "Narrative of the Battle of Lexington," 1:A528.

69. The present-day reenactor organization Lexington Minutemen Inc. successfully substantiated the addition of three men to the list in 2006, bringing the total from seventy-seven to eighty.

70. Parker, "Deposition." Fifty years later, depositions claimed that Parker told his men to hold their ground for a time. One has him saying, "Stand your ground. Don't fire unless fired upon. Bur if they want a war let it begin here."

71. Clarke, "Narrative of the Battle of Lexington," 1:A528.

72. Elias Phinney, *Lexington: On the Morning of April 19, 1775* (Lexington, MA: Phelps and Farnham, 1825), 20.

73. Clarke, "Narrative of the Battle of Lexington," 1:A530.

74. Ibid., 1:A529.

75. Ibid., 1:A530.

76. Ware, *Memoir of the Life of Henry Ware, Jr.*, 1:4.

77. *New England Historical and Genealogical Society Register*, "Reminiscences by Gen. Wm. H. Sumner," 188. This is a report by General Sumner, whom Dolly told it to. The quotations are his words.

78. Clarke, "Extracts of Letter of Miss Betty Clarke," 4:92.

79. JCD, vol. 2, accounts, 1775.

80. Ibid., June 17, 1775.

81. Fischer, *Paul Revere's Ride*, 209.

82. Carrie Batchelder, *Munroe Tavern: The Custodians Story* (Lexington, MA: Lexington Historical Society, n.d.), 7.

83. To Governor Gage, Boston, April 20, 1775, found in Bolton, *Letters of Hugh, Earl Percy*, 49–50. Quotation on page 50.

84. Mackenzie, *Diary of Frederick Mackenzie*, 21.

85. Clarke, "Narrative of the Battle of Lexington," 1:532.

86. Mackenzie, *Diary of Frederick Mackenzie*, 20.

87. Fischer, *Paul Revere's Ride*, 258.

88. Mackenzie, *Diary of Frederick Mackenzie*, 20.

89. Ware, *Memoir of the Life of Henry Ware, Jr.*, 5.

90. Clarke, "Extracts of Letter of Miss Betty Clarke," 4:92.

91. Fischer, *Paul Revere's Ride*, 321.

92. JCD, vol. 2, April 19, 1775.

93. Fischer, *Paul Revere's Ride*, 321.

94. George O. Smith, "Reminiscences of a Participant in the Occurrences of April 19, 1775," *PLHS* (1890), 1:61.

95. Baxter, *House of Hancock*, 145.

96. Alden, *General Gage in America*, 255–56.

97. JCD, vol. 2, May 1, 1775.

98. Ibid., May 17, 1775.

99. Ibid., August 17, 1775.

100. Ibid., May 12, 1775.

101. Ibid., July 18, 1775; Fowler, *Baron of Beacon Hill*, 192.

102. JCD, vol. 2, May 6, 1775.

103. Hudson, *History of Lexington, Mass.*, 2:424.

104. Ibid., 2:425.

105. Ibid., 2:111.

CHAPTER 9

1. Jonas Clarke sermon at Lexington, March 24, 1776, LHS.

2. Fenn, *Pox Americana*, 19.

3. Ibid., 51.

4. Jacqueline Barbara Carr, *After the Siege: A Social History of Boston, 1775–1800* (Boston: Northeastern University Press, 2005), 39.

5. See David McCullough, *1776* (New York: Simon and Schuster, 2005), 106.

6. JCD, vol. 2, April 19, 1776.

7. David Waldstreicher, *In the Midst of Perpetual Fetes: The Making of American Nationalism, 1776–1820* (Chapel Hill: University of North Carolina Press, n.d.), 36.

8. Diary, Reverend John Marrett, April 19, 1776, in Cutter and Cutter, *History of the Town of Arlington*, 84–85.

9. Clarke, *Fate of the Blood-Thirsty Oppressors*, 3.

10. Ibid., 12.

11. Ibid., 27.

12. Ibid., 32.

13. LTMSR, February 24, 1777.

14. Sarah J. Purcell, *Sealed in Blood: War, Sacrifice and Memory in Revolutionary America* (Philadelphia: University of Pennsylvania Press, 2002), 27, 105–6.

15. LTMSR, March 22, 1777.

16. JCD, vol. 2, May 25, 1775.

17. Ibid., June 3 and 4, 1776.

18. In Duane Hamilton Hurd, *The History of Middlesex County, Massachusetts* (Philadelphia: J.W. Lewis and Company, 1890), 394.

19. JCD, vol. 2, January 29, 1776. This service is not listed in *Massachusetts Soldiers and Sailors in the Revolutionary War*, vol. 2 (Boston: Wright and Potter Printing Company, State Printers, 1896), 279. This may be because in Hudson, *History of Lexington, Mass.*, 1:427, Reverend Jonas Clarke is listed as substituting for his son. This is certainly not so, even as chaplain, as Clarke's diary attests.

20. Hudson, *History of Lexington, Mass.*, 1:426.

21. *Massachusetts Soldiers and Sailors*, 279.

22. Stout, *New England Soul*, 304. Quotation from *Common Sense*.

23. See Pauline Maier, *American Scripture* (New York: Knopf, 1997) for the definitive treatment of these.

24. LTMSR, May 23, 1776.

25. Ronald M. Peters Jr., *The Massachusetts Constitution of 1780: A Social Compact* (Amherst: University of Massachusetts Press, 1978), 29.

26. Lexington town meeting records, October 21, 1776.

27. JCD, vol. 2, November 19–20, 1776.

28. Ibid., December 16–17, 1776.

29. Fenn, *Pox Americana*, 15–16.

30. JCD, vol. 2, December 20, 1776.

31. Ibid.

32. Ibid., January 22, 1777.

33. Ibid., January 26, 1777.

34. Baldwin, *New England Clergy*, 137.

35. LTMSR, June 15, 1778.

36. Ibid., February 20, 1781.

37. Ibid., December 28, 1779.

38. Ibid., March 17, 1780.

39. Ibid., June 14, 1780.

40. Peters, *Massachusetts Constitution*, 20.

41. Samuel Elliot Morrison, *A History of the Constitution of Massachusetts* (Boston: Wright and Potter Printers, 1917), 18–20.

42. Peters, *Massachusetts Constitution*, Article 2 and 3, 196–97.

43. *Journal of the Convention for Framing a Constitution of Government for the State of Massachusetts Bay* (Boston: Dutton and Wentworth, 1832), 59.

44. Ibid., 65.

45. Ibid., 139.

46. Morrison, *A History of the Constitution*, 21–22.

47. Hudson, *History of Lexington, Mass.*, 1:327.

48. *Report of the Record Commissioners of Boston, Containing Boston Marriages from 1700 to 1751*, "Marriages in Boston," 1700–1809, vol. 28 (Boston: Municipal Printing Office, 1898).

49. Oliver Ayer Roberts, *History of the Military Company of the Massachusetts Now Called the Ancient and Honorable Artillery of Massachusetts, 1637–1888* (Boston: Alfred Mudge and Sons, 1897), 201.

50. Carr, *After the Siege*, 182.

51. *Salem Gazette*, April 24, 1783, 3.

52. Hudson, *History of Lexington, Mass.*, 1:245–46.

CHAPTER 10

1. Leonard L. Richards, *Shays's Rebellion* (Philadelphia: University of Pennsylvania Press, n.d.), 75.

2. LTMSR, August 8, 1782.

3. Richards, *Shays's Rebellion*, 82.

4. Letter, George Washington to Benjamin Lincoln, November 7, 1786, Gilder Lehrman Institute of American History, www.gilderlehrman.org/collections.

5. Hudson, *History of Lexington, Mass.*, 1:249.

6. LTMSR, May 1787.

7. Ibid., December 10, 1787.

8. JCD, vol. 4, January 18, 1788.

9. *Columbian Centinel*, December 21, 1805, 1.

10. JCD, vol. 4, January 24–27, 1788.

11. Reverend Jonas Clarke to Jonas Clarke (son), January 31, 1793, LHS.

12. Pauline Maier, *Ratification: The People Debate the Constitution, 1787–1788* (New York: Simon and Schuster, 2010), 145–46.

13. *Debates and Proceedings in the Convention of the Commonwealth of Massachusetts, Held in the Year 1788, and which Finally Ratified the Constitution of the United States. Printed by Authority of Resolves of the Legislature* (Boston: William White, 1856), 88.

14. Reverend Jonas Clarke to Mary Cotton, January 28, 1785, LHS.

15. LTMSR, January 1791.

16. Lexington, Massachusetts, *Record of Births, Marriages and Deaths to January 1898* (Boston: Wright and Potter, 1898), 170.

17. JCD, vol. 4, March 31, 1789; *Independent Chronicle*, April 2, 1789, 3. This was among several newspapers that reported on the wedding. Lexington vital records incorrectly lists the marriage exactly one year later.

18. JCD, vol. 4, April 6, 1789.

19. Ibid., April 9, 1789.

20. Reverend Jonas Clarke to Jonas Clarke, June 7, 1789, LHS.

21. JCD, vol. 4, September 25, 1789.

22. Ibid., September 16, 1789.

23. Ibid., September 19, 1789.

24. Letter to Jonas Clarke (son), June 7, 1789, LHS.

25. Letter, Mary Ware to sisters, April 25, 1789, Ware-Allen Papers, Massachusetts Historical Society.

26. Letter, Mary Ware to Mary Cotton, May 29, 1790, Ware-Allen Papers.

27. Letter to Jonas Clarke (son), June 7, 1789, LHS.

28. JCD, vol. 4, June 17, 1789.

29. Reverend C.A. Staples, "Early Schools and Schoolmasters," *PLHS* (1900), 2:167. Staples confuses Lucy and Lydia in the article.

30. JCD, vol. 4, August 8, 1789.

31. Staples, "Early Schools and Schoolmasters," 167.

32. Hudson, *History of Lexington, Mass.*, 2:112–13.

33. Ibid., 2:112, 758.

34. Thomas Jefferson to Albert Gallatin, August 28, 1801, in *The Papers of Thomas Jefferson*, vol. 35, ed. Julian Parks Boyd (Princeton, NJ: Princeton University Press, 2009), 57.

35. This led to the landmark case *Marbury v. Madison.*

36. Letter, Jonas Clarke (son) to Reverend Jonas Clarke, October 17, 1785, LHS.

37. Hudson, *History of Lexington, Mass.*, 2:112–13.

38. Letter, Mary Cranch to Abigail Adams, December 12, 1790, found at http://founders.archives.gov/documents/Adams/04-09-02-0082.

39. JCD, vol. 4, July 22, 1791.

40. LTMSR, March 24, 1791.

41. Washington decided against visiting Rhode Island because it had not yet ratified the Constitution.

42. Donald Jackson and Dorothy Tohig, *The Diaries of George Washington* (Charlottesville: University of Virginia Press, 1976), 477. Washington's flu coincided with an outbreak in Boston, leading it to be called the "Washington influenza."

43. Ibid., 492.

44. JCD, vol. 4, November 5, 1789.

45. Munroe, *Sketch of the Munro Clan*, 64. The letter seems to contradict itself, however, by having Washington later greeting Clarke on November 5 in a way that indicates they never met. Perhaps when Clarke visited Washington on October 23, he met one of Washington's secretaries.

46. Ibid., 68.

47. JCD, vol. 4, March 11, 1793.

48. Hudson, *History of Lexington, Mass.*, 1:477. Hudson estimated that the population doubled from 453 in 1710 to 941 in the first federal census. Fuhrer's estimates, based on enumeration of polls, run higher for the earlier years.

49. JCD, vol. 4, March 12, 1793.

50. Hudson, *History of Lexington, Mass.*, 1:252.

51. Worthen, "Jonas Clarke of Lexington," 49.

52. JCD, vol. 4, March 30, 1794.

53. Ibid., June 11 and 12, 1794.

54. Ibid., vol. 5, April 6, 1803.

55. Ibid., vol. 4, January 15, 1795.

56. Harold Milton Ellis, "Joseph Dennie and His Circle," *Bulletin of the University of Texas* 40 (July 15, 1915): n22.

57. JCD, vol. 5, September 15, 1795.

58. LTMSR, September 1795.

59. Edward E. Bourne, *The History of Wells and Kennebunk* (Portland, ME: B. Thurston and Company, 1857), 586.

60. Hudson, *History of Lexington, Mass.*, 1:253. Charles Hudson either assumed that Clarke took the leading role or has other evidence he did not cite. If Clarke were healthy, logic would place Clarke at the committee's head.

61. LTMSR, April 9, 1798.

62. Bourne, *History of Wells and Kennebunk*, 588.

63. *Salem Gazette*, "Ship News," December 4, 1798, 3; JCD, vol. 5, December 26, 1798; Hudson, *History of Lexington, Mass.*, 2:113.

64. LTMSR, April 4, 1791.

65. Ibid., May 2, 1795.

66. Ibid., October 27, 1795.

67. Petition, Joseph Simonds to the Massachusetts General Court, 1797, manuscript copy in LHS Archives.

68. *Acts and Laws of the Commonwealth of Massachusetts*, "Chapter 49" (Boston: Young and Minns, 1896), 312.

69. *Acts and Resolves Passed by the the Commonwealth of Massachusetts*, "Chapter 67" (Cambridge, MA: University Press of Cambridge, 1897), 557.

70. Reverend Jonas Clarke, "Inscription," 1799 monument, Lexington, Massachusetts.

71. LTMSR, March 11, 1799.

72. Purcell, *Sealed in Blood*, 126.

73. JCD, vol. 5, July 3 and 4, 1799.

74. Speech, manuscript copy, dated July 4, 1799, found in LHS archives.

75. JCD, vol. 5, May 19 and 29, 1799.

76. Ibid., June 2, 1799.

77. Ibid., June 26, 1799.

78. Hudson, *History of Lexington, Mass.*, 2:112.

79. JCD, vol. 5, June 10, 1805, in the accounting section of the diary.

80. Letter, Jonas Clarke (son) to Reverend Jonas Clarke, December 2, 1799, LHS; Daniel Remich, *History of Kennebunk from Its Earliest Settlement to 1890* (Kennebunk, ME: Lakeside Press, 1911), 147.

81. JCD, vol. 5, August 24, 1805.

82. *Columbian Centinel*, December 21, 1805, 1.

83. Excerpt of Reverend Dr. Jacob Cushing, funeral sermon on November 19, 1805, found in "Reverend Avery Williams Centennial Sermon," 1813, LHS.

84. *Repertory*, November 19, 1805, 3. The sermon itself cannot be found among Cushing's papers at the Massachusetts Historical Society.

85. *Columbian Centinel*, December 21, 1805, 1.

INDEX

About the Author

R ichard Kollen has taught at Lexington High School, Middlesex Community College and Northeastern University. He has served as the historian for the Lexington Historical Society and has written several books on Lexington, among them *Lexington: From Liberty's Birthplace to Progressive Suburb* and *Lexington: Treasures from Historical Archives*.